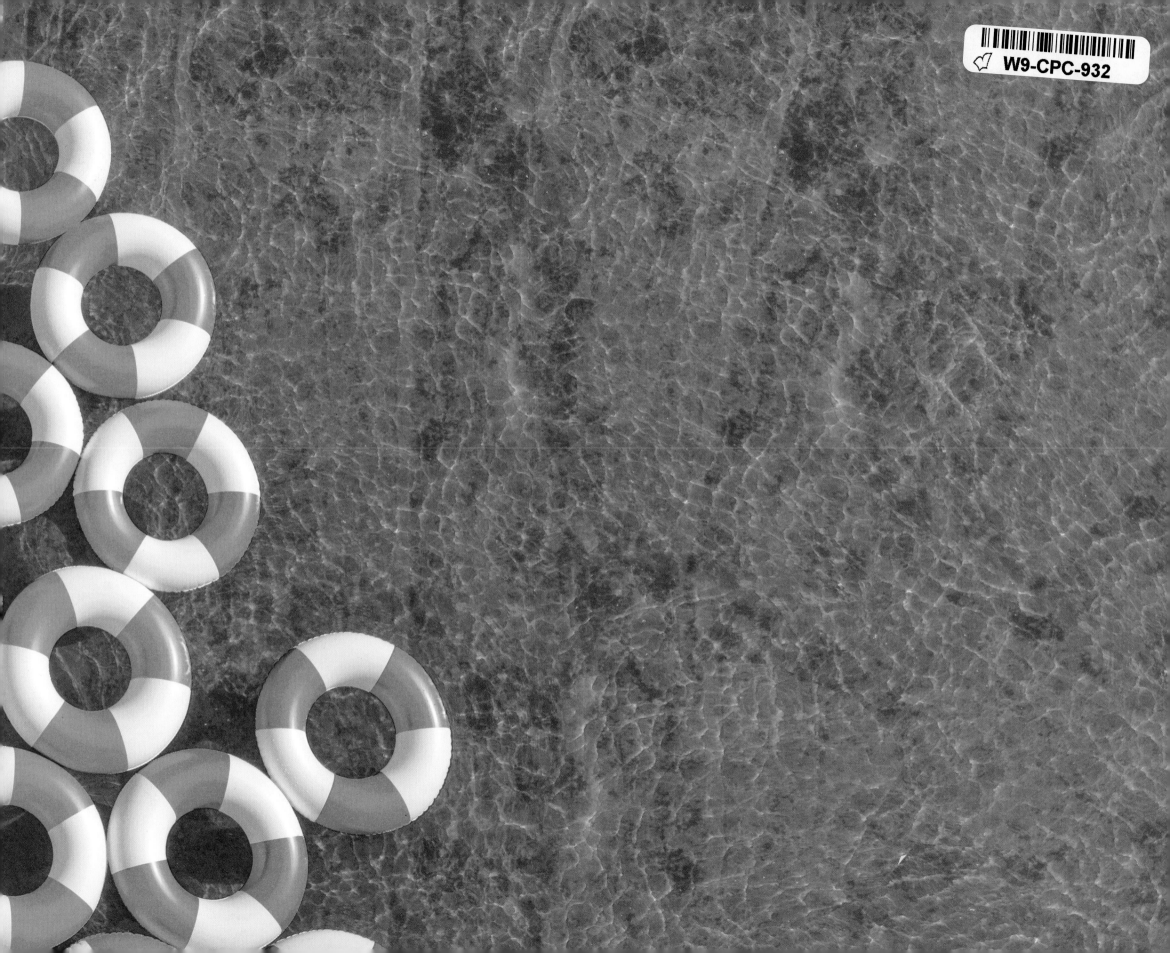

GRAY MALIN

ESCAPE

GRAY MALIN

Library of Congress Control Number: 2017932981

ISBN: 978-1-4197-2759-7

Text and Photography © 2017 Gray Malin

Printed and bound in China

10 9 8 7 6 5 4 3 2 1

Abrams books are available at special discounts when purchased in quantity
for premiums and promotions as well as fundraising or educational use.
Special editions can also be created to specification.

For details, contact specialsales@abramsbooks.com or the address below.

ABRAMS
The Art of Books

115 West 18th Street
New York, NY 10011
abramsbooks.com

This book is dedicated to
my darling husband,
Jeff.

INTRO p. 9

SURF p. 10

SNOW p. 44

POOLS p. 80

SAND p. 104

ISLES p. 134

PARKS p. 184

CREDITS p. 222

Introduction

Growing up, I spent my summers at our family's vacation home on the shores of Lake Michigan. All year I would dream of returning to this magical place where I was surrounded by peaceful beauty, family love, and blossoming freedom— a true escape that ignited a lifelong passion.

When I set out to become a fine art photographer, I knew I had a desire to create beautiful images but I did not know this eagerness would evolve into an insatiable obsession with bringing inspired imagery to life.

Over the past decade, I have dedicated myself to navigating the longitudes and latitudes of this earth to destinations that have awakened my artistic eye. Throughout this journey, I have realized that the feeling of escape is a shared experience, both physical and emotional, that constantly nurtures our inner spirit.

Whether the beauty of a local park, a wondrous sandy shore, a perfectly pink sky, a frosted mountaintop, or a candy-colored swimming pool, there are infinite places near and far that relax the mind and help us unwind. No matter where we are from, this shared connection to our surroundings, and to one another, and the desire to experience the multitude of places in this world unite us all as we seek to escape from our day-to-day lives. We are continuously inspired to quench our thirst for serenity and contentment.

The literal definition of escape is to break free from confinement or control, and that is exactly what I hope the viewer feels with each image I create. Go ahead and daydream—sink your toes into the sand, feel the snowflakes falling on your skin, the surf rushing by your body, and the salt air in your lungs. Join me as I celebrate the timeless beauty of our world and depict its joyful spirit through my lens.

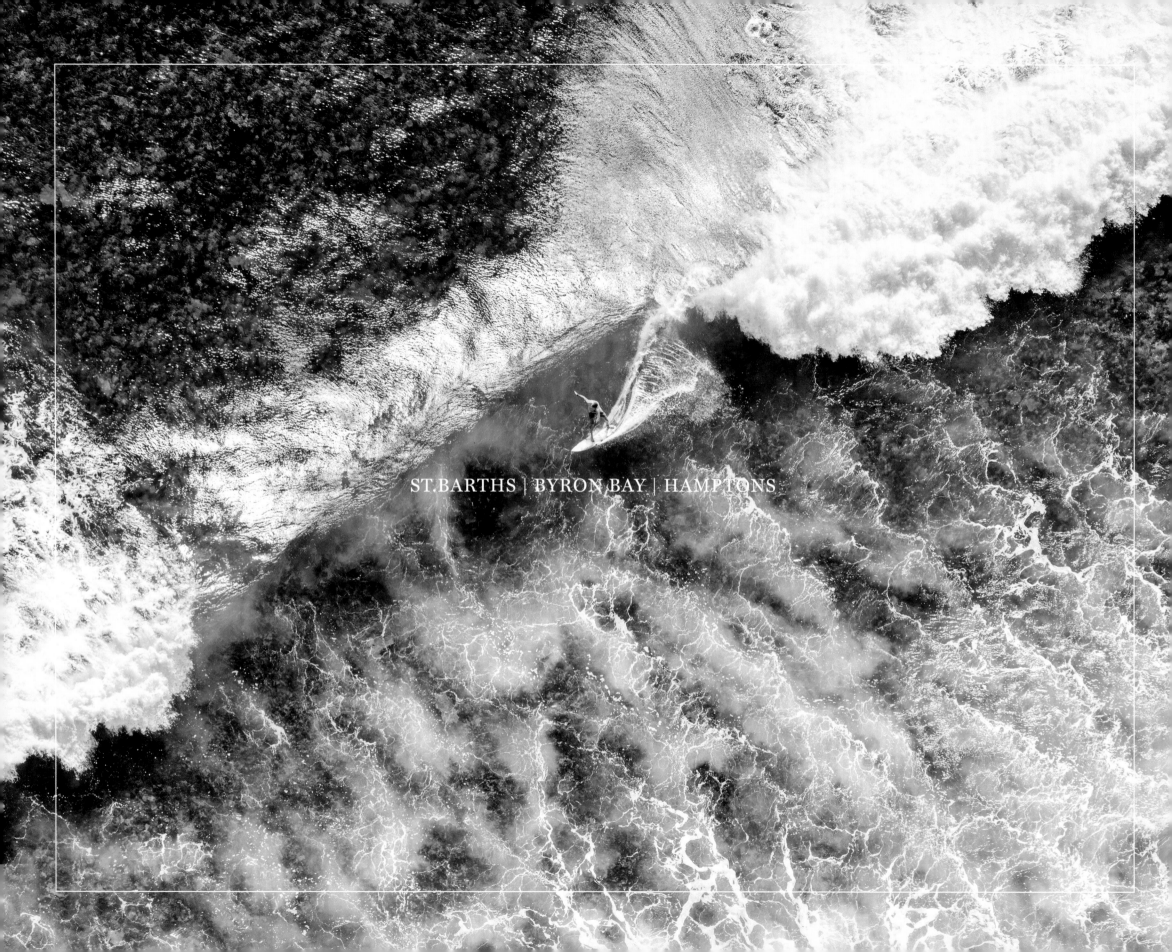

ST.BARTHS | BYRON BAY | HAMPTONS

Surf: the word itself evokes a passion in many who participate in the sport, live in a beach town, or relate to the culture in some capacity. It conjures visions of defying the odds and pushing one's body to the limit while becoming one with the elements: crashing waves, rising swells, and bursts of wind.

Whenever I find myself at a beach that is known for its surf, I can hardly wait to get in the water. Paddling out and escaping into the breaking waves, there is a special feeling that engages the mind while affording a deeper appreciation of the relationship humanity has with the ocean.

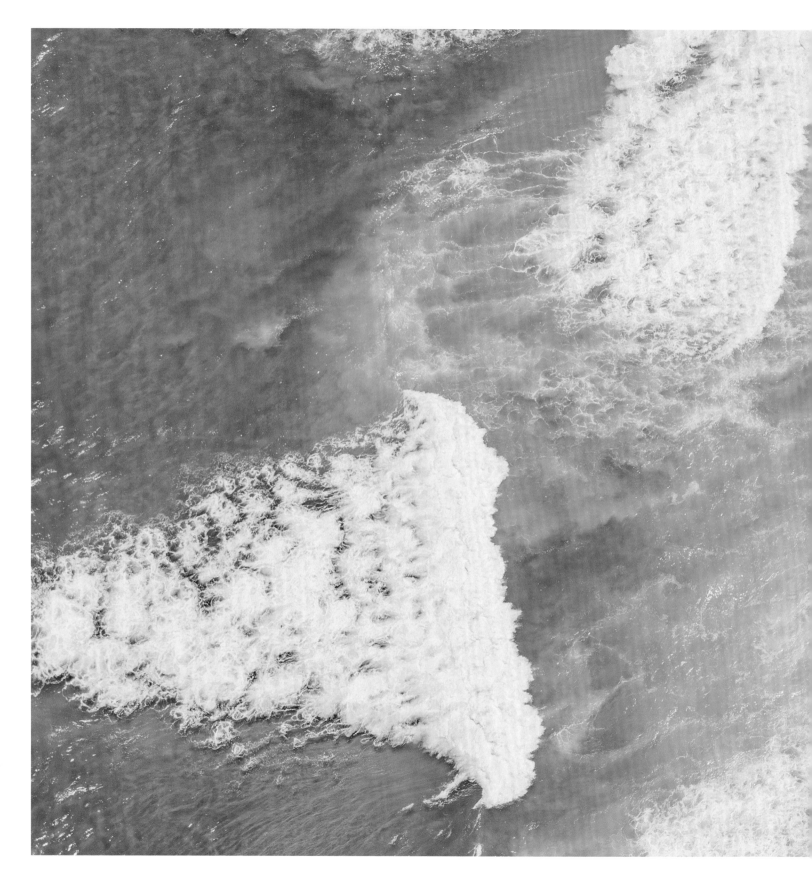

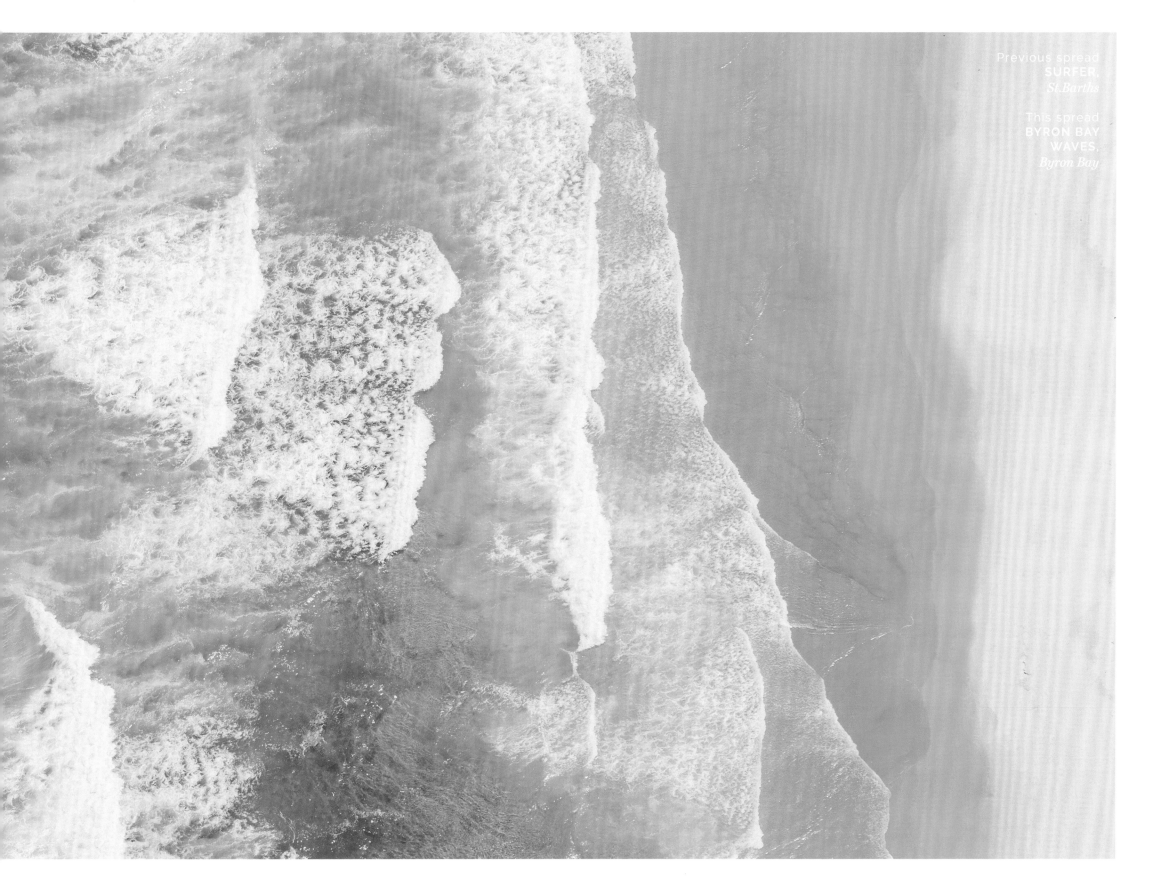

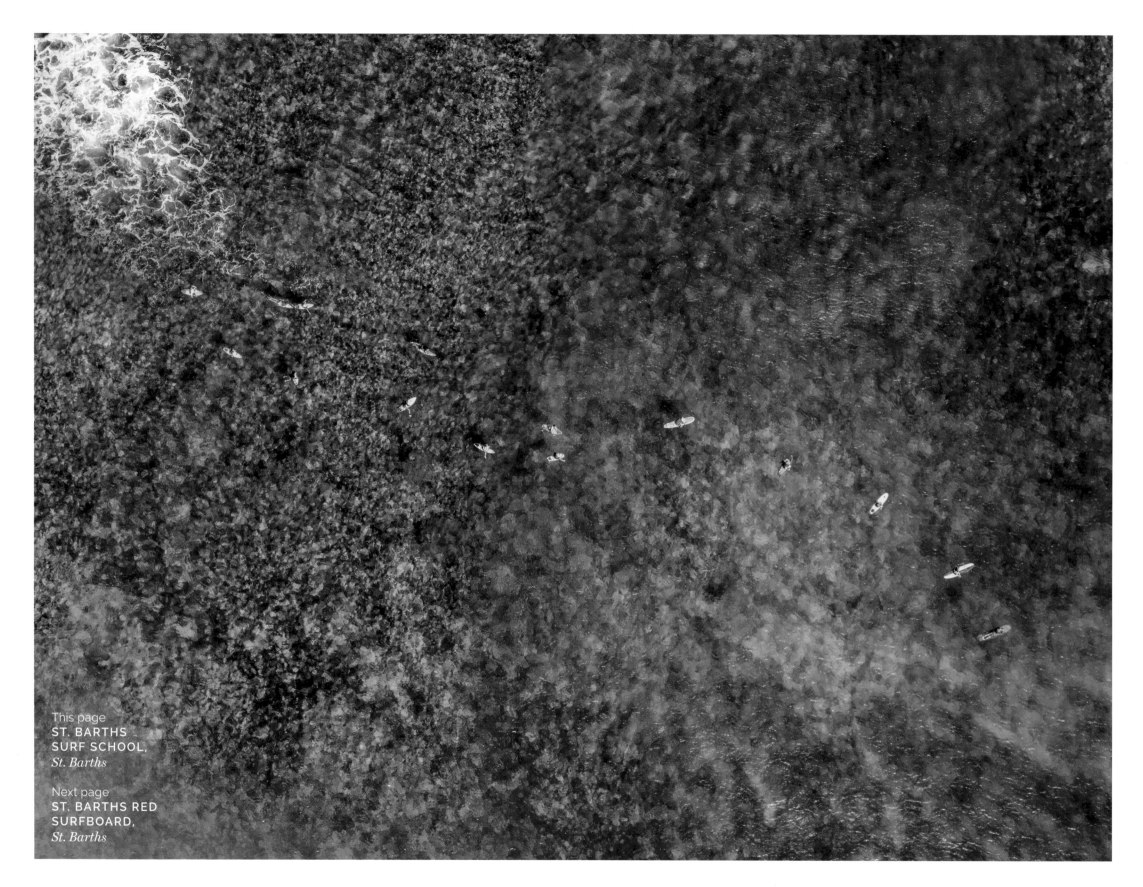

This page
**ST. BARTHS
SURF SCHOOL,**
St. Barths

Next page
**ST. BARTHS RED
SURFBOARD,**
St. Barths

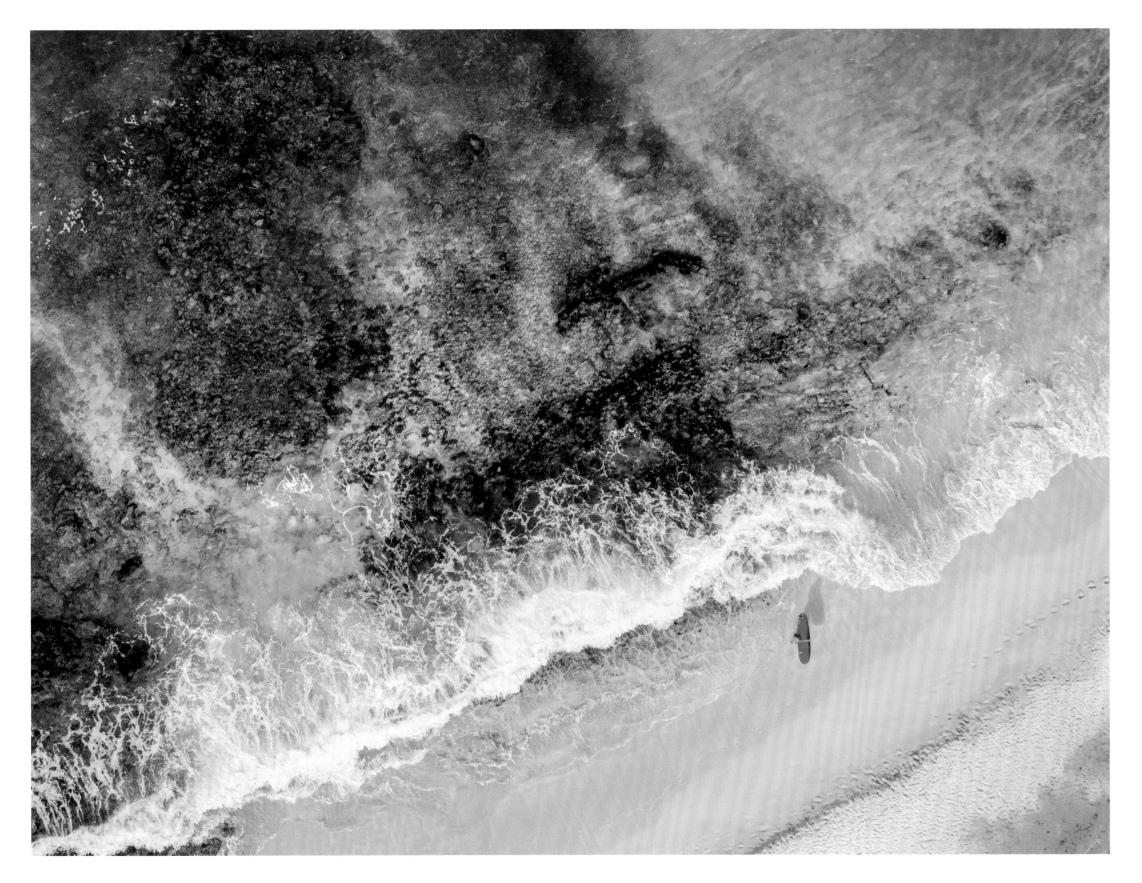

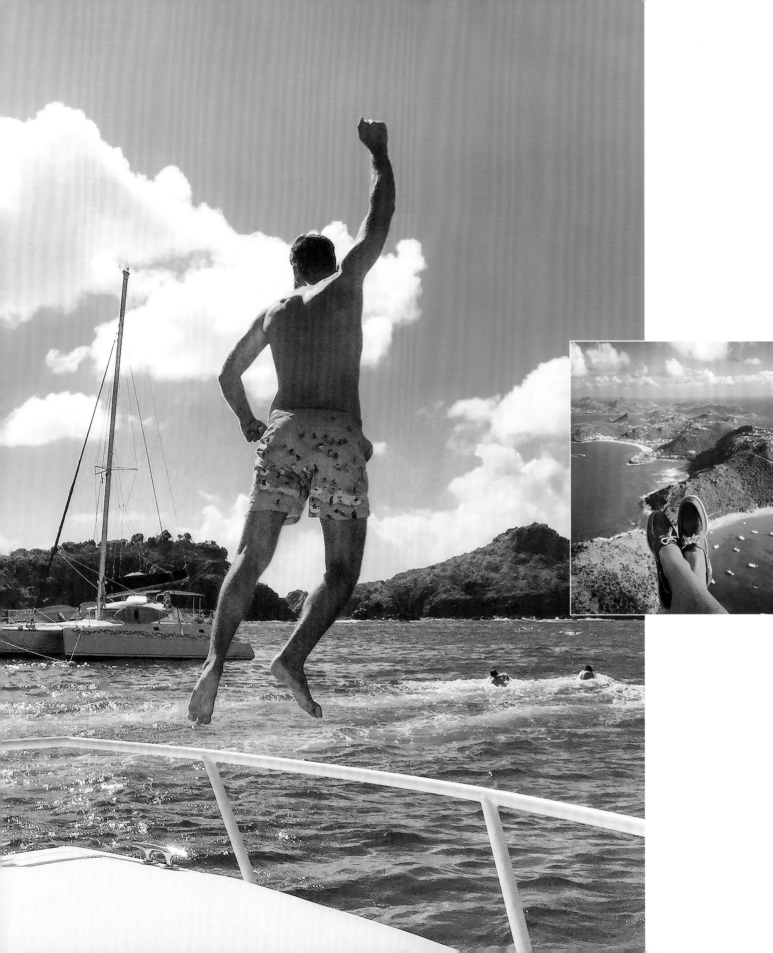

Famous for being popular with the rich and famous, St. Barths is one of the most glamorous locations I have ever visited. Regardless of the glamour, I was delighted to witness the incredible surf scenery around the island— it was unexpected yet delightful.

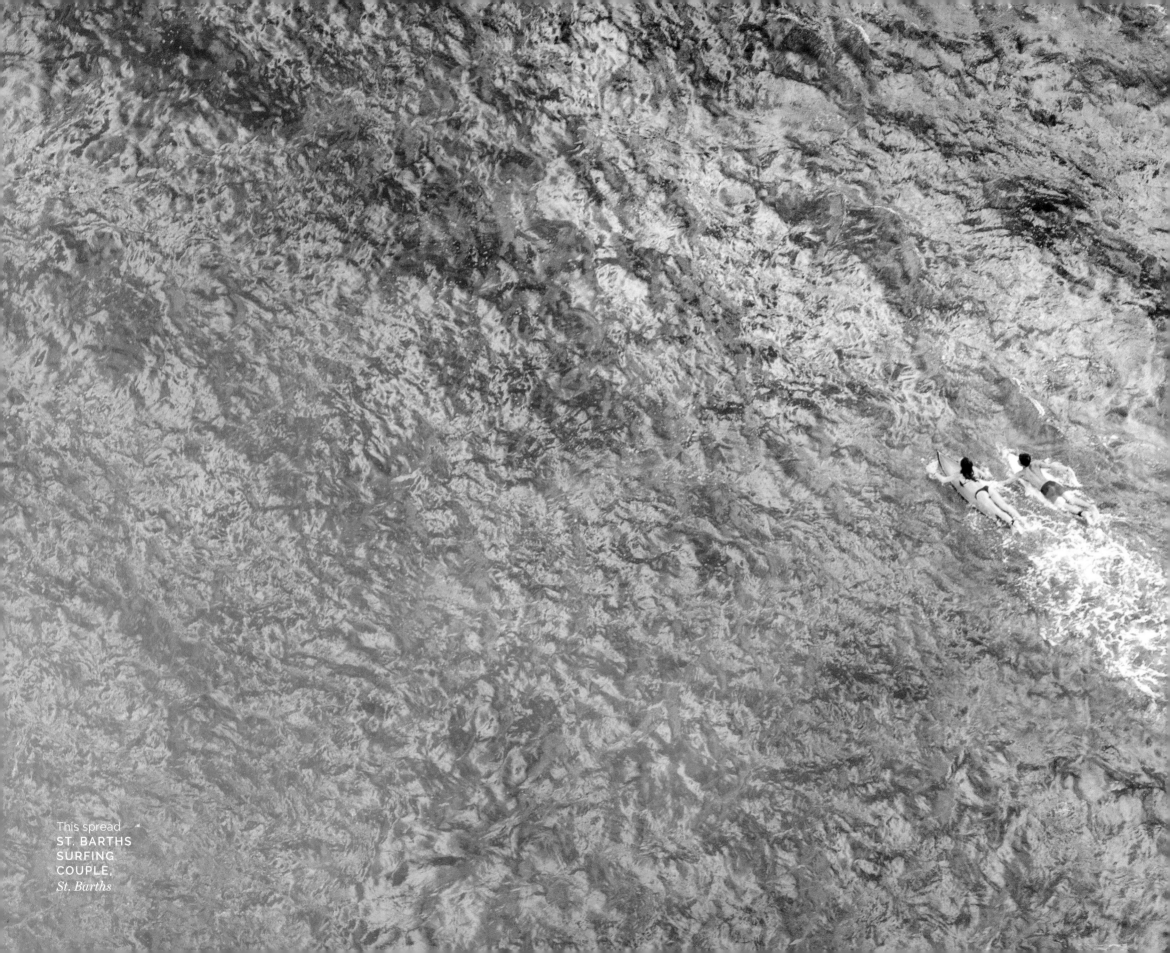

This spread
ST. BARTHS
SURFING
COUPLE,
St. Barths

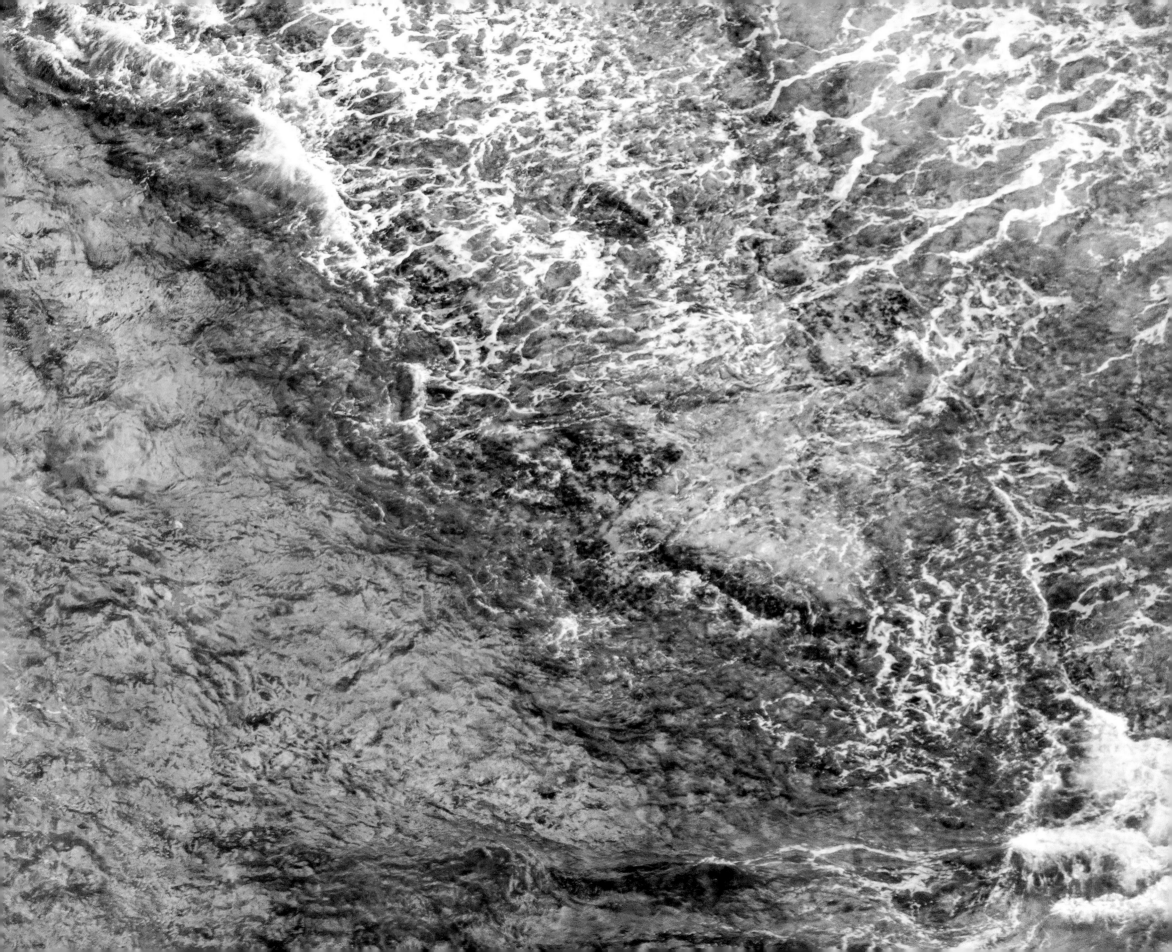

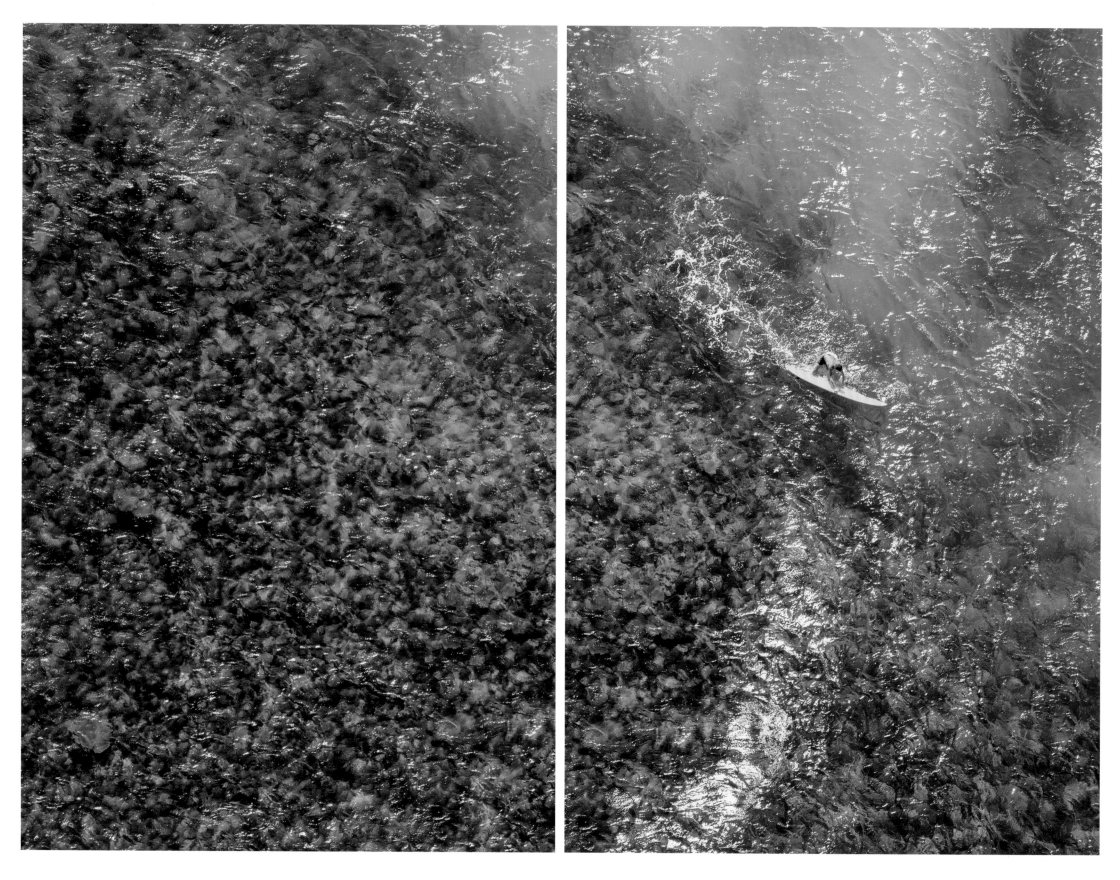

This spread
ST. BARTHS
SURFER
TRIPTYCH,
St. Barths

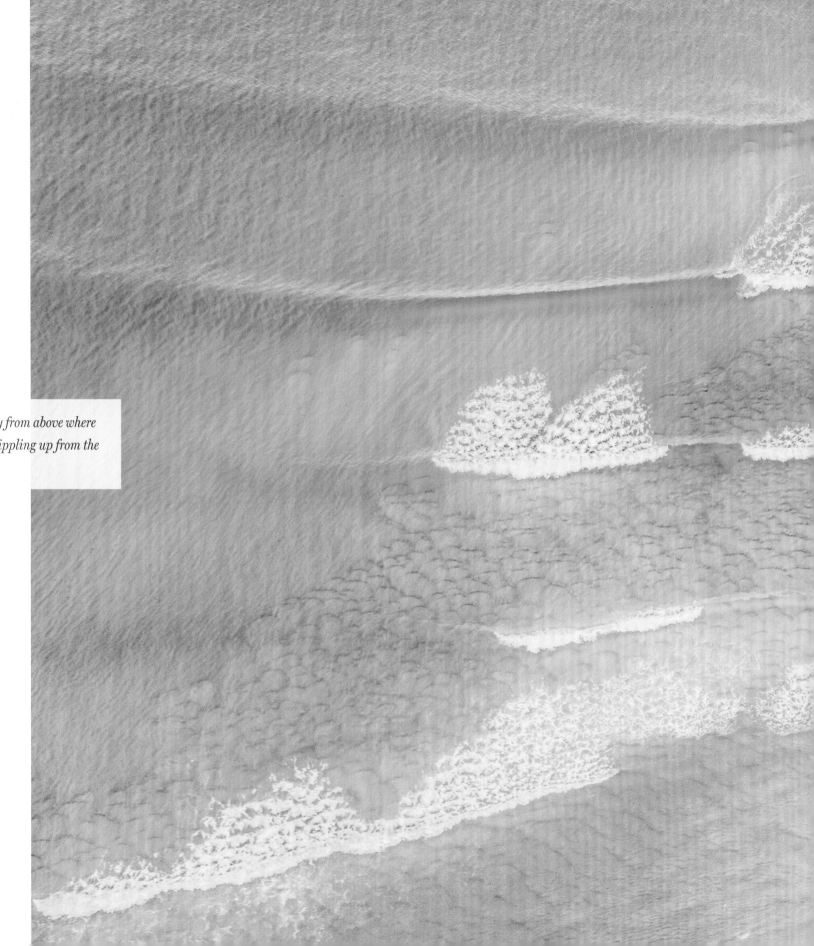

Byron Bay

I am often asked to recommend some of my favorite locations around the world, and I recently discovered a new favorite: the most easterly point in Australia, Byron Bay. Once a sleepy coastal town with an alternative hippie lifestyle, this secluded surf-happy beach community is now a vibrant notable destination for the trendsetting crowd. The locals say Byron has a special celestial spirit and relaxes anyone who visits—and I couldn't agree more.

A coastal point with a walking path separates the two main beaches, and though similar in location, they are different in experience. Byron Beach is larger and wider with easier access for surfers, while its sister beach, Wategos, is smaller and more private with a rocky southern coast.

The water color of both beaches is entrancing, especially from above where you can see the layers of translucent blues and greens rippling up from the ocean's floor beneath the colorful surfers.

To experience the perfect day in Byron Bay I recommend the following: a morning walk to the Cape Byron Lighthouse, breakfast at Harvest Café, a stroll through the Newrybar Merchants for a boutique upscale shopping experience, an afternoon surf lesson and swim at Byron Beach, sunset cocktails at Wategos, and then a sushi dinner in town.

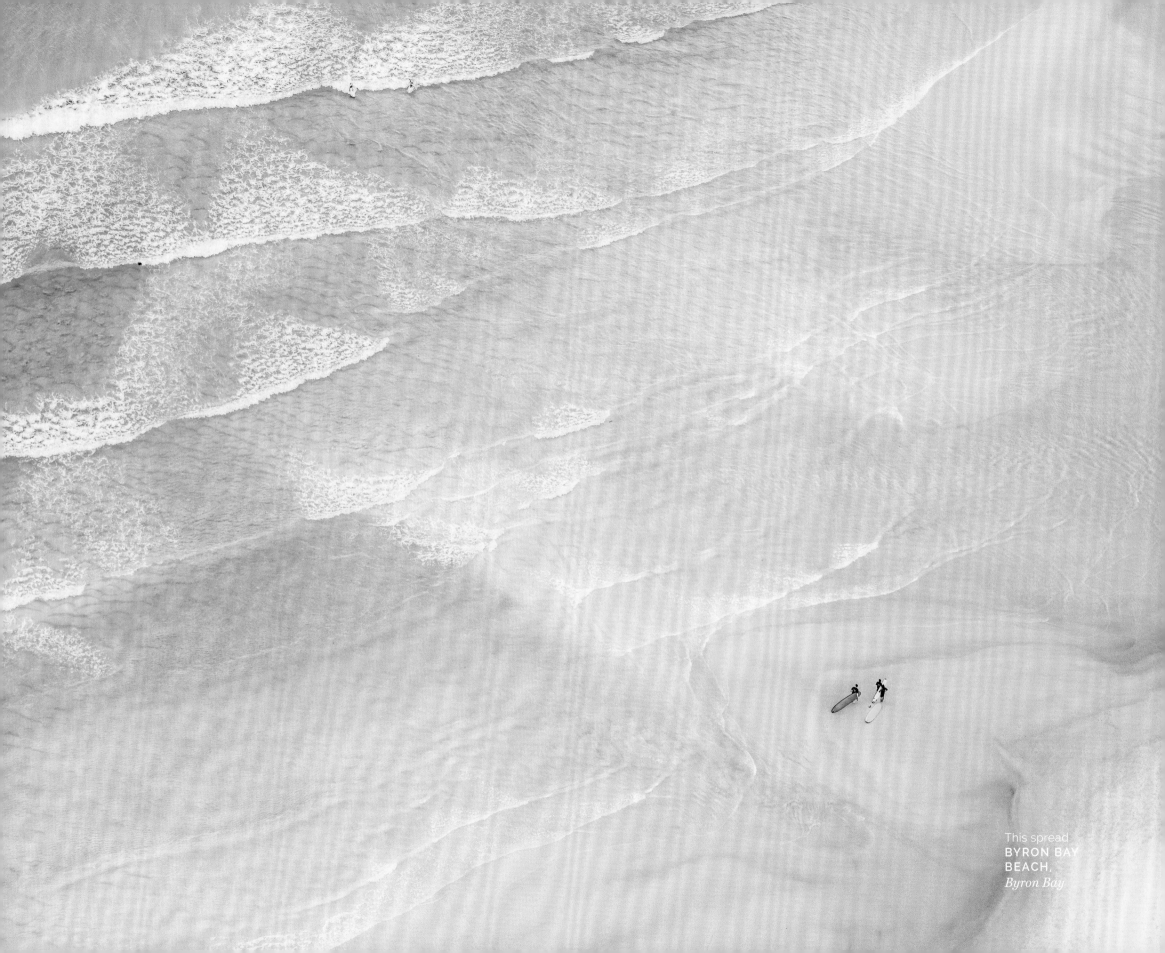

This spread
BYRON BAY
BEACH,
Byron Bay

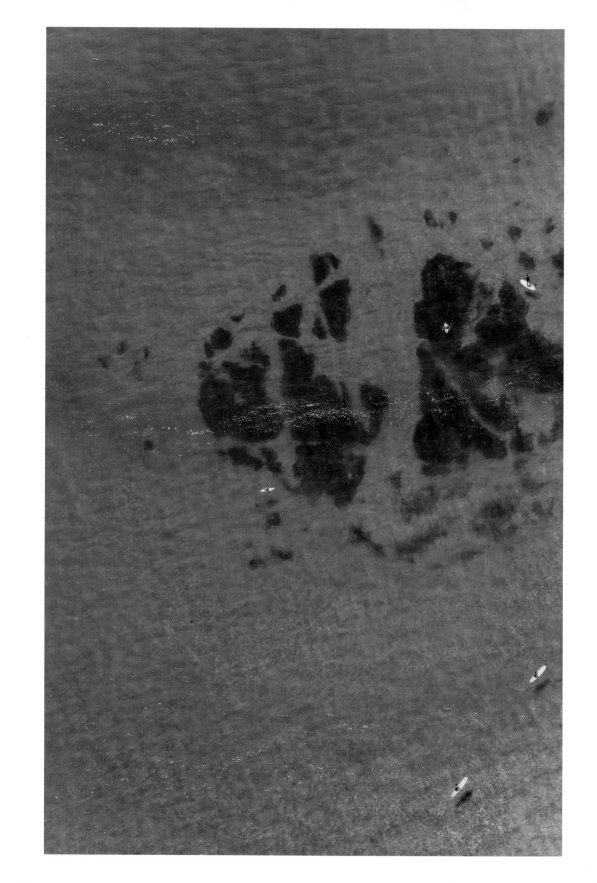

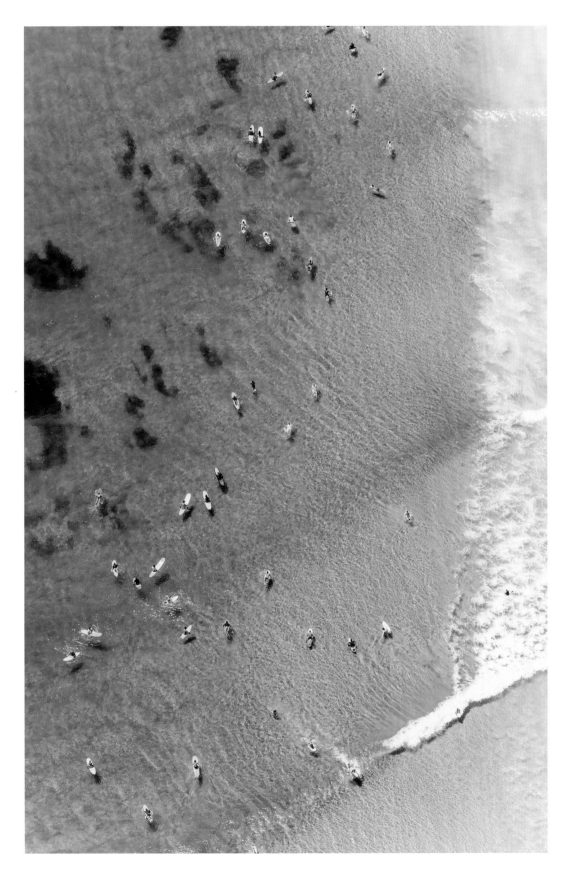

This spread
BYRON BAY
DIPTYCH,
Byron Bay

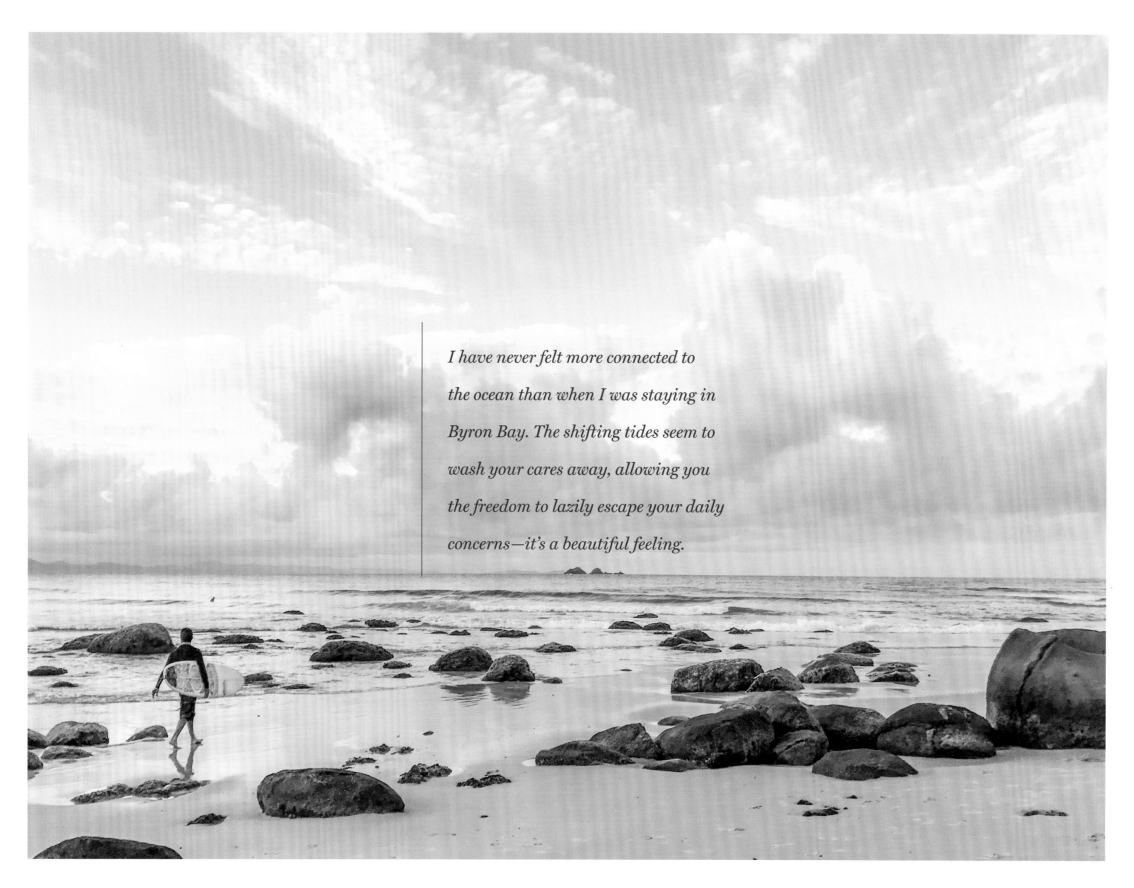

I have never felt more connected to the ocean than when I was staying in Byron Bay. The shifting tides seem to wash your cares away, allowing you the freedom to lazily escape your daily concerns—it's a beautiful feeling.

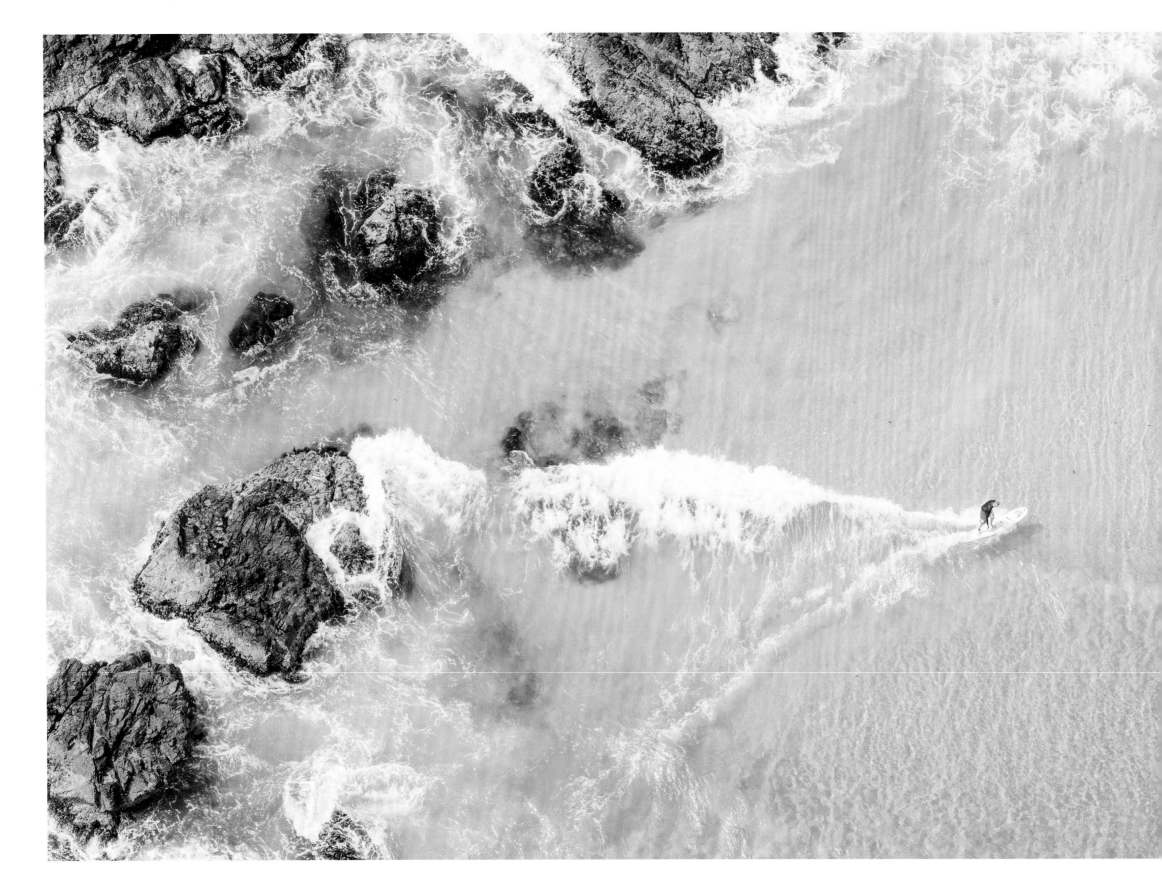

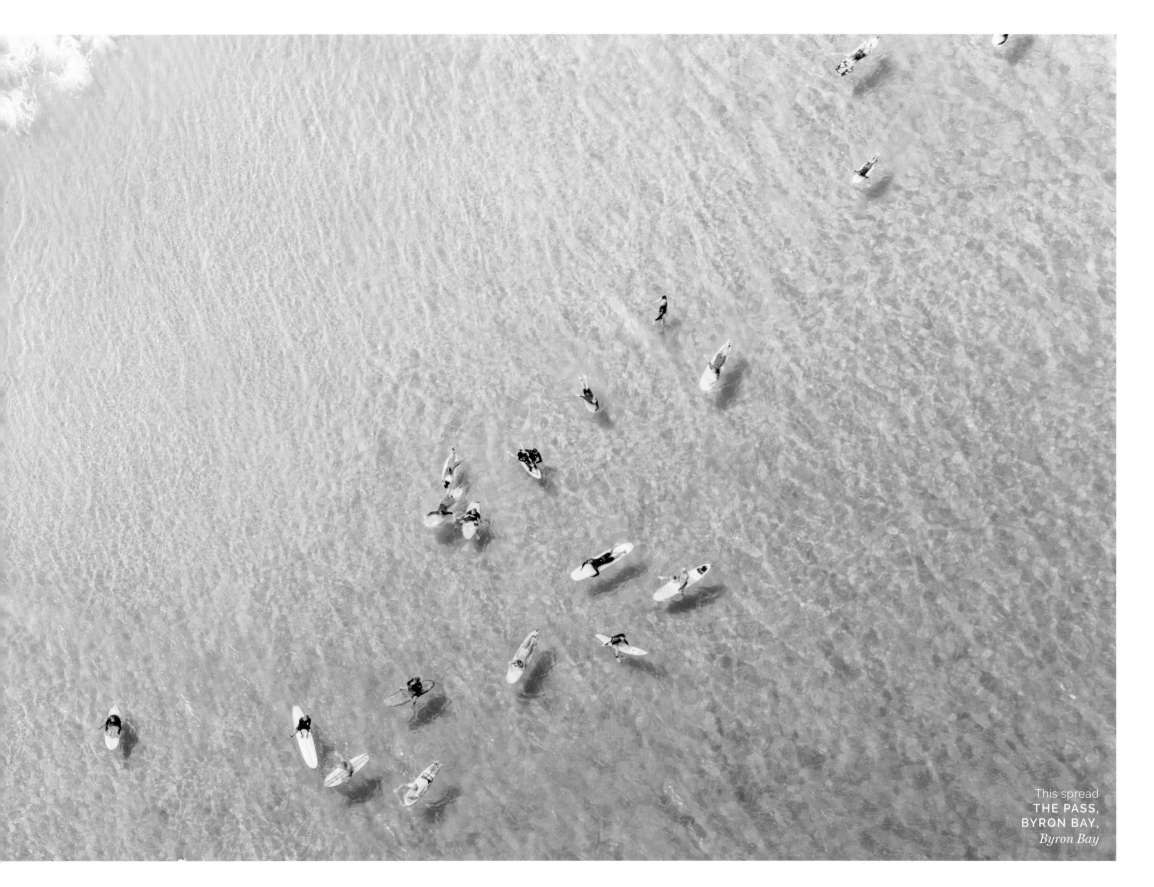

This spread
**THE PASS,
BYRON BAY,**
Byron Bay

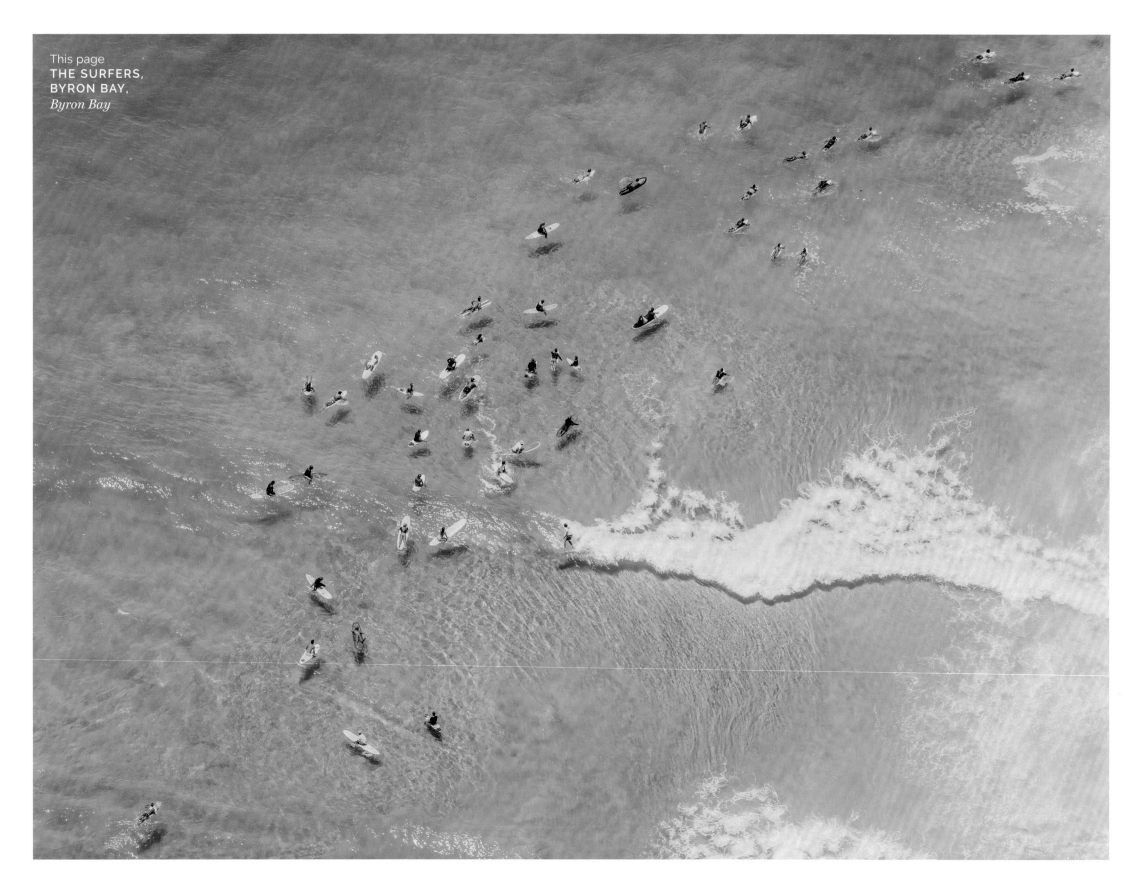

This page
**THE SURFERS,
BYRON BAY,**
Byron Bay

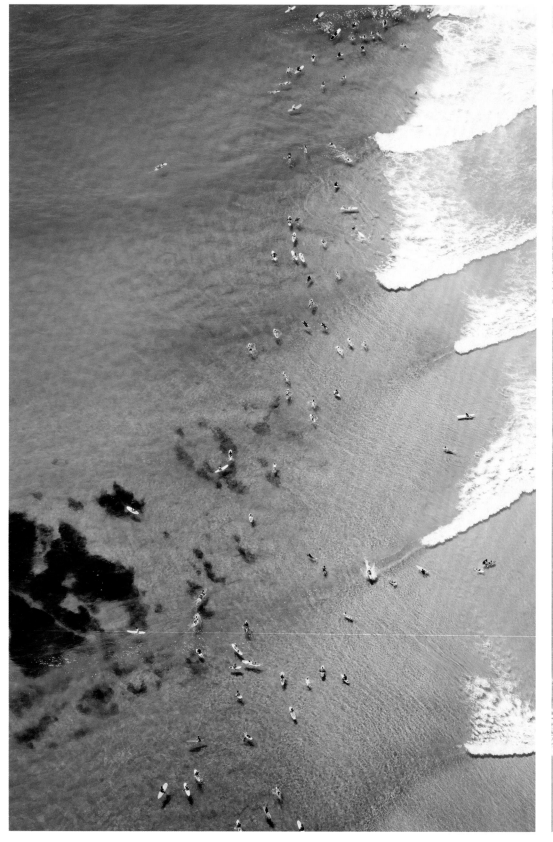
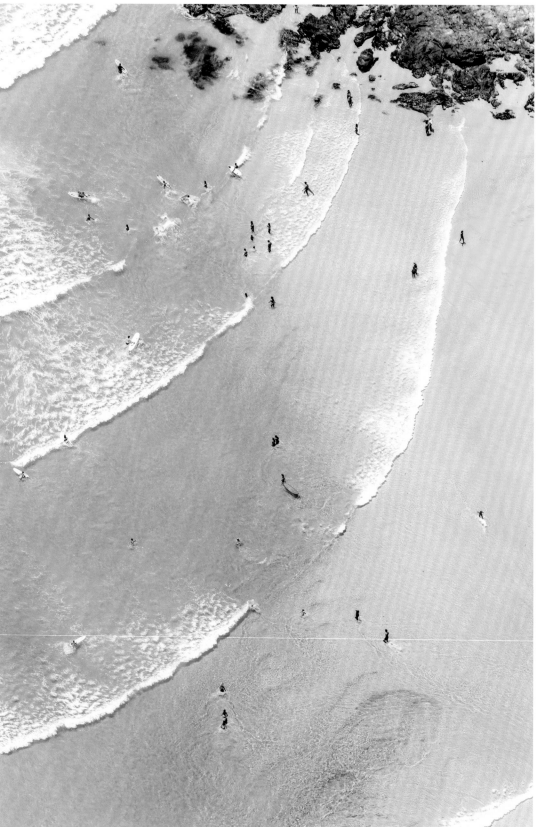

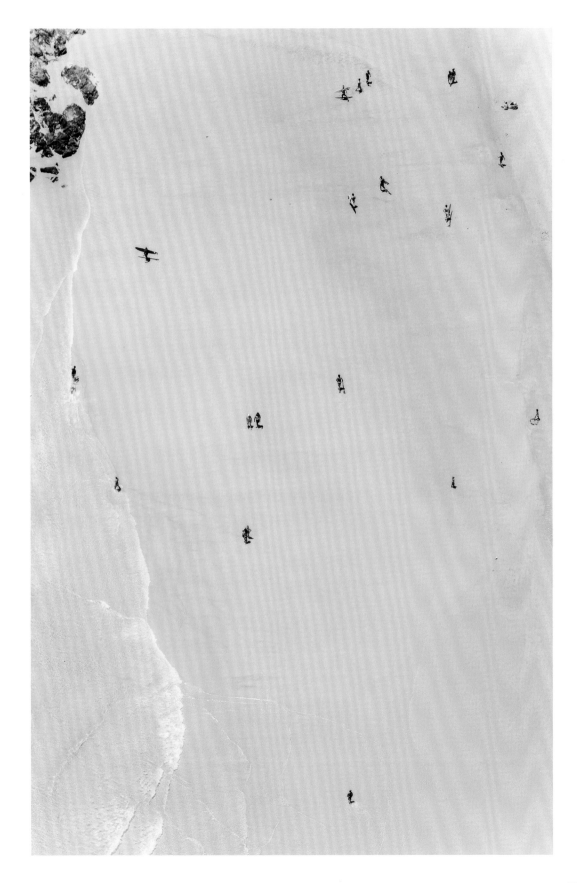

This spread
BYRON BAY TRIPTYCH,
Byron Bay

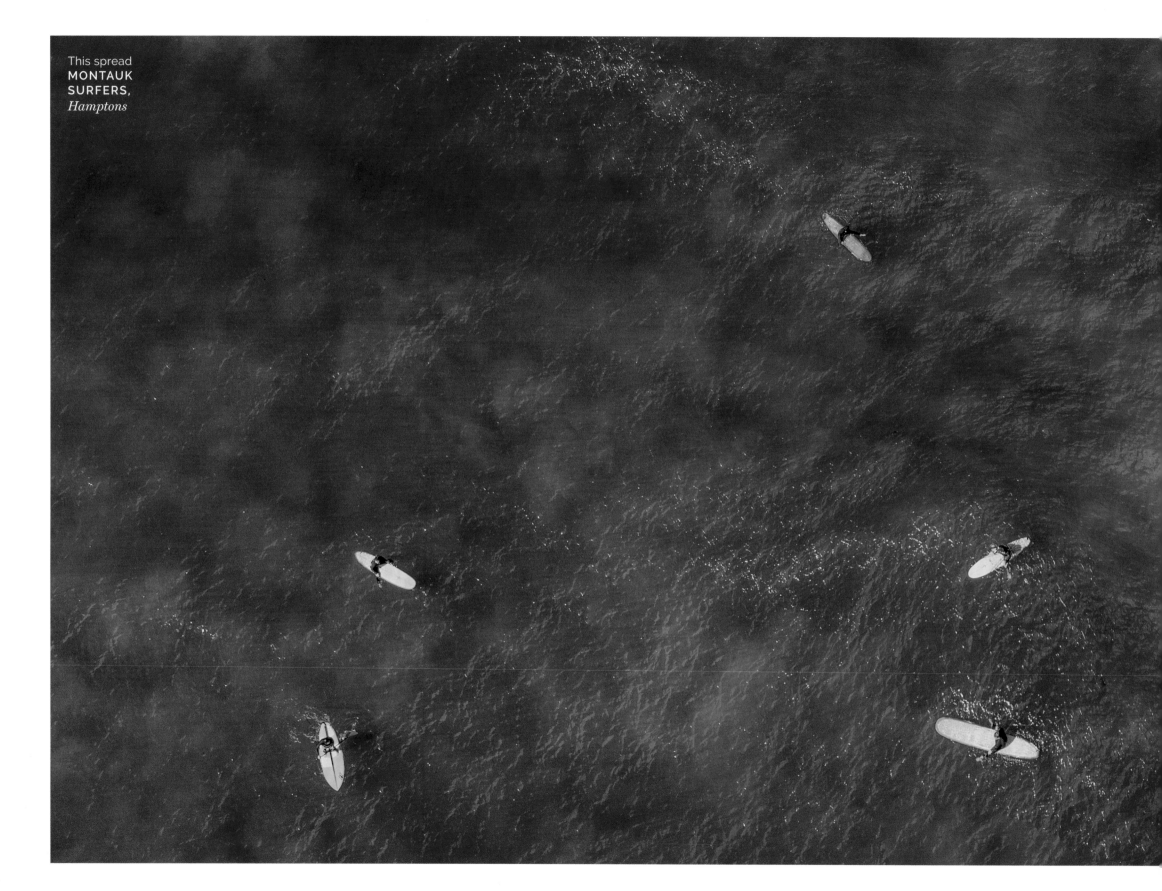

This spread
**MONTAUK
SURFERS,**
Hamptons

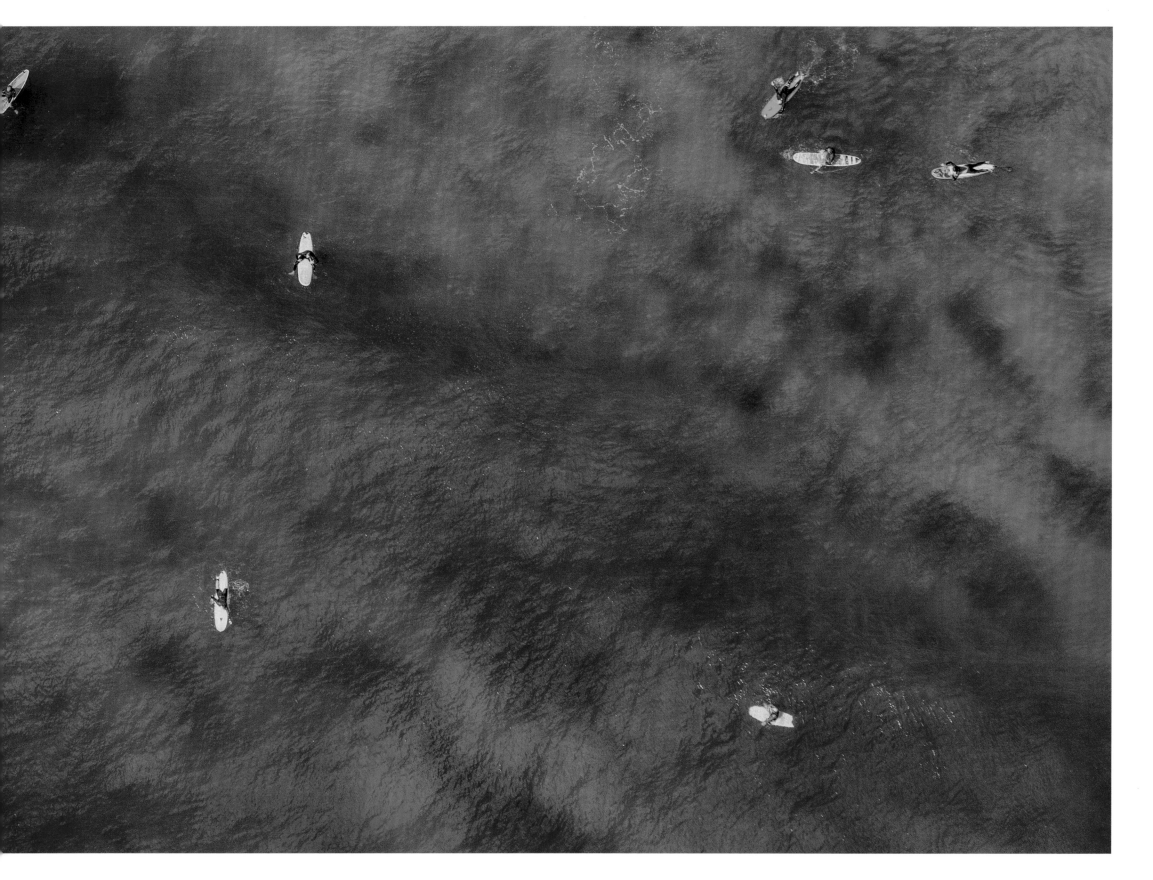

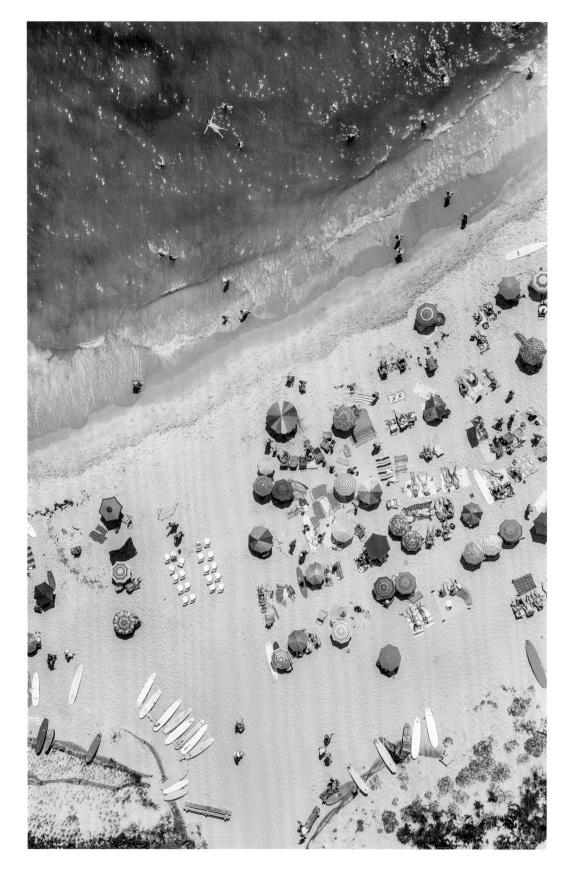

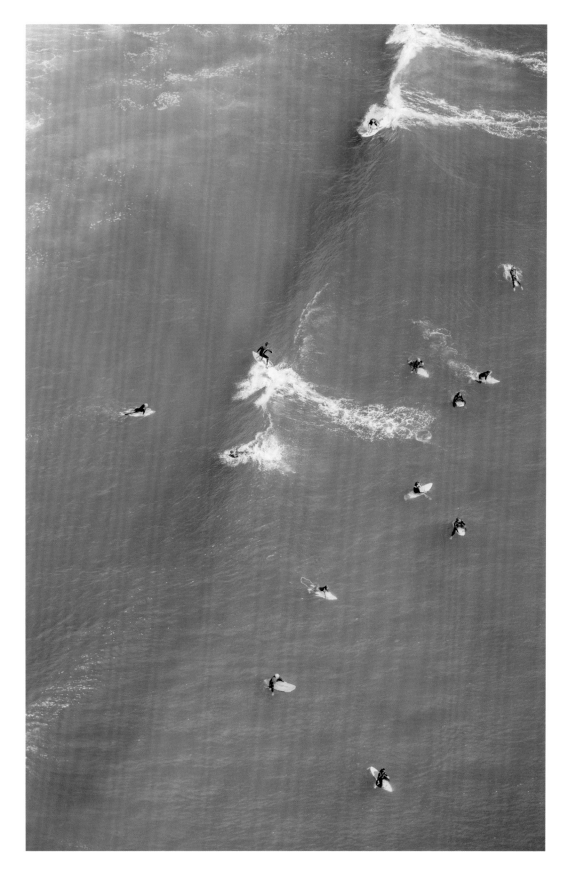

Previous page
MONTAUK
POINT BEACH
VERTICAL,
Hamptons

This page
MONTAUK
SURFERS
VERTICAL,
Hamptons

During the summertime, the Hamptons
are known for glitz and glamour on
and off the beach. For those seeking surf,
though, it's best to head to the eastern end
of the South Shore of Long Island, and the
quintessential beach town of Montauk.

For the ultimate Montauk escape, stay in
one of the Surf Lodge hotel's beach-chic
rooms, ride the waves at two of the best
surf beaches on the East Coast (in summer
and wintertime alike), Turtle Cove and
Ditch Plains, then spend the afternoon
lounging in the sun at The Beach Club,
Gurney's Montauk.

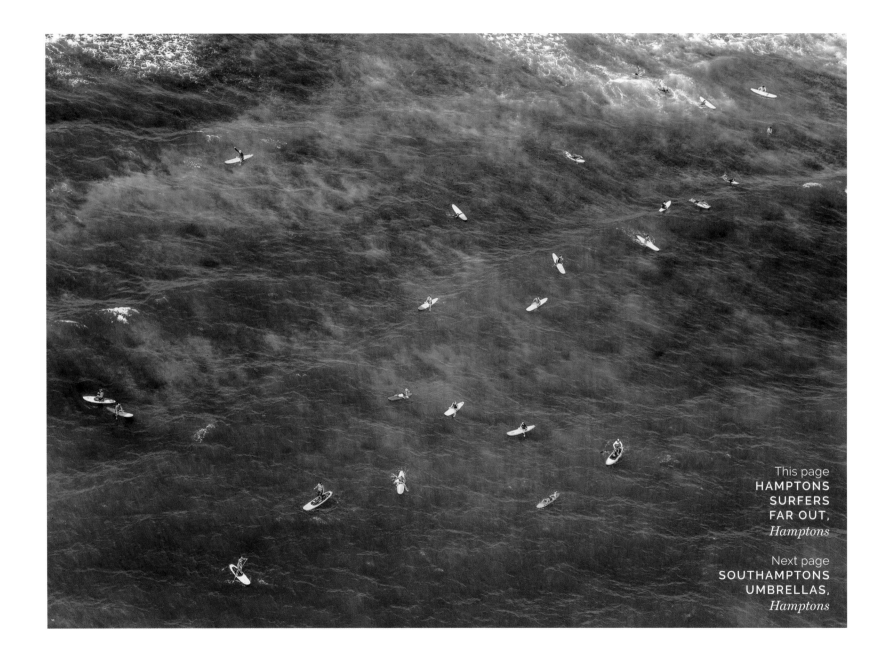

This page
**HAMPTONS
SURFERS
FAR OUT,**
Hamptons

Next page
**SOUTHAMPTONS
UMBRELLAS,**
Hamptons

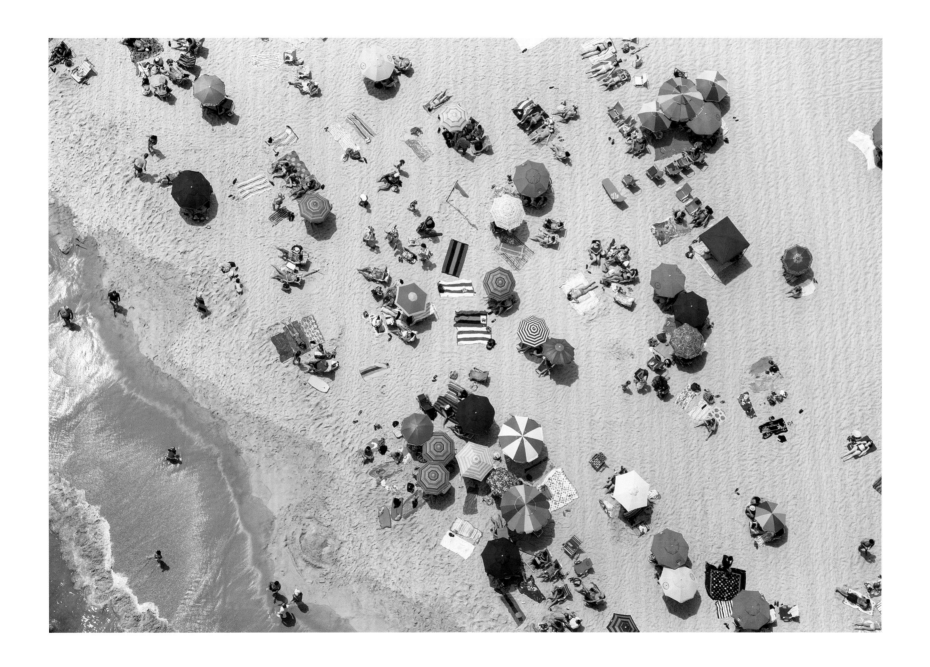

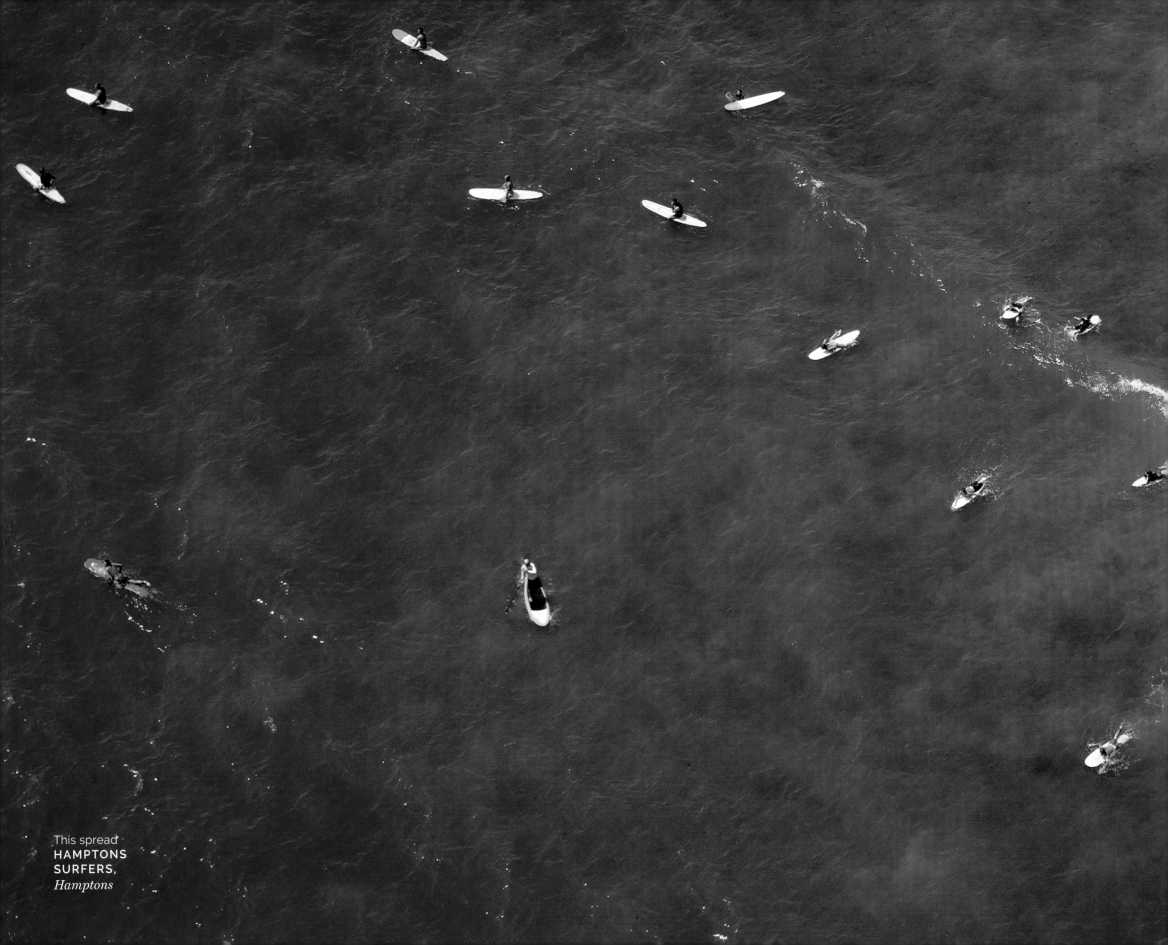

This spread
HAMPTONS
SURFERS,
Hamptons

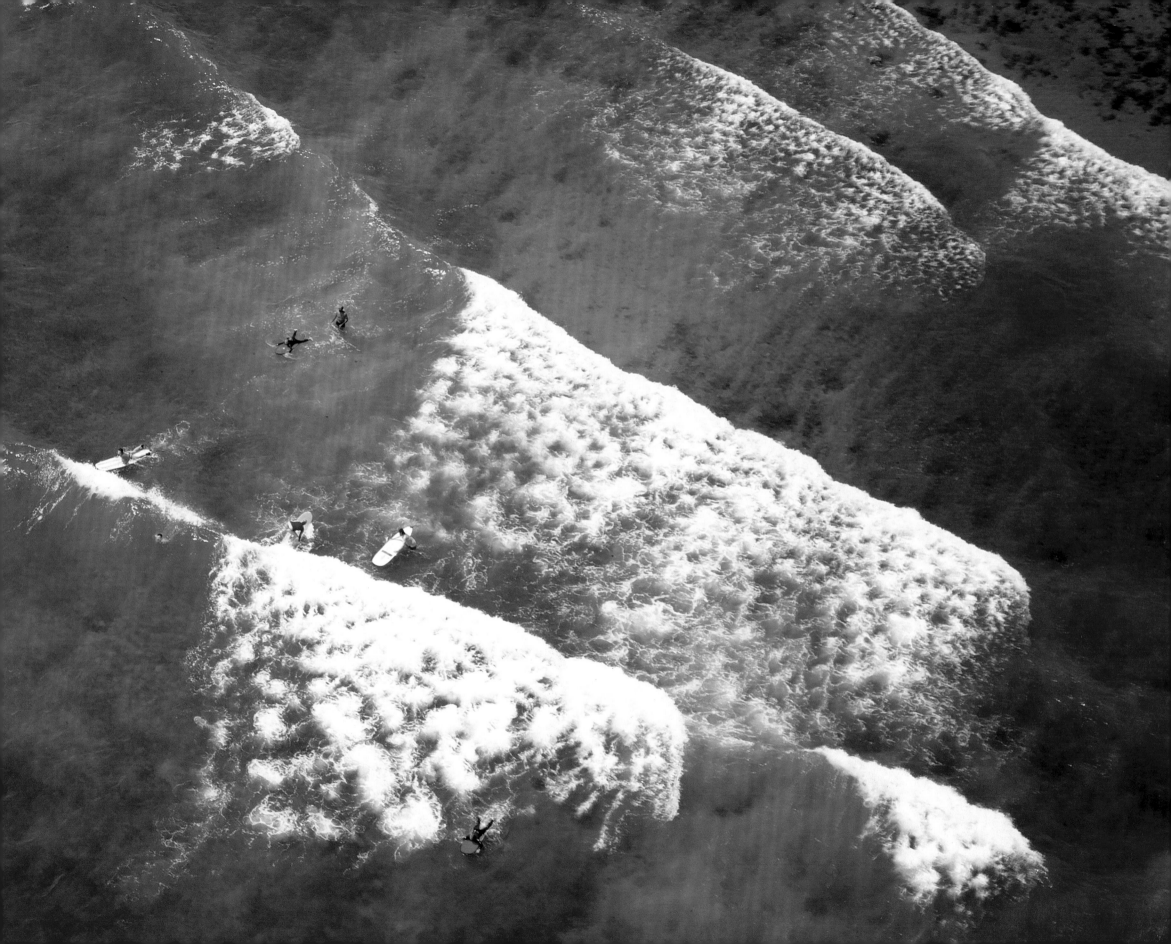

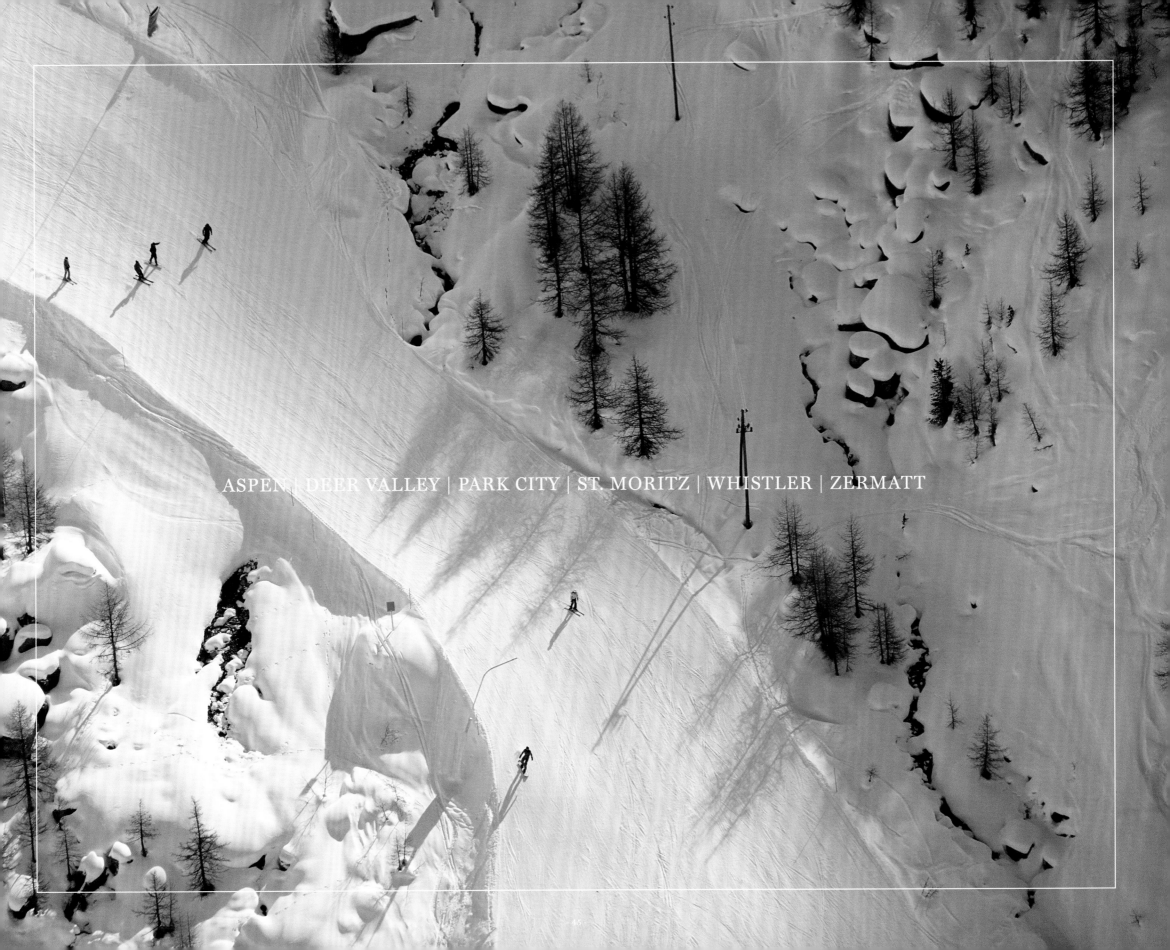

ASPEN | DEER VALLEY | PARK CITY | ST. MORITZ | WHISTLER | ZERMATT

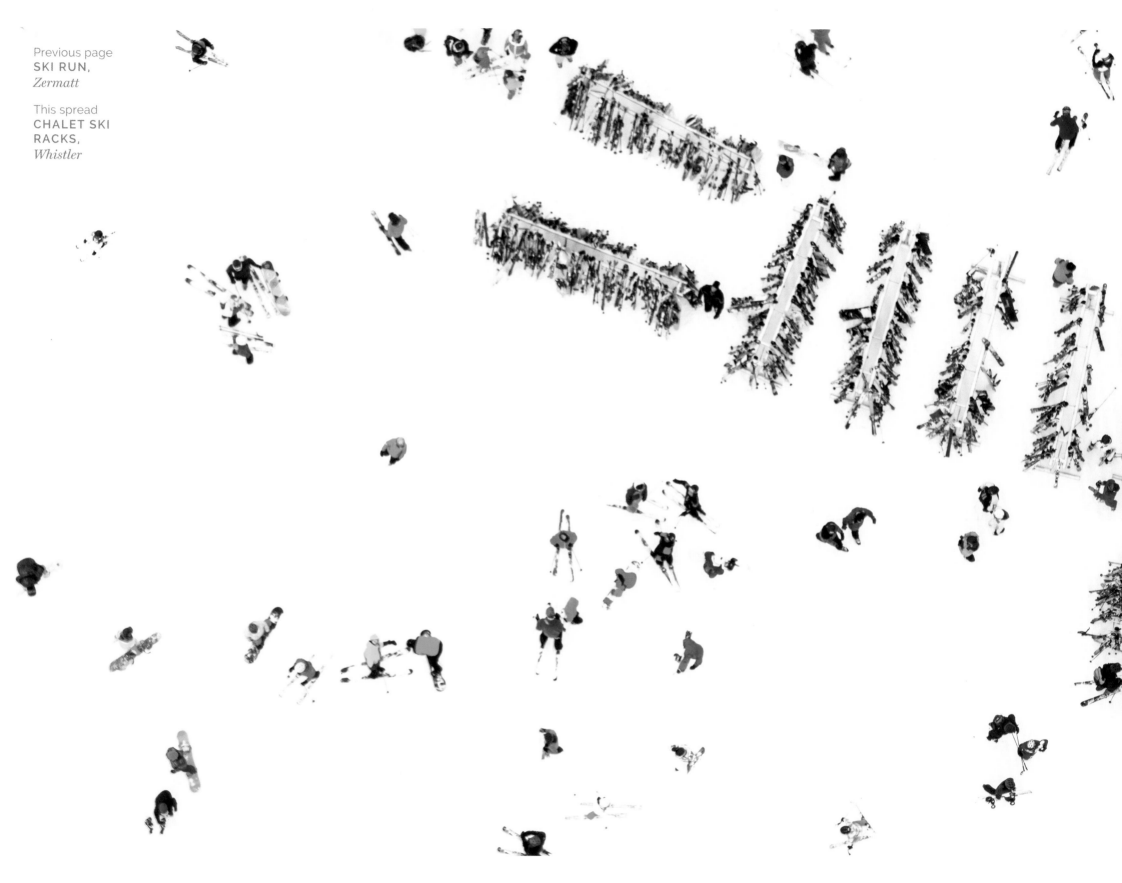

Previous page
SKI RUN,
Zermatt

This spread
CHALET SKI
RACKS,
Whistler

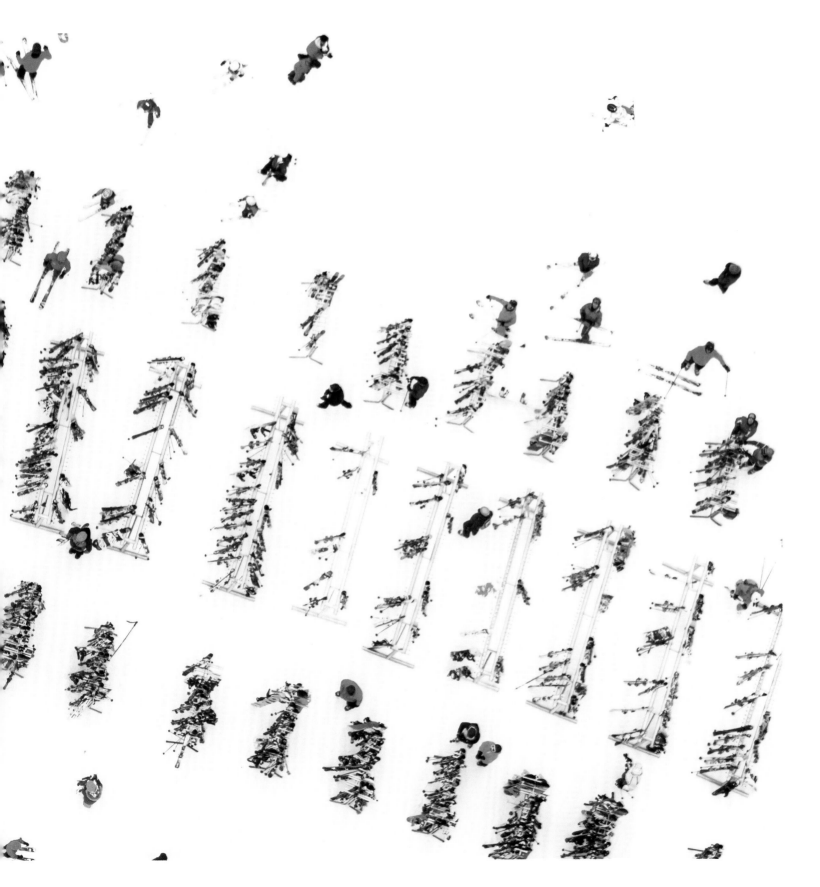

After shooting beaches from an aerial perspective for one year I began to imagine other scenery from above.

Looking at vintage ski posters, I became inspired to create images of colorfully dressed skiers and snowboarders atop the pristine white landscape of snow.

It took me three months to logistically finalize my first shoot, which took place over Aspen, Colorado, but it was worth the tremendous effort because the images turned out even better than I could have imagined.

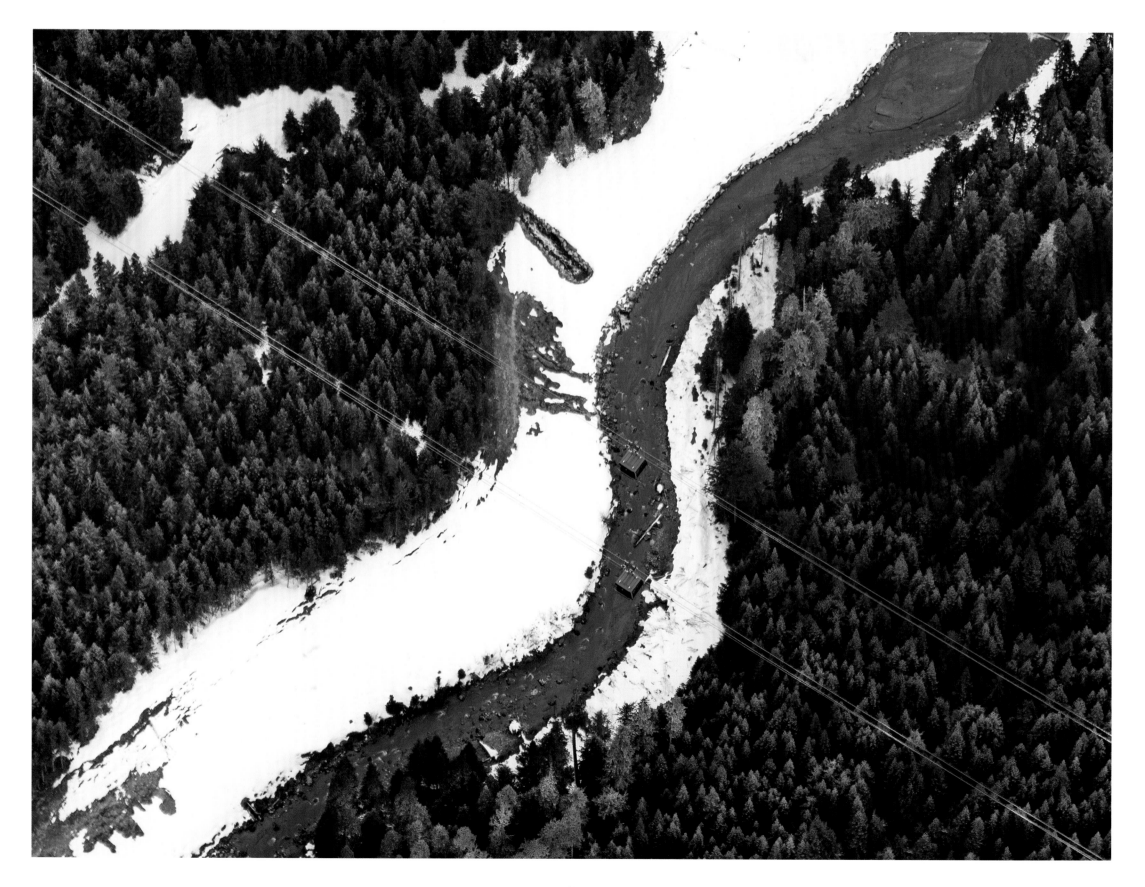

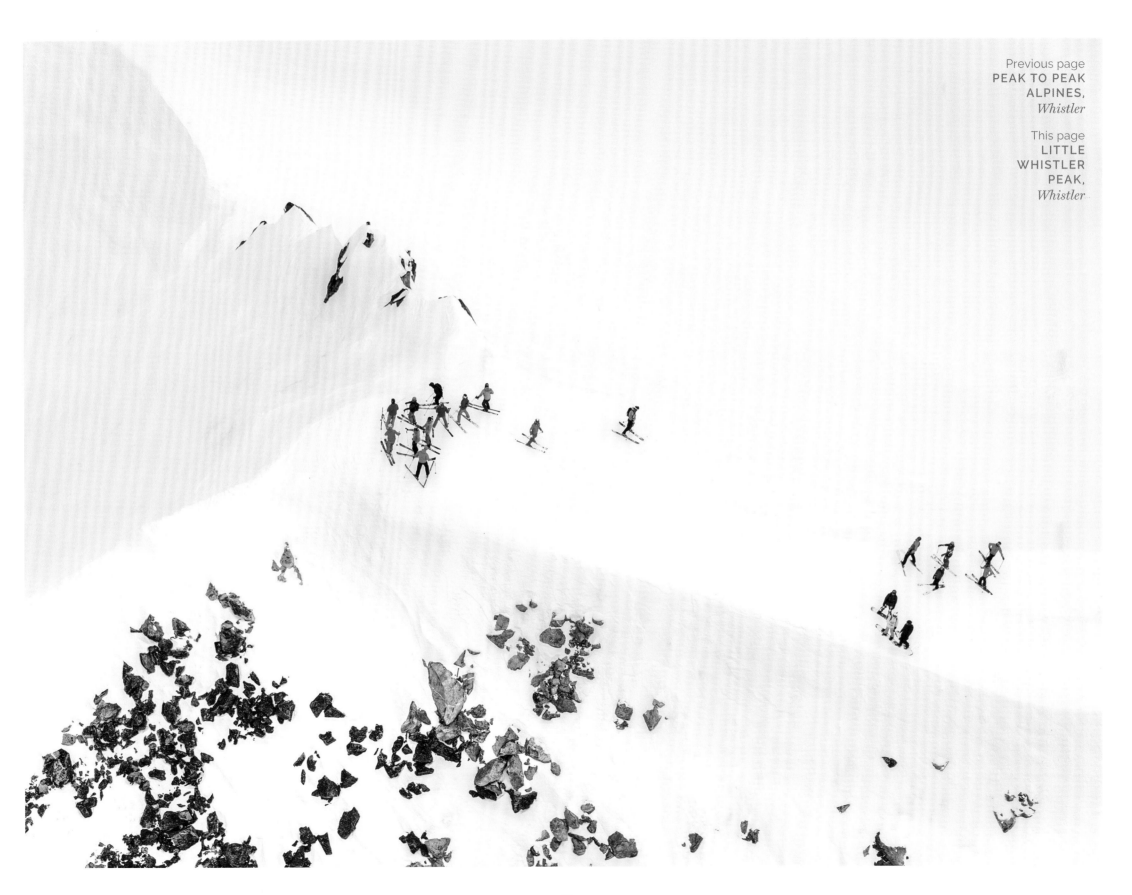

Previous page
**PEAK TO PEAK
ALPINES,**
Whistler

This page
**LITTLE
WHISTLER
PEAK,**
Whistler

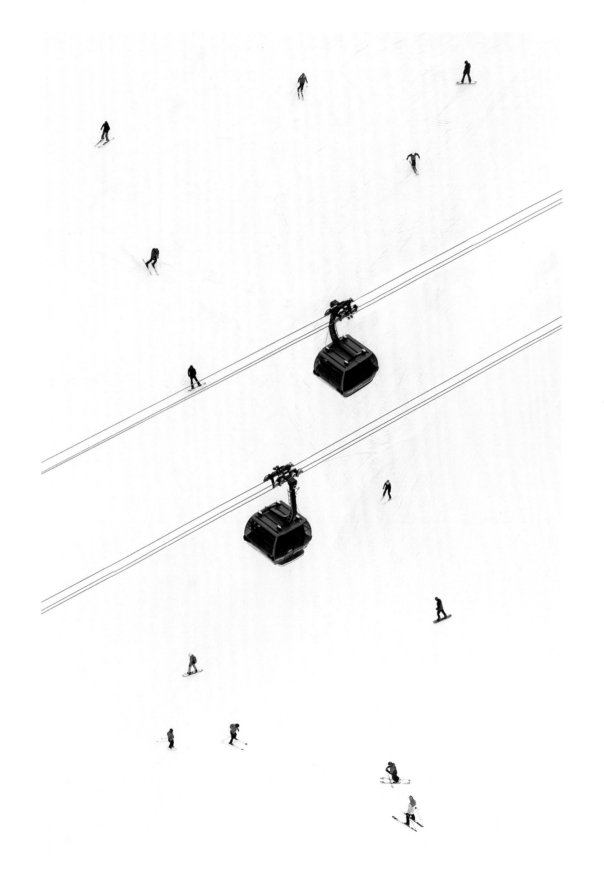

Previous page
PEAK TO PEAK GONDOLAS,
Whistler

This page
SKI SCHOOL,
Whistler

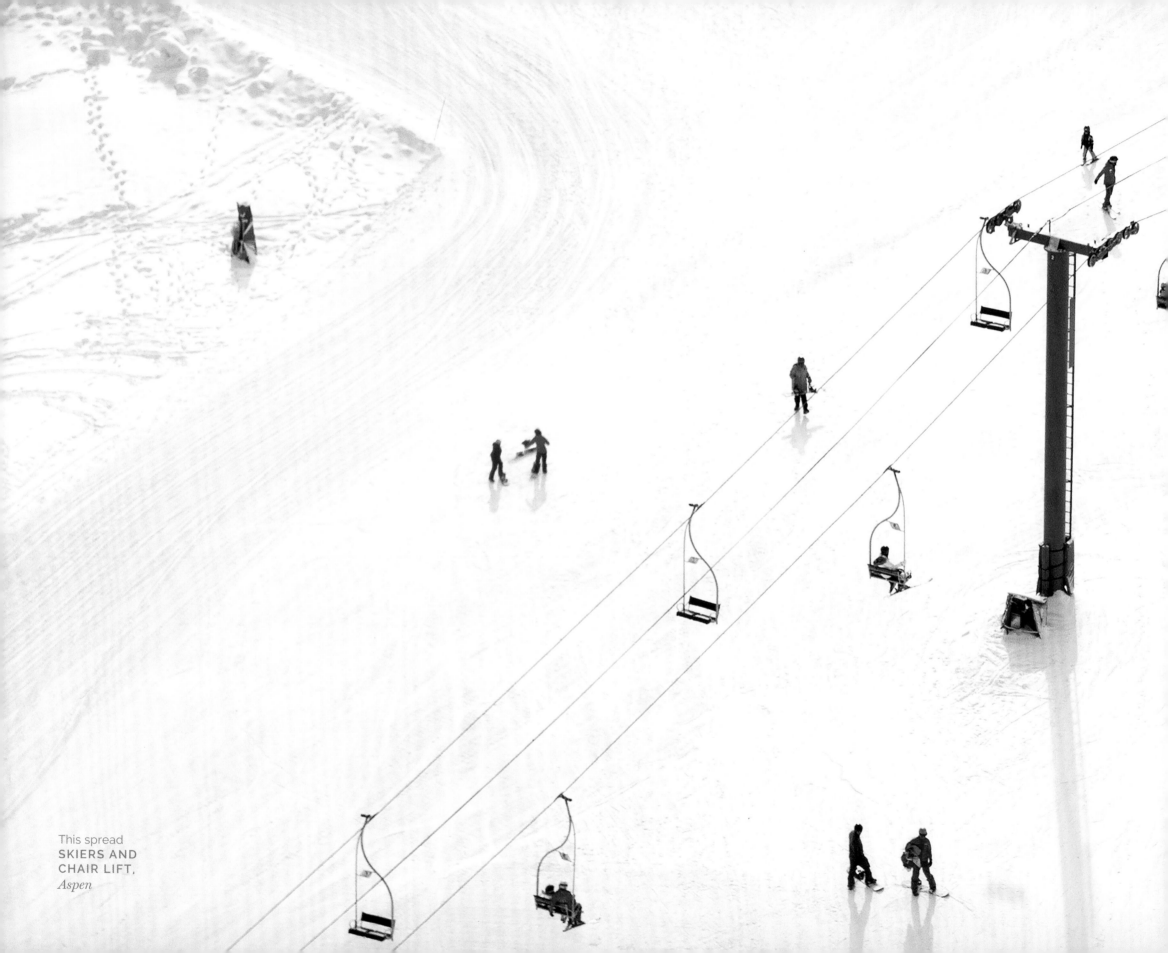

This spread
SKIERS AND
CHAIR LIFT,
Aspen

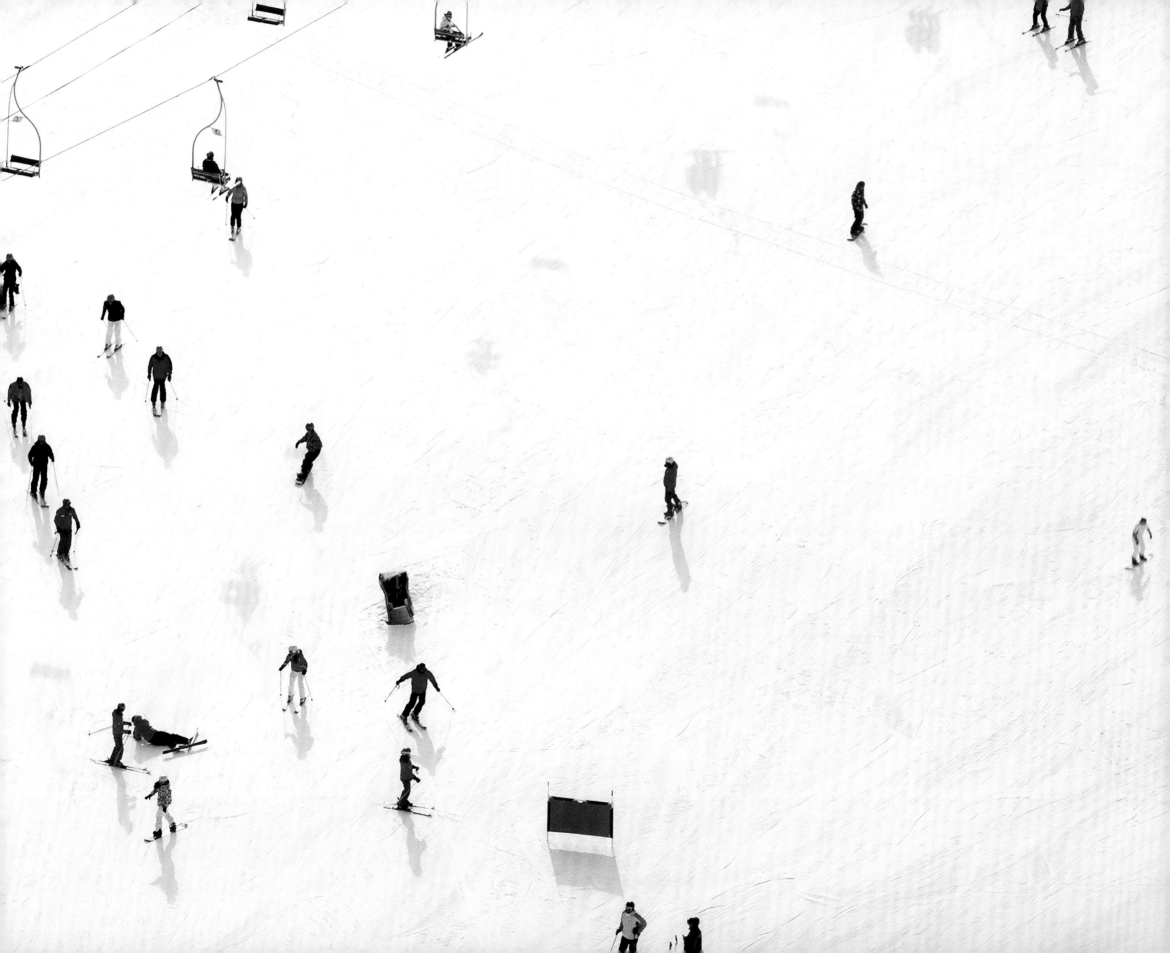

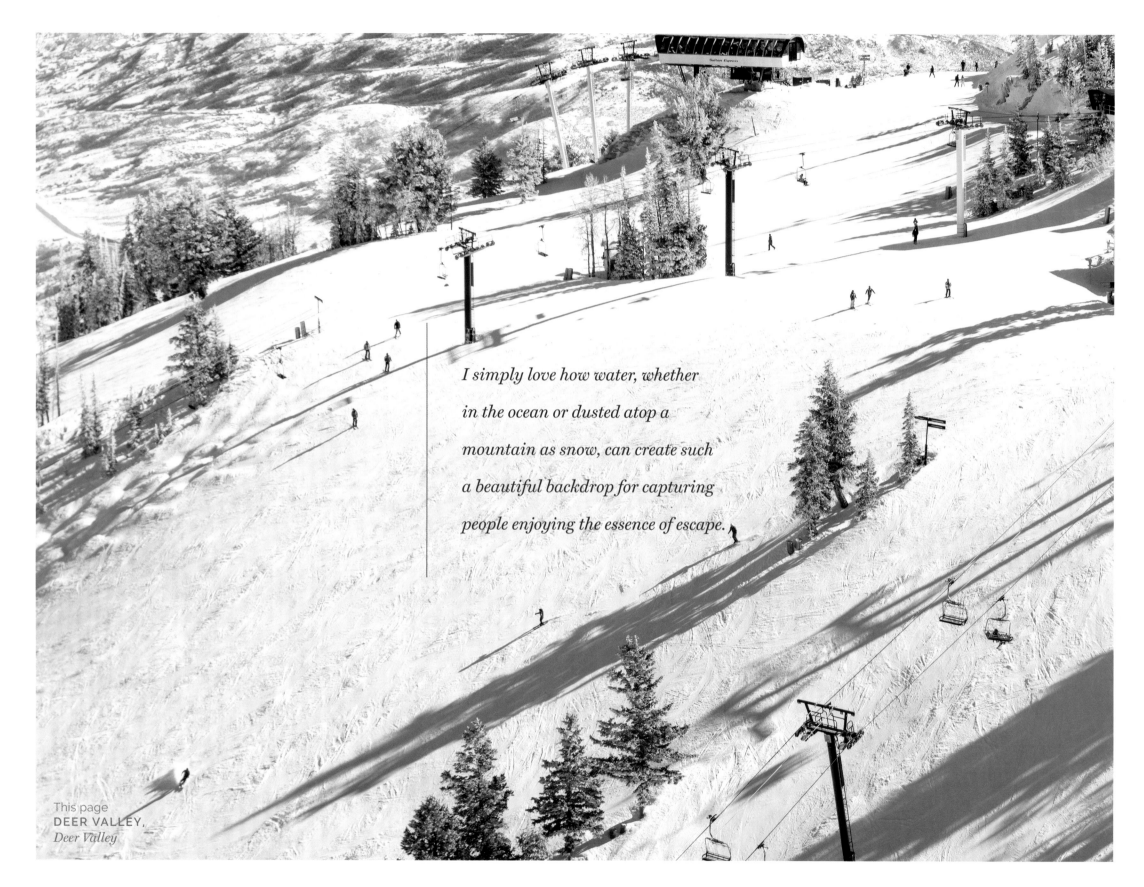

I simply love how water, whether in the ocean or dusted atop a mountain as snow, can create such a beautiful backdrop for capturing people enjoying the essence of escape.

This page
DEER VALLEY,
Deer Valley

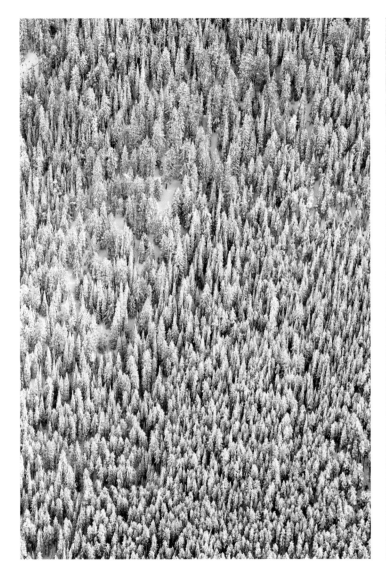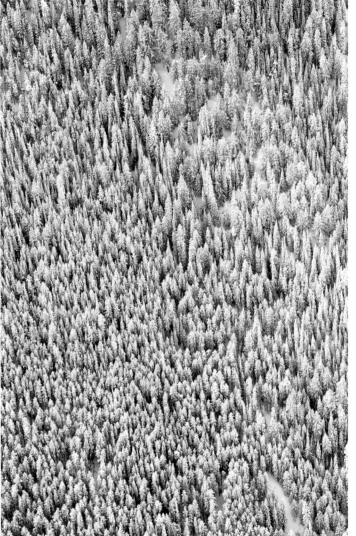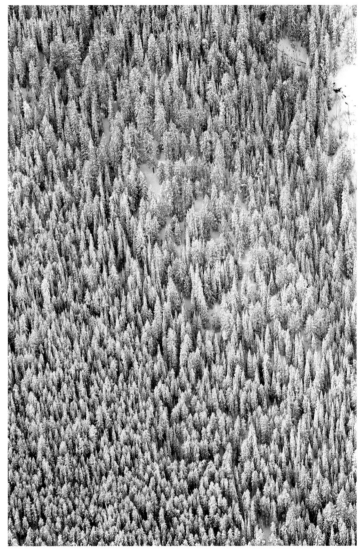

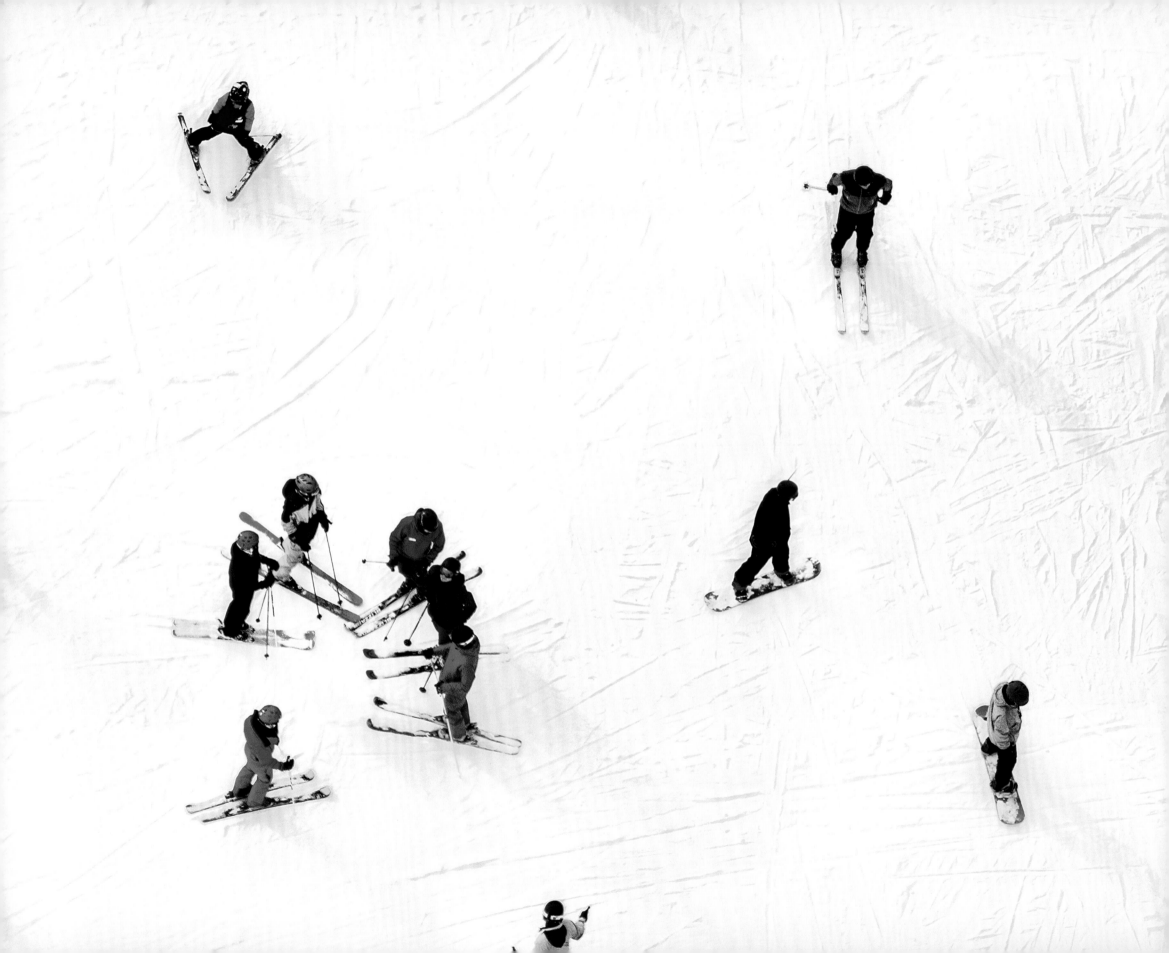

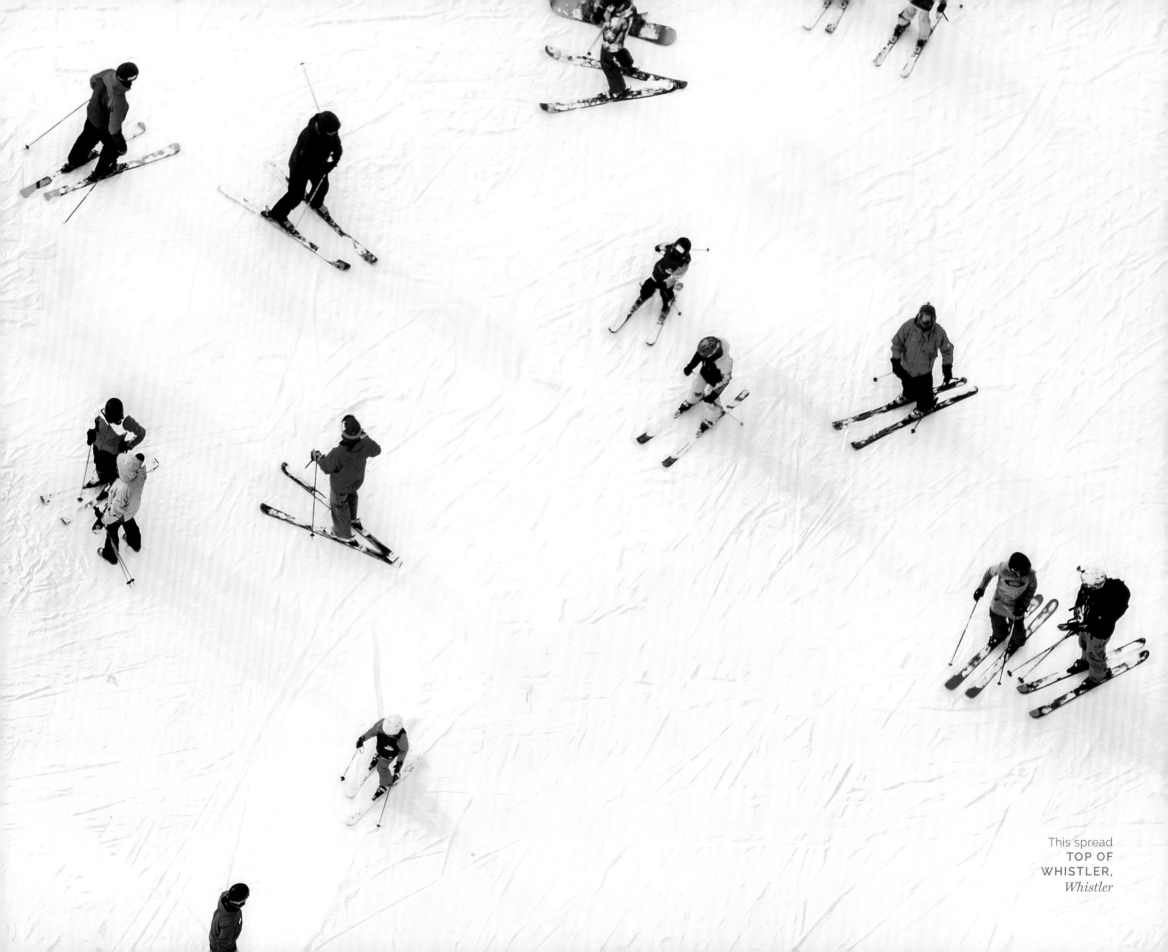

To date, Aspen is still the coldest shoot I have ever experienced. It was definitely a lesson quickly learned for future aerial mountain shoots. My hands needed a good thawing out that day!

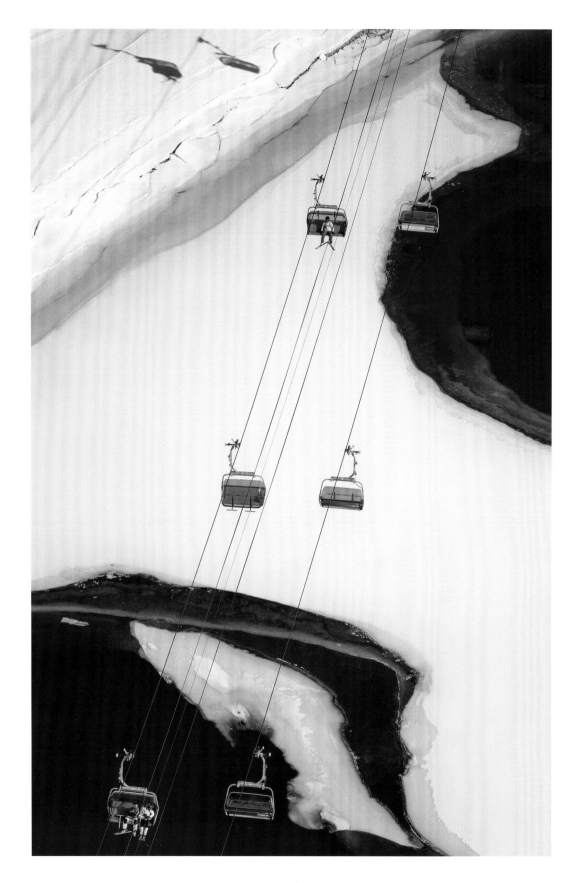

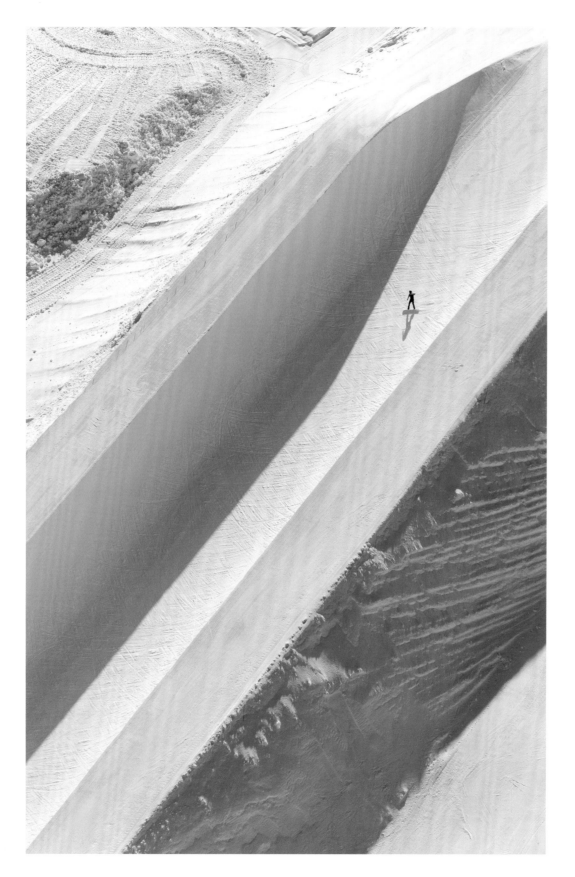

Previous page
CANYON
SKI LIFT,
Park City

This page
PARK CITY
SNOWBOARDER,
Park City

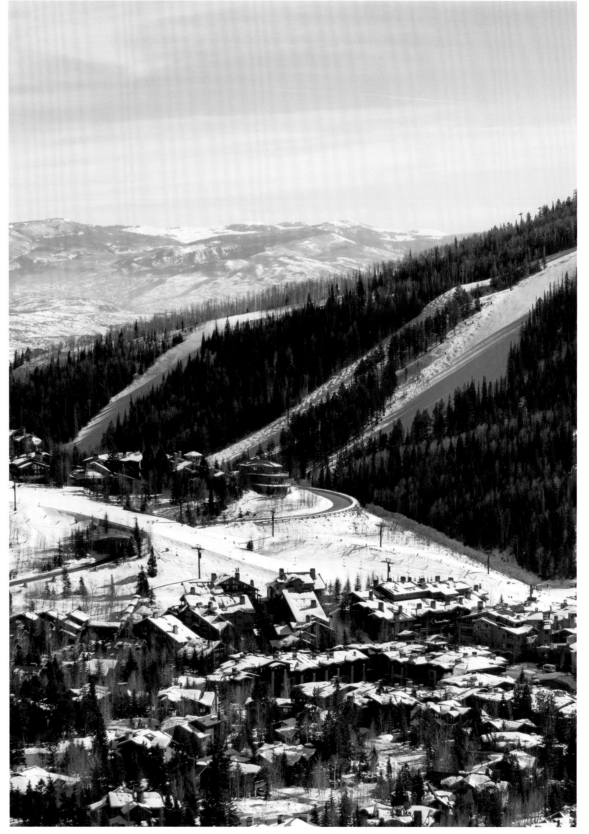
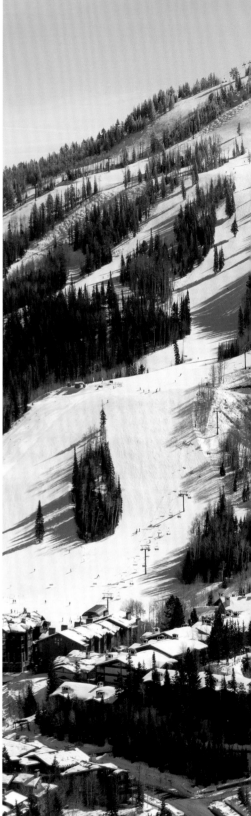

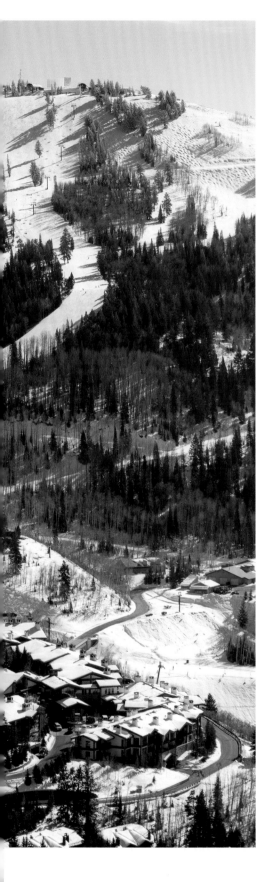
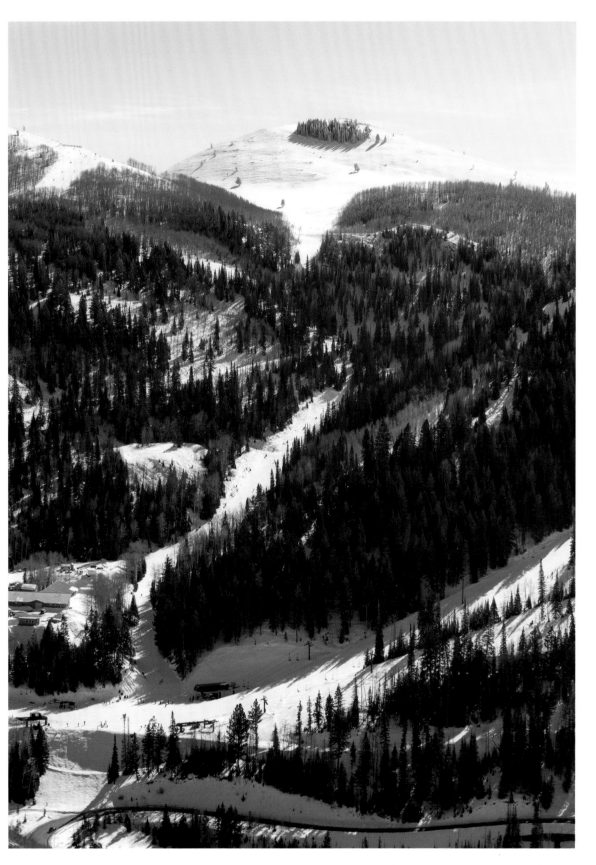

This spread
**DEER VALLEY
TRIPTYCH,**
Deer Valley

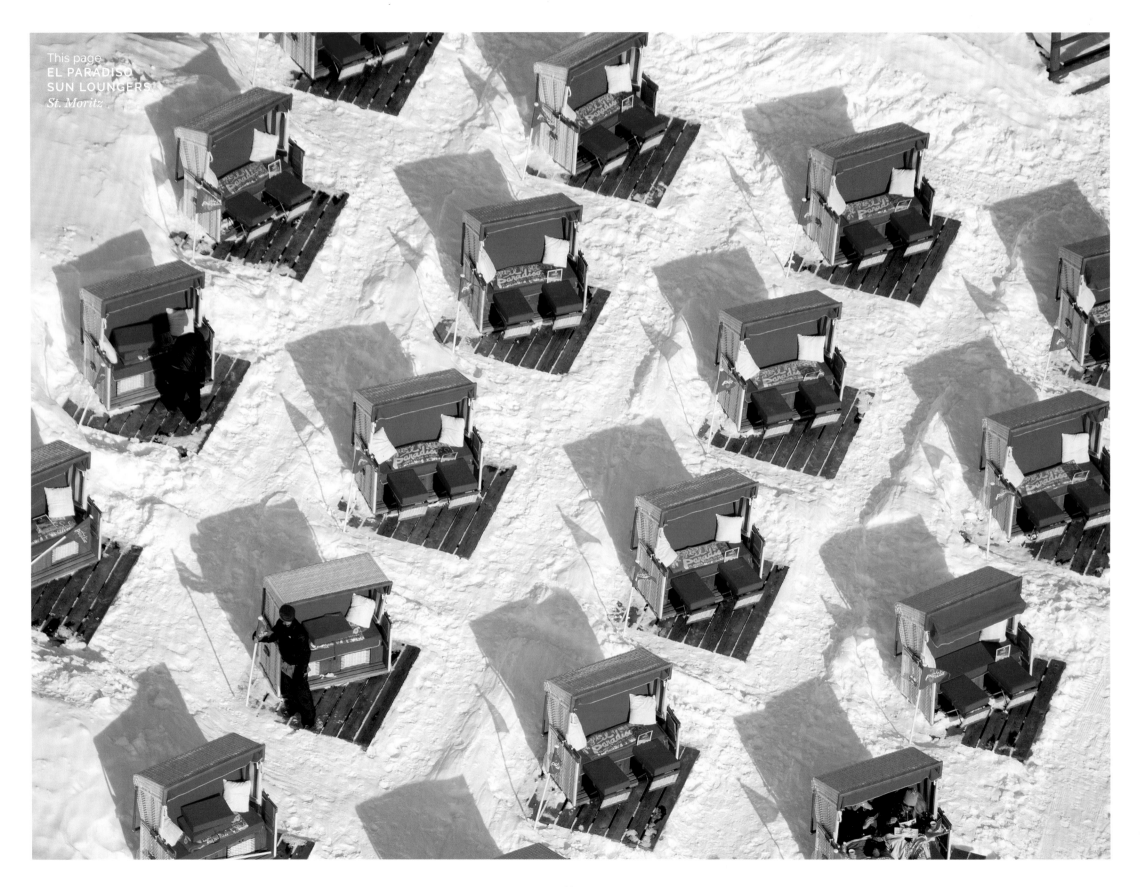

This page
EL PARADISO
SUN LOUNGERS
St. Moritz

SWITZERLAND · SWITZERLAND

Flying along the snowy pistes of **St. Moritz**, I came across the most unusual sight resting in the white snow—*a "beach" club* with lifeguard towers and all! After the shoot I discovered it was a restaurant named **El Paradiso**. I often daydream of returning to St. Moritz so I can bundle up in a blanket, sip champagne, and *bask in one of their snowy cabanas under the sun*.

Snow Polo St. Moritz

When I began to research St. Moritz, Switzerland, I discovered there are many experiences that make this location unique—one of which is the sport of snow polo. Atop a frozen lake, four polo teams from around the world compete for the coveted Cartier Trophy. As soon as I learned of this sport, I knew I had to see it to believe it and immediately made plans to attend the championship.

Set below the magnificent snowy peaks of St. Moritz, the tournament is a spectacle of breathtaking surroundings and the glistening glamour of the rich and famous.

Capturing the championship from above, below, and by a special invitation into the raised announcer's booth, this photographic series pays tribute to the tradition of "the sport of kings," inspiring us to revel in its honorable and graceful spirit. Watching the elegance of the horses gliding across the white backdrop, while rubbing shoulders with fur-clad guests, champagne in hand, I realized this was a total escape one has to experience to believe.

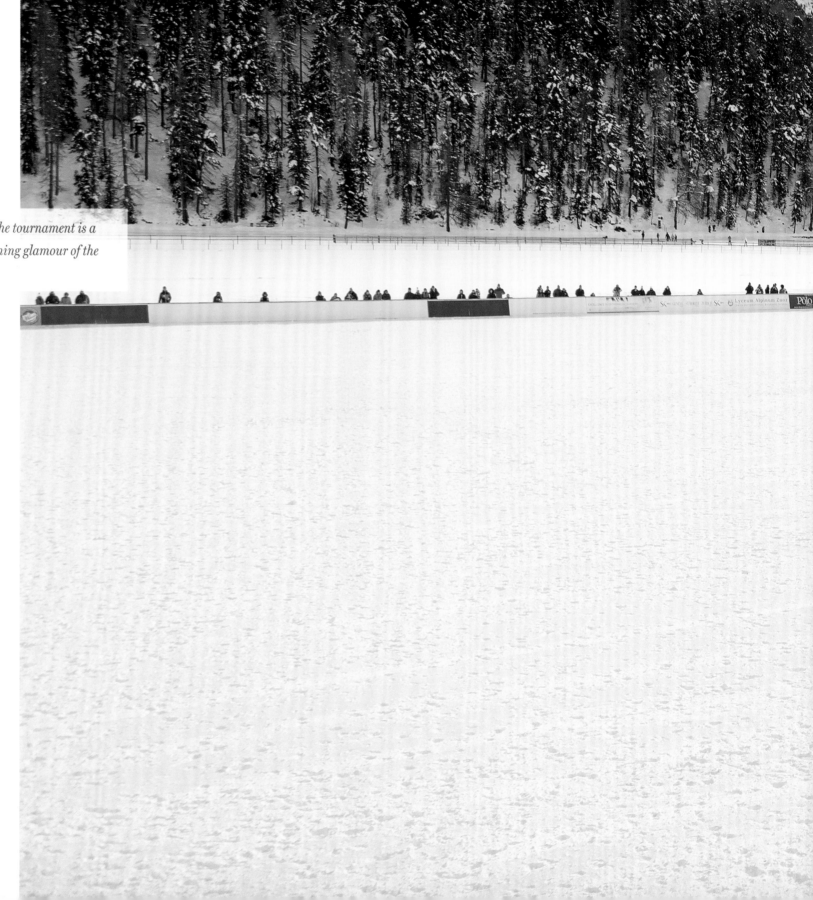

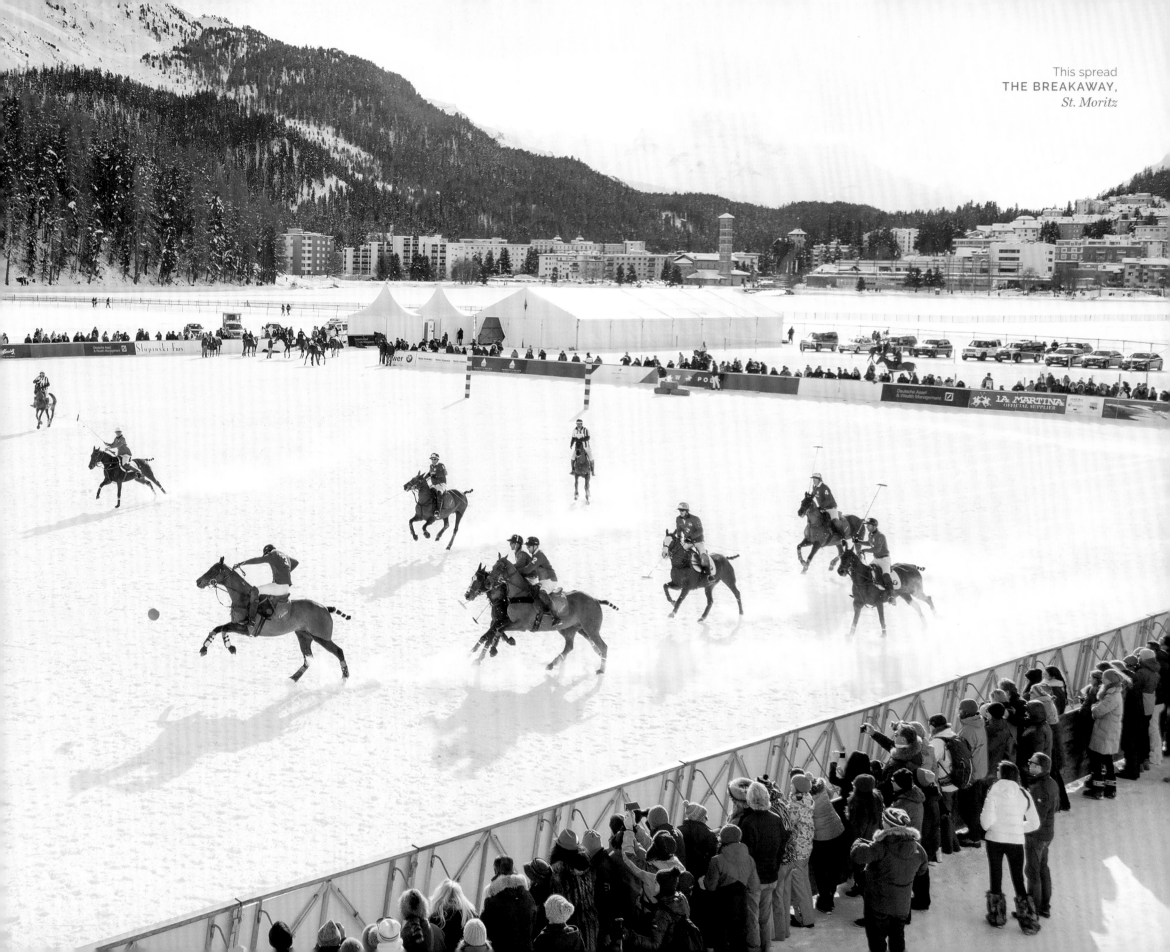

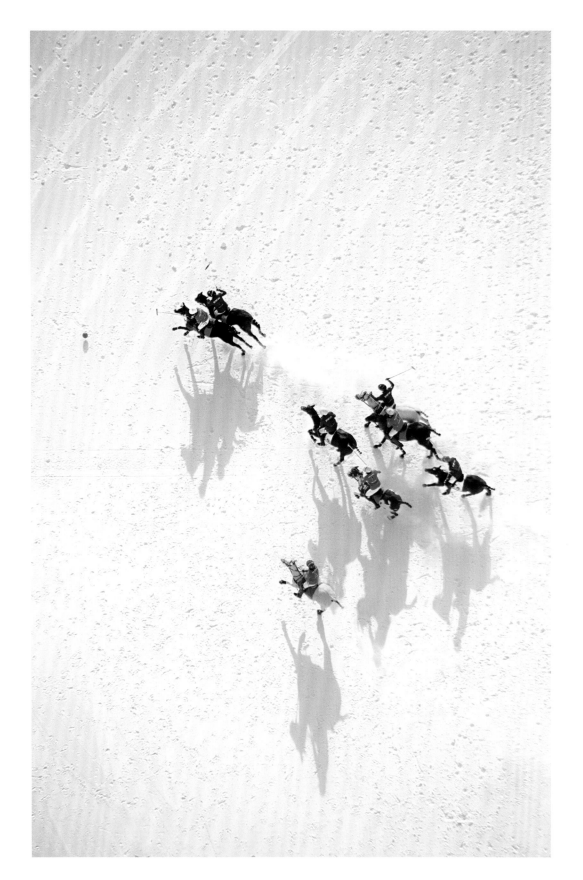

This page
THE RIDE OFF,
St. Moritz

Next page
THE FIELD,
St. Moritz

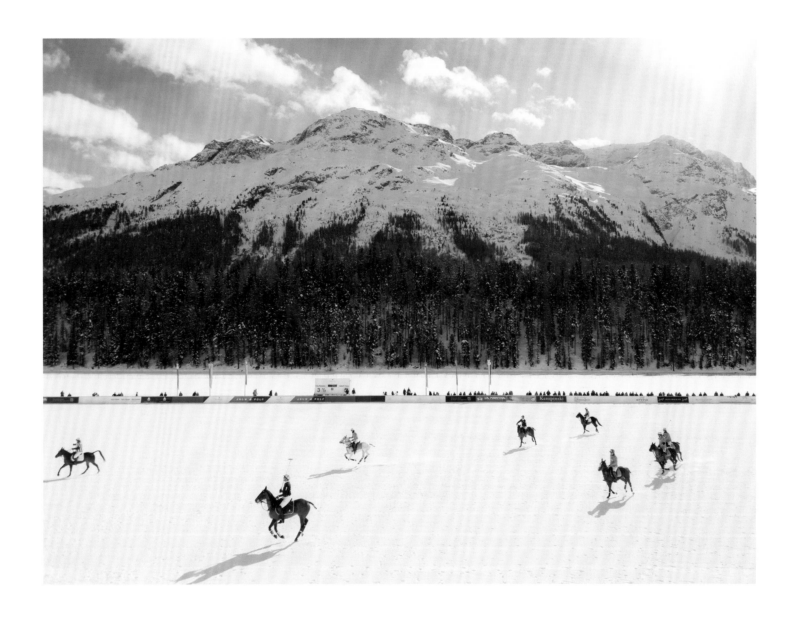

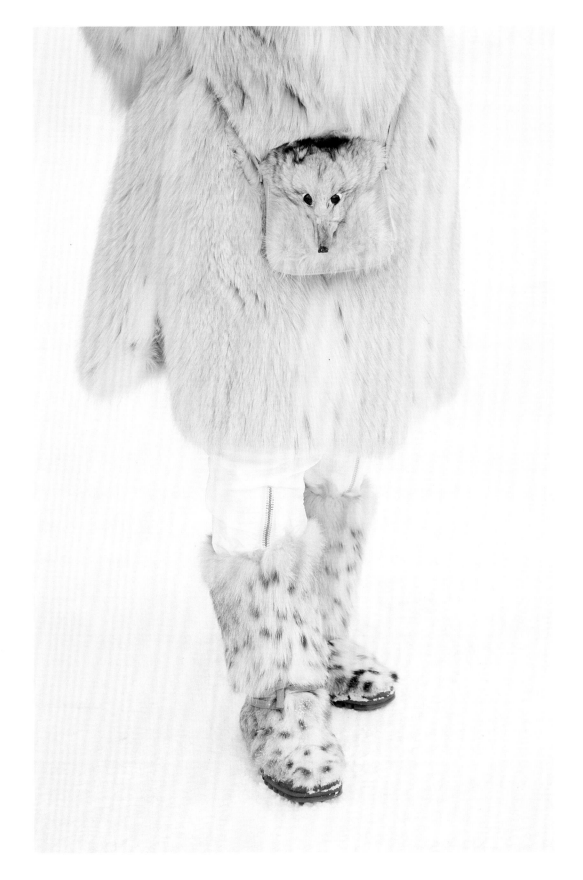

Previous page
THE CROWD,
St. Moritz

This page
THE FOX,
St. Moritz

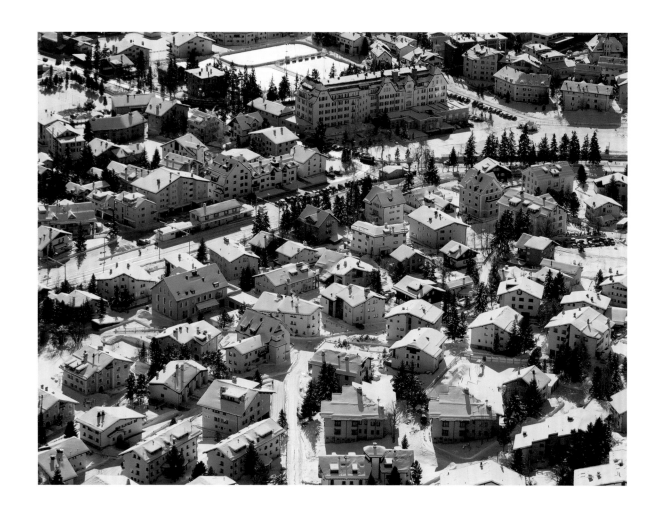

Previous page
ST. MORITZ,
St. Moritz

This page
SWISS SKI
CHALET,
St. Moritz

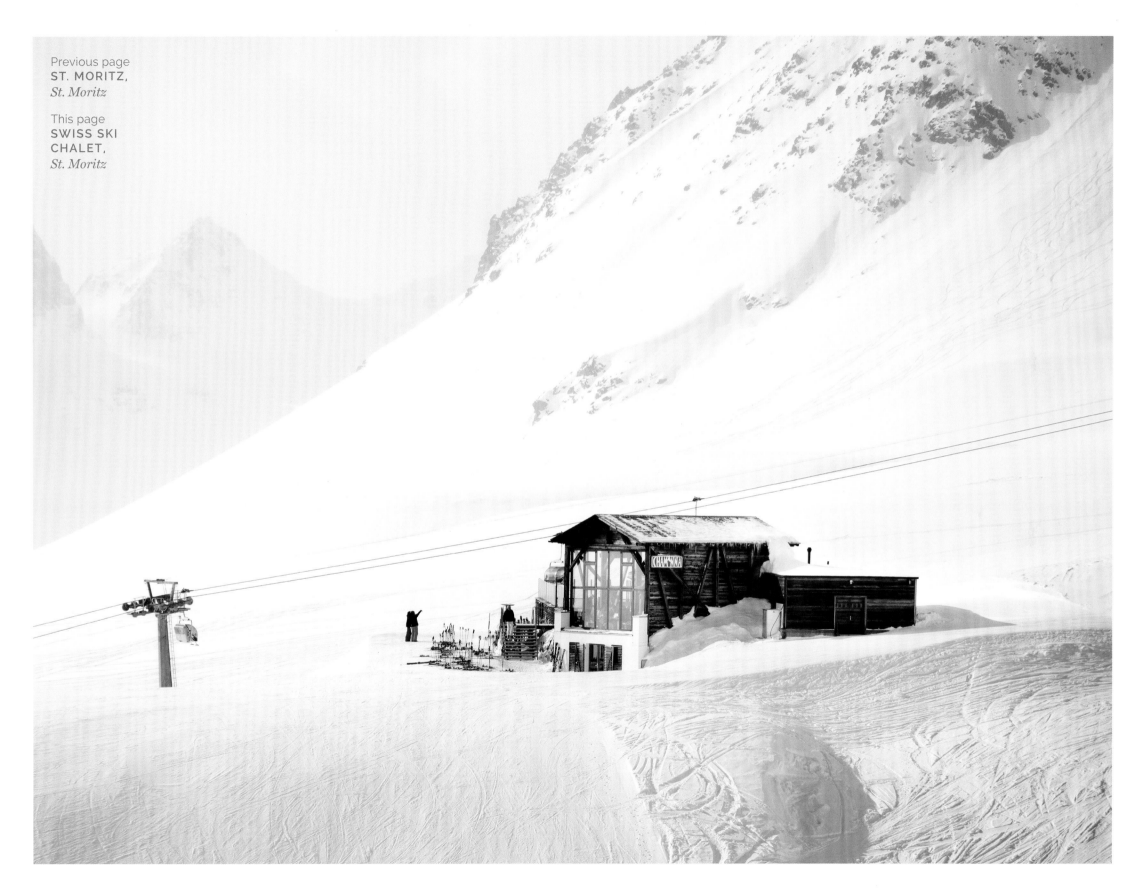

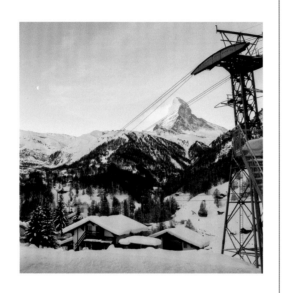

SWITZERLAND SWITZERLAND

Upon arriving at *Zermatt*, the weather was so dismal, I could barely make out the very thing I most wanted to see, *the Matterhorn*. That evening, a local man told me that most days the clouds block the Matterhorn and many visitors come for as long as a week and never get to see it with their own eyes. *Much to my delight, though*, when I woke up the next morning, I opened my hotel blinds to see *a beaming blue sky* and the golden light of the sunrise gilding the tip of *Europe's most recognizable mountain*. I still feel lucky to have had the beautiful weather the day of my photo shoot.

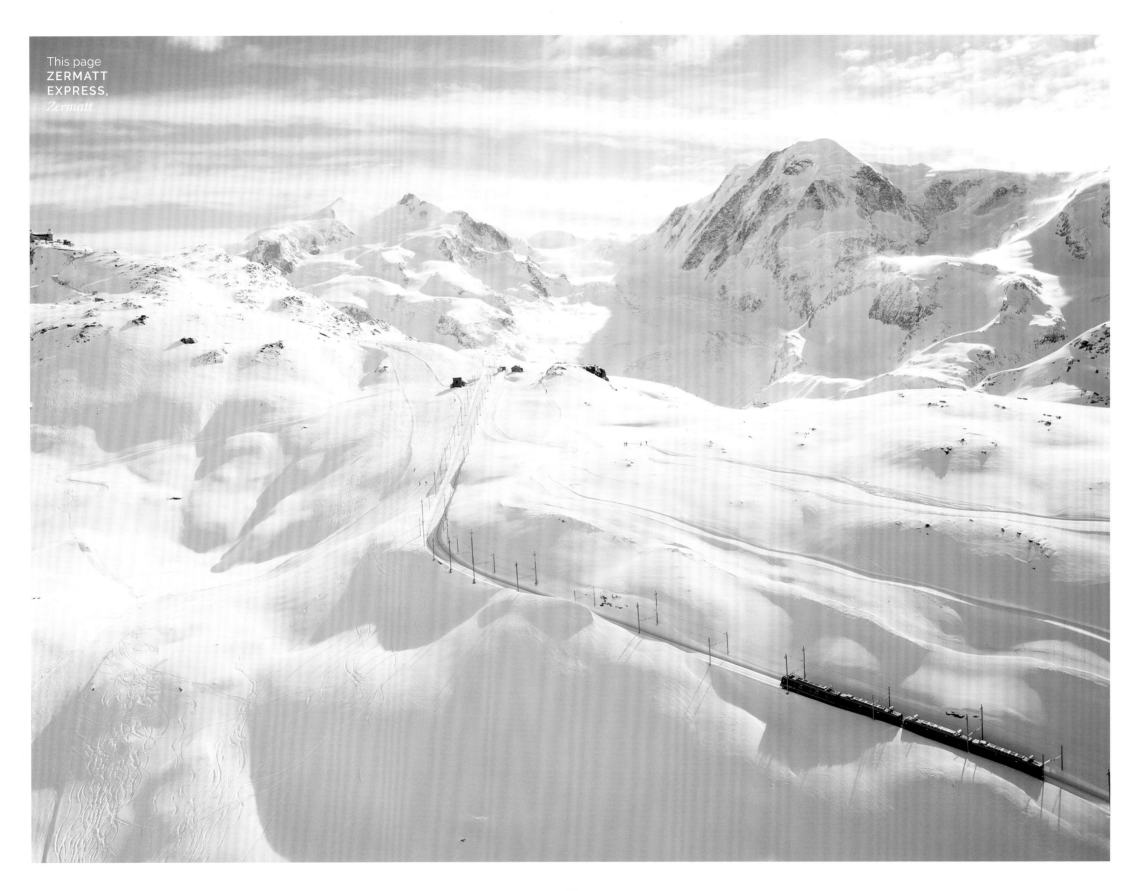

This page
ZERMATT
EXPRESS,
Zermatt

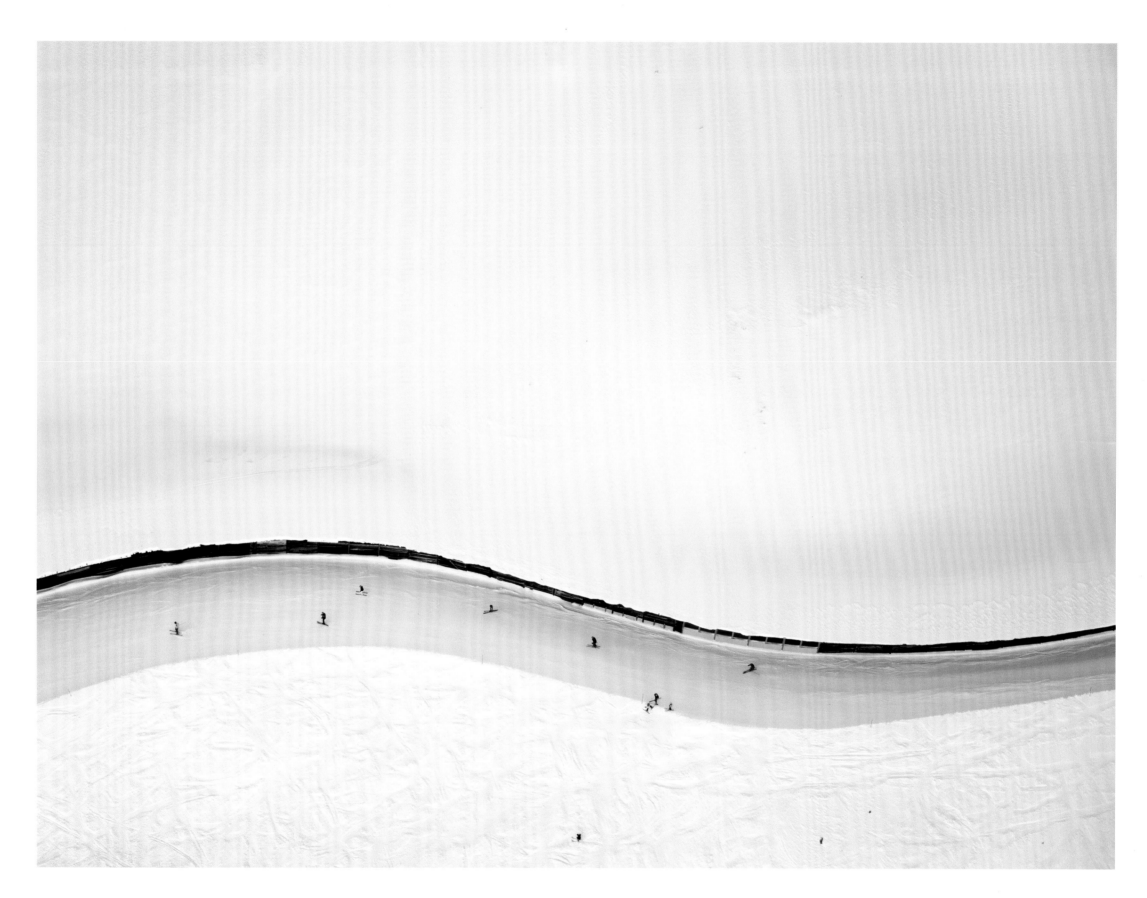

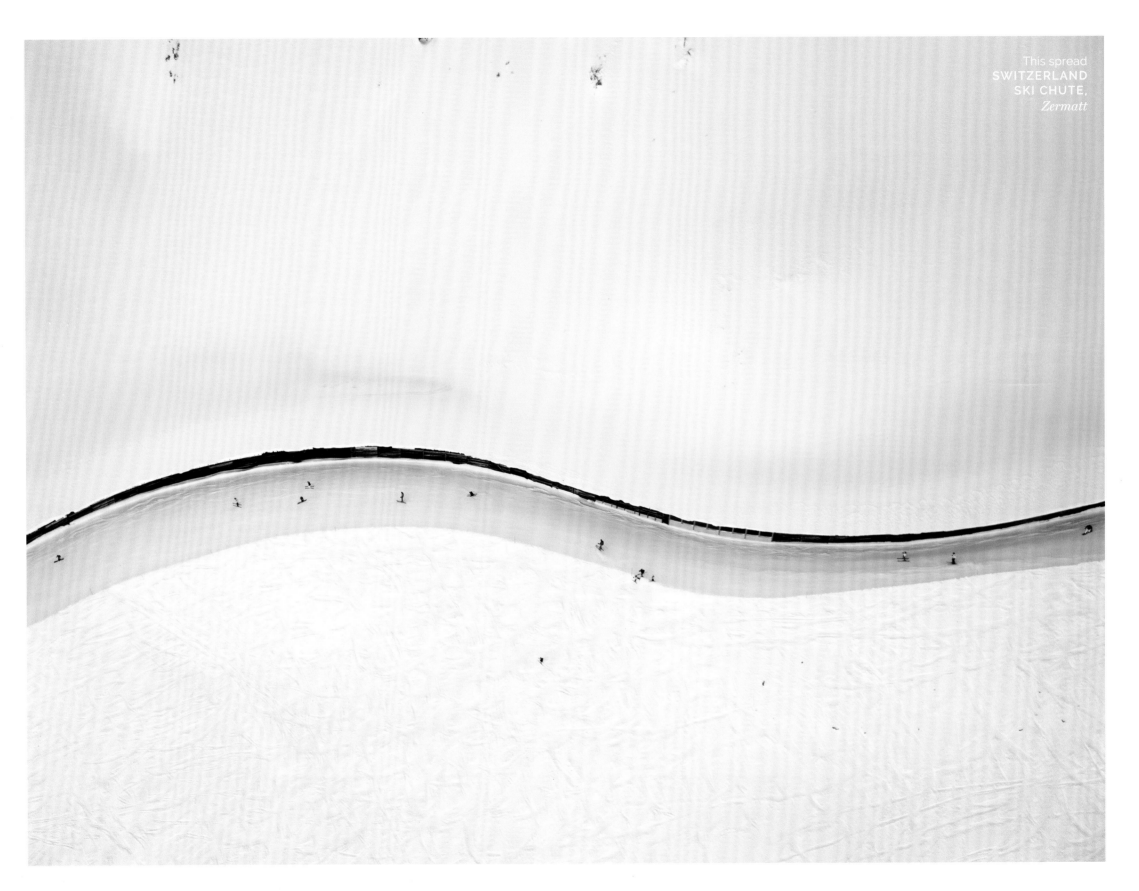

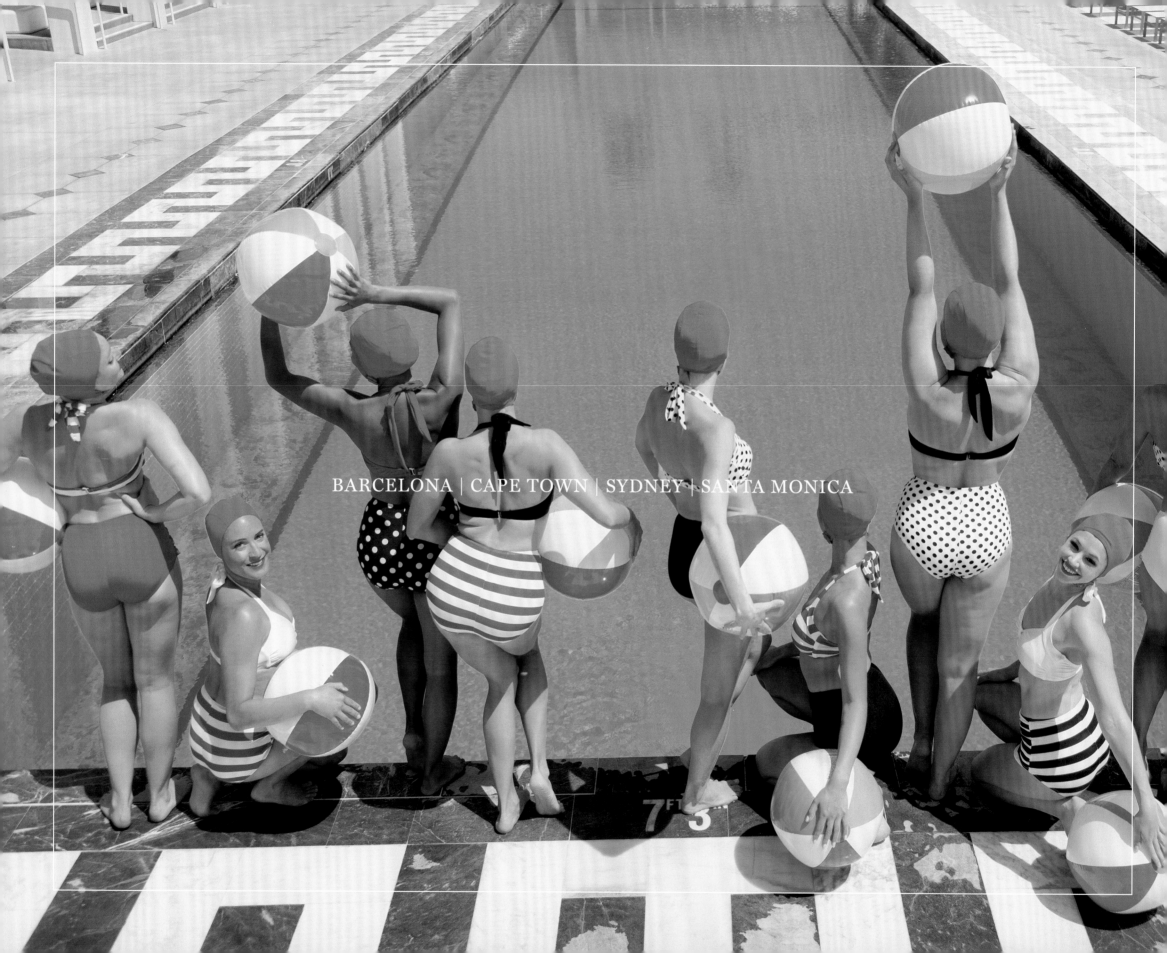

BARCELONA | CAPE TOWN | SYDNEY | SANTA MONICA

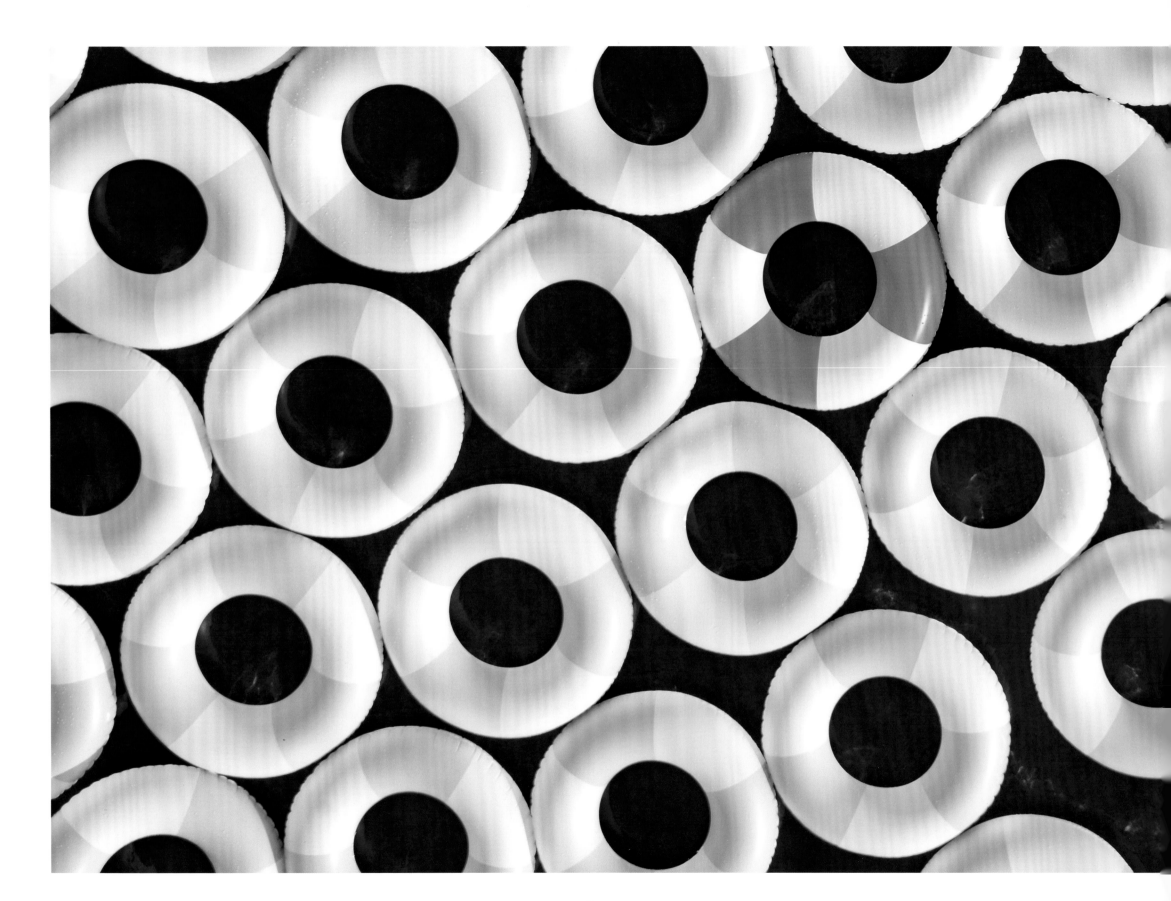

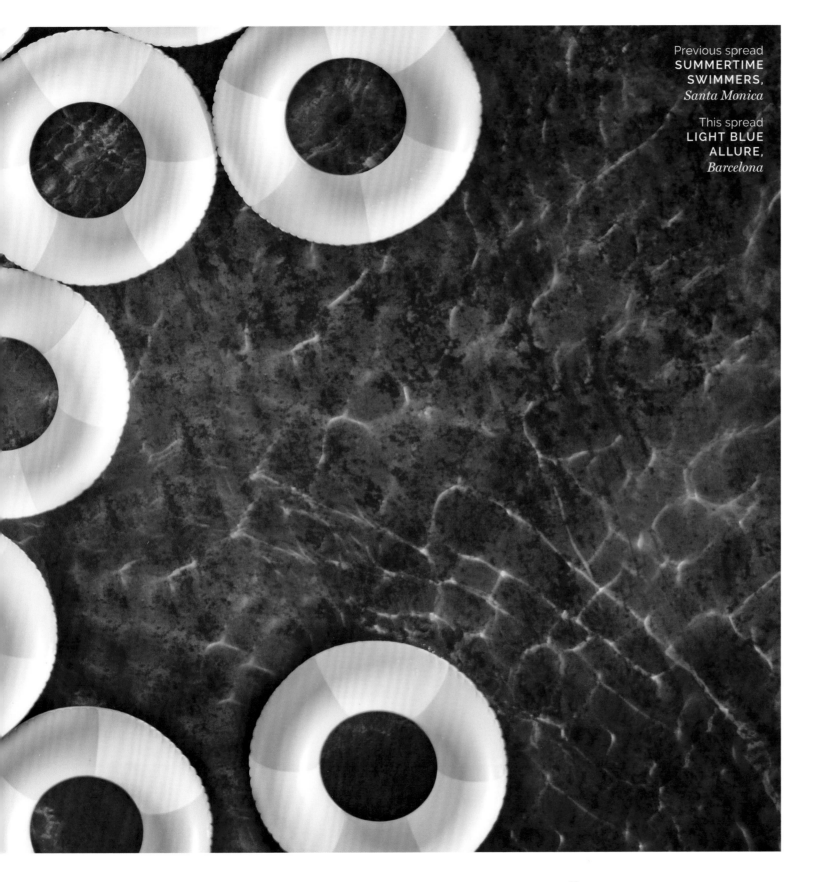

Previous spread
SUMMERTIME SWIMMERS,
Santa Monica

This spread
LIGHT BLUE ALLURE,
Barcelona

Though the beach is alluring, my obsession with sun-drenched aerial imagery actually began with swimming pools. Synonymous with bronzing bodies under the sun, pools evoke the splendor of a life of leisure whether at a resort or in your own backyard. Though at times artificial pools may be overshadowed by our world's natural bodies of water, I would be remiss not to acknowledge the countless escapes a poolside splash has afforded me. Whether a childhood treat during summer break, the scene of an adolescent skinny-dip, or a favorite spot during a vacation, the pool offers a break you can almost always find when you need it—inviting you to sit back and enjoy "the life."

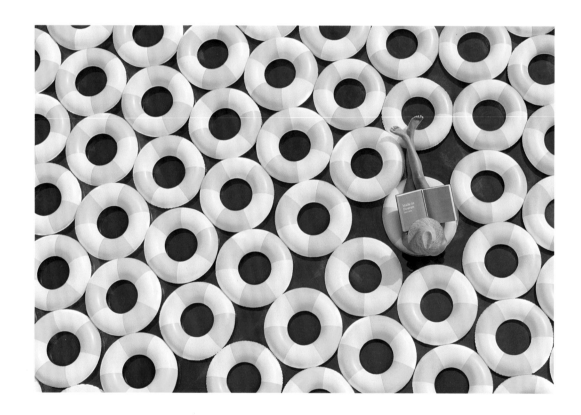

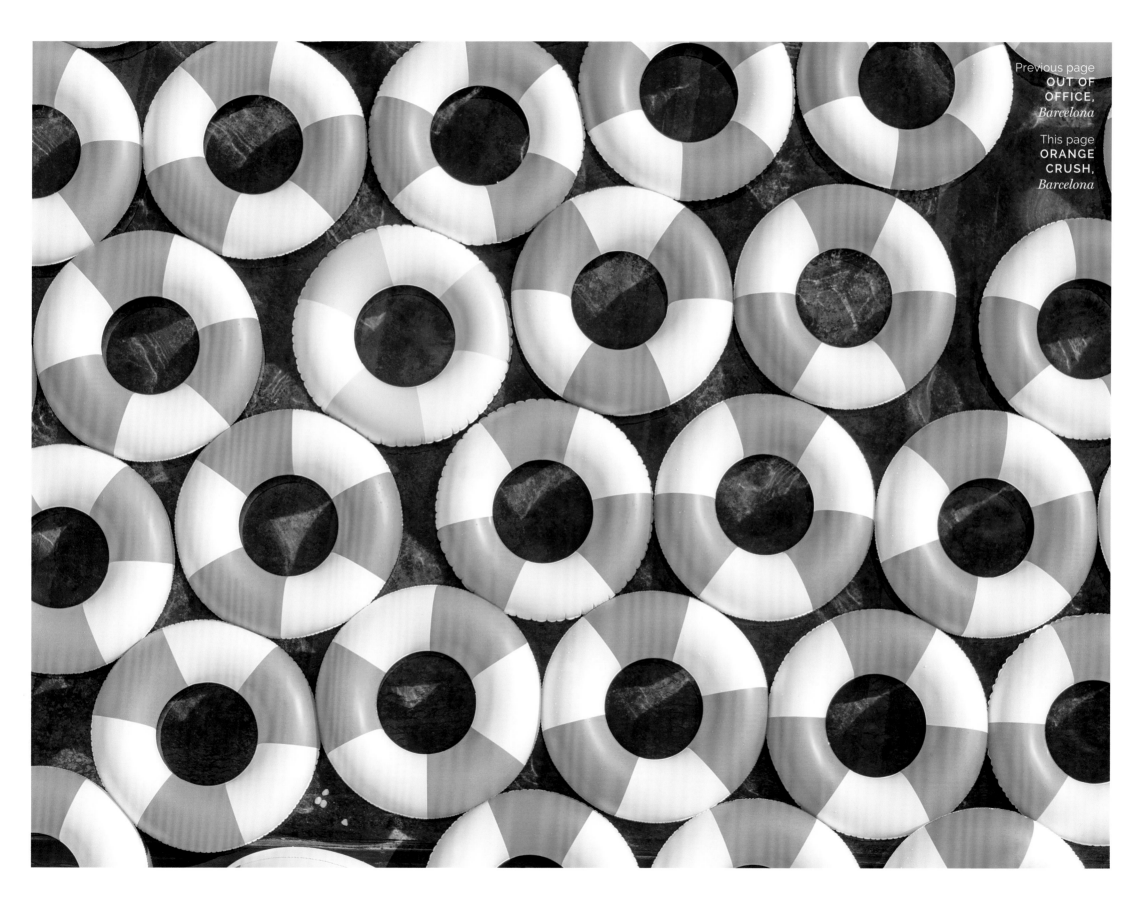

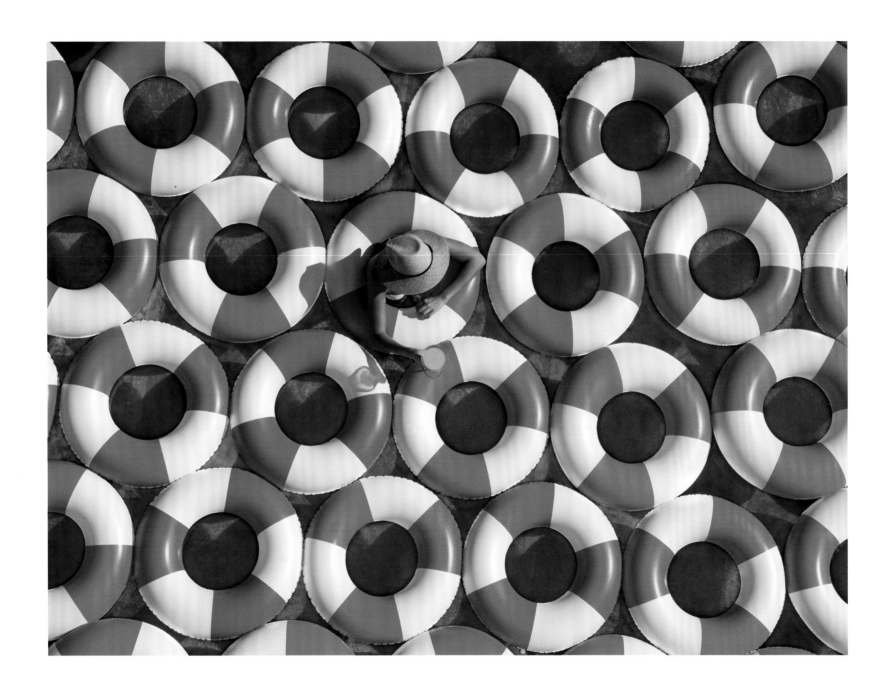

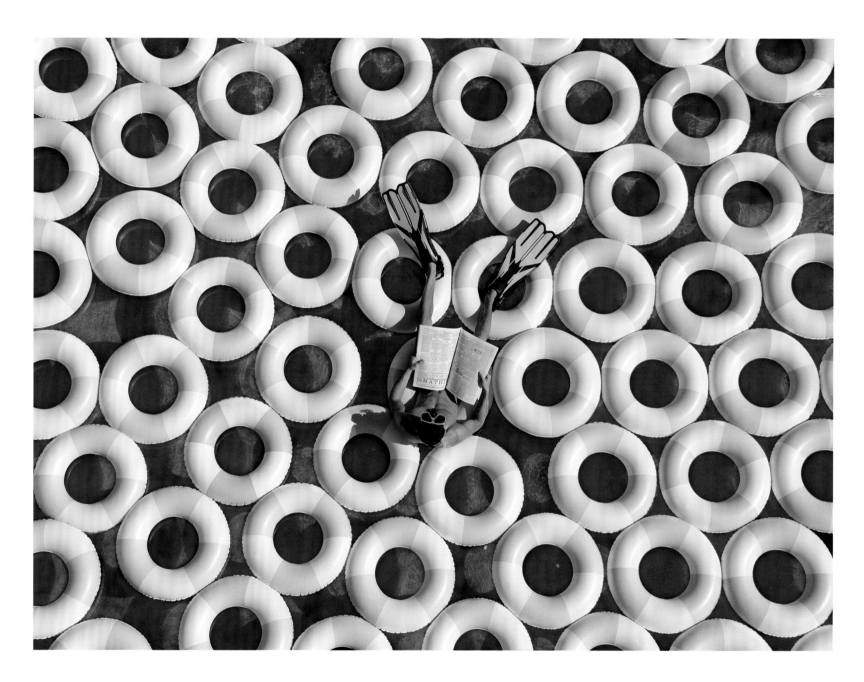

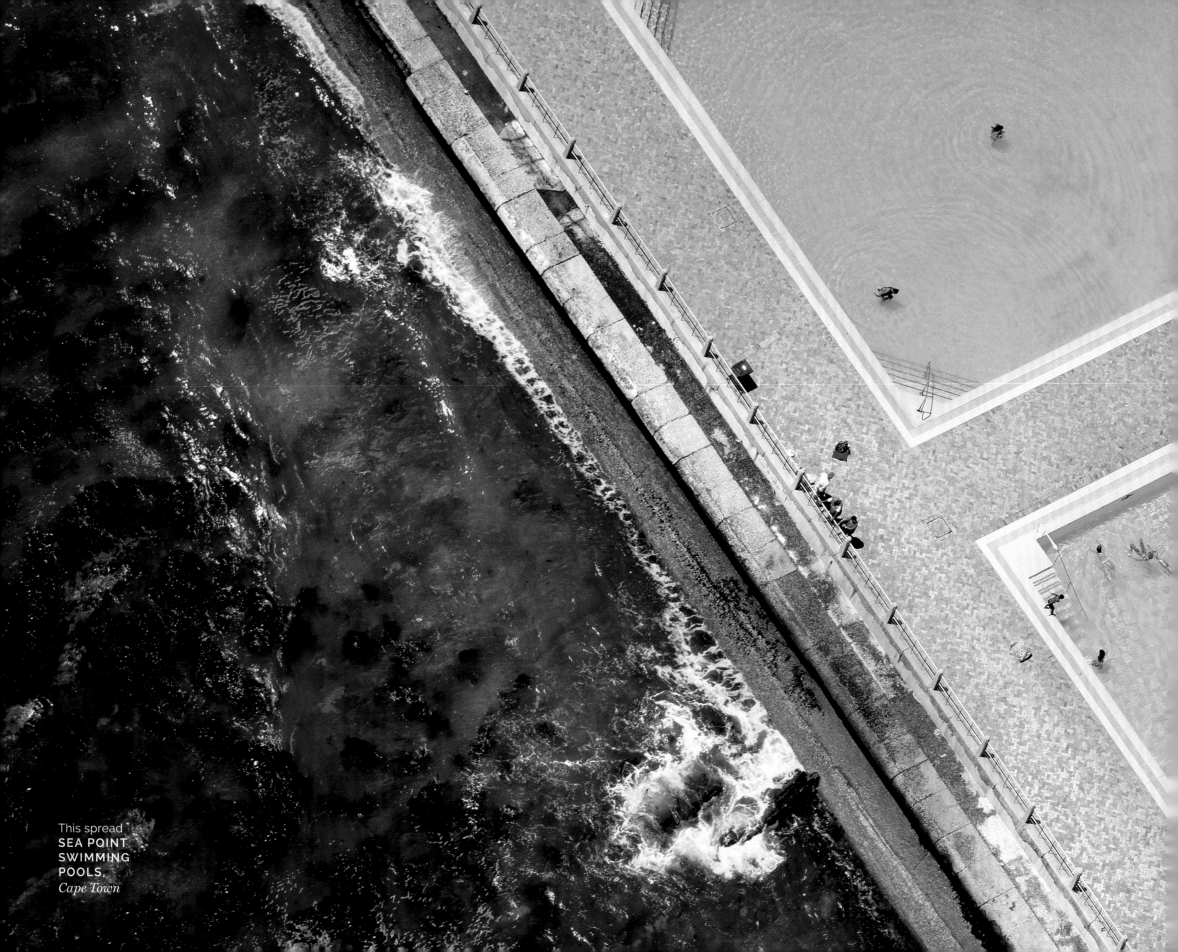

This spread
SEA POINT
SWIMMING
POOLS,
Cape Town

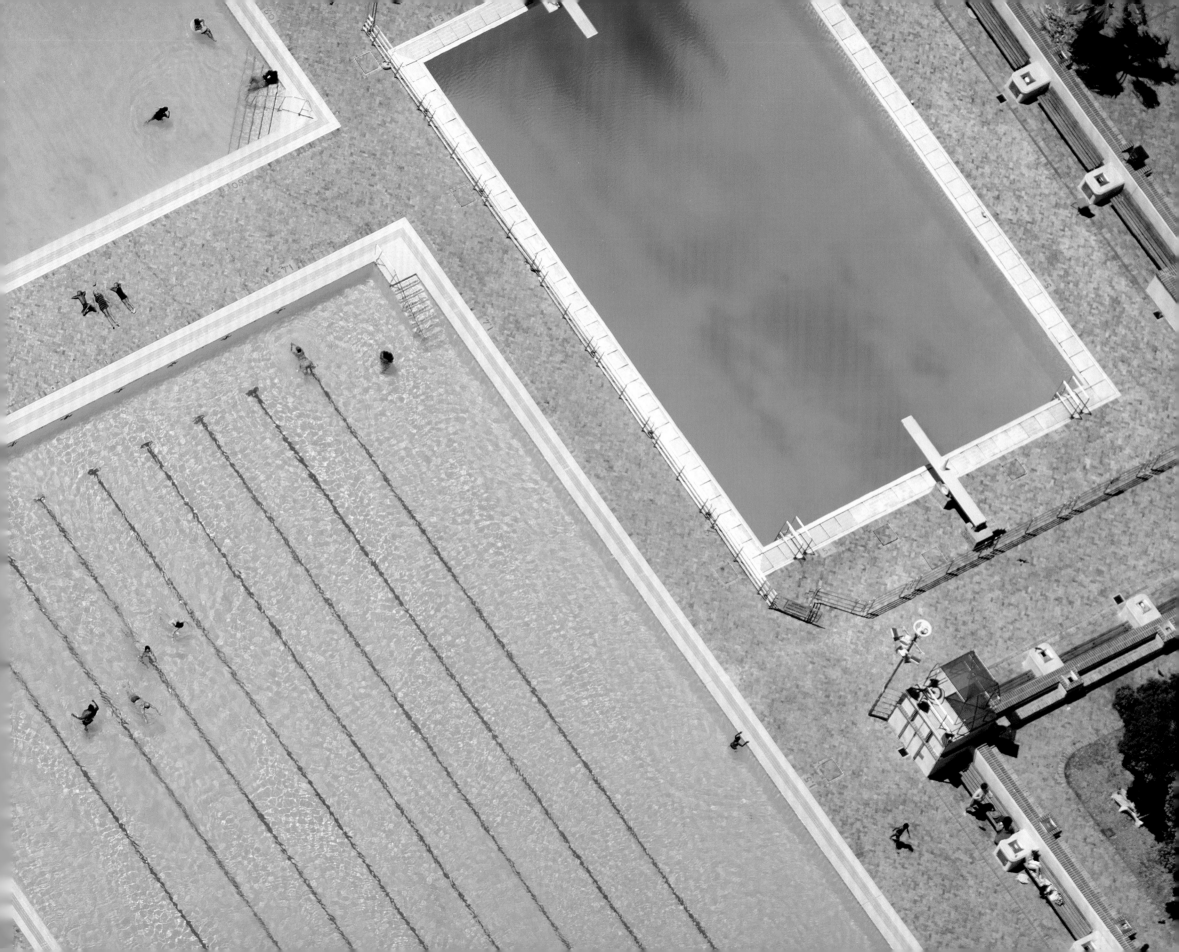

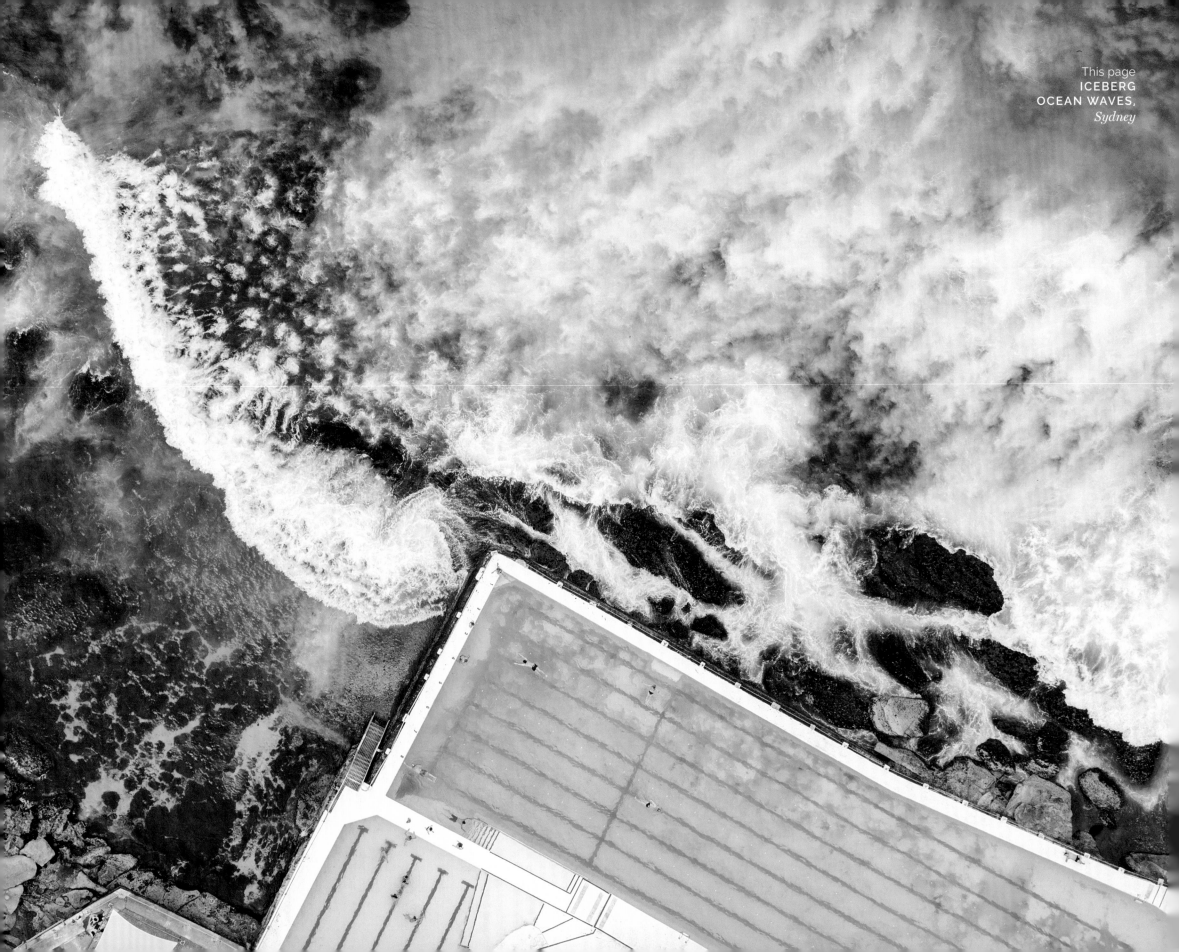

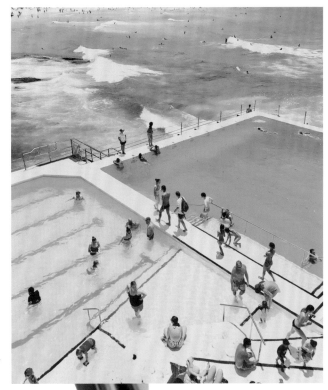

Sydney is one of my favorite destinations to shoot from above because it combines two of life's greatest escapes—swimming pools and the beach—into one. Almost every major beach has an ocean-side pool, offering a natural way for people to swim without the risk of the ocean currents. For an aerial photographer this is pure bliss.

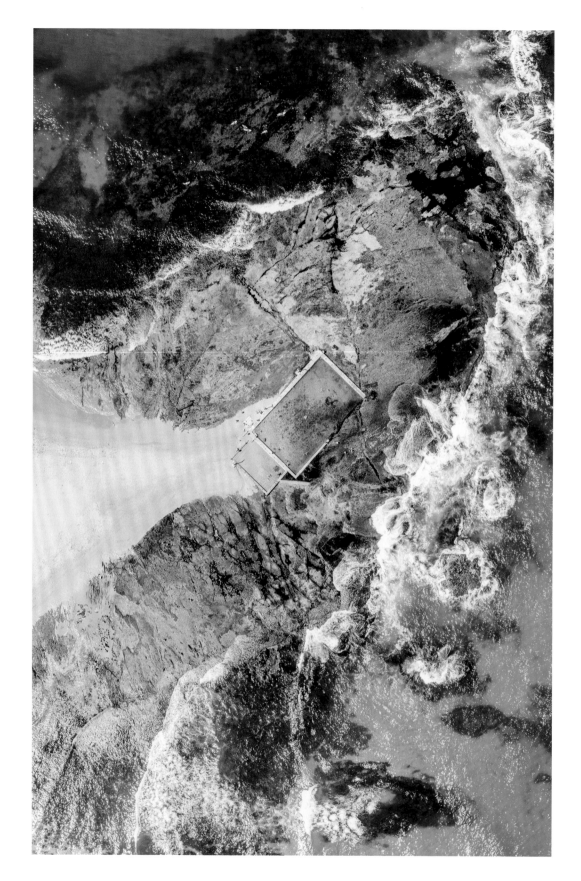

This page
MONA VALE
BEACH POOL,
Sydney

Next page
BRONTE
POOLS,
Sydney

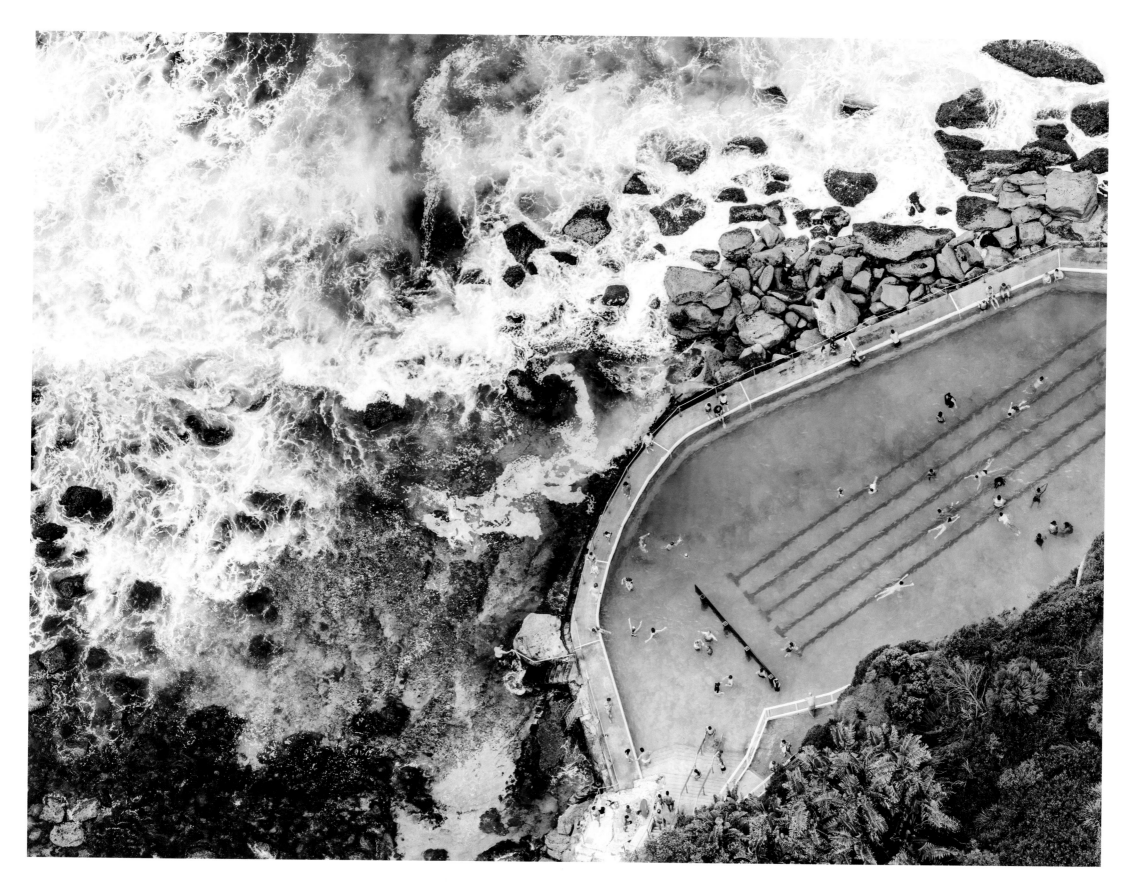

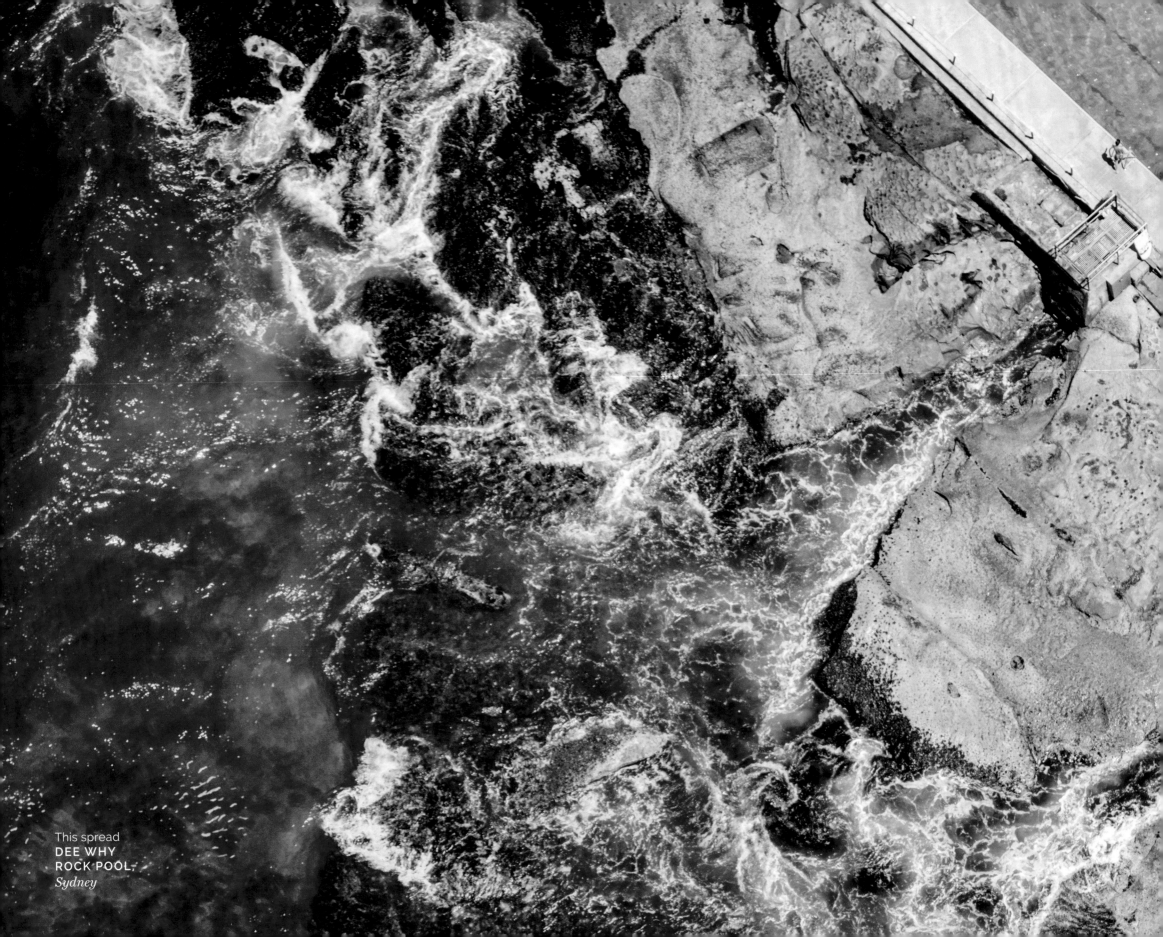

This spread
DEE WHY
ROCK POOL,
Sydney

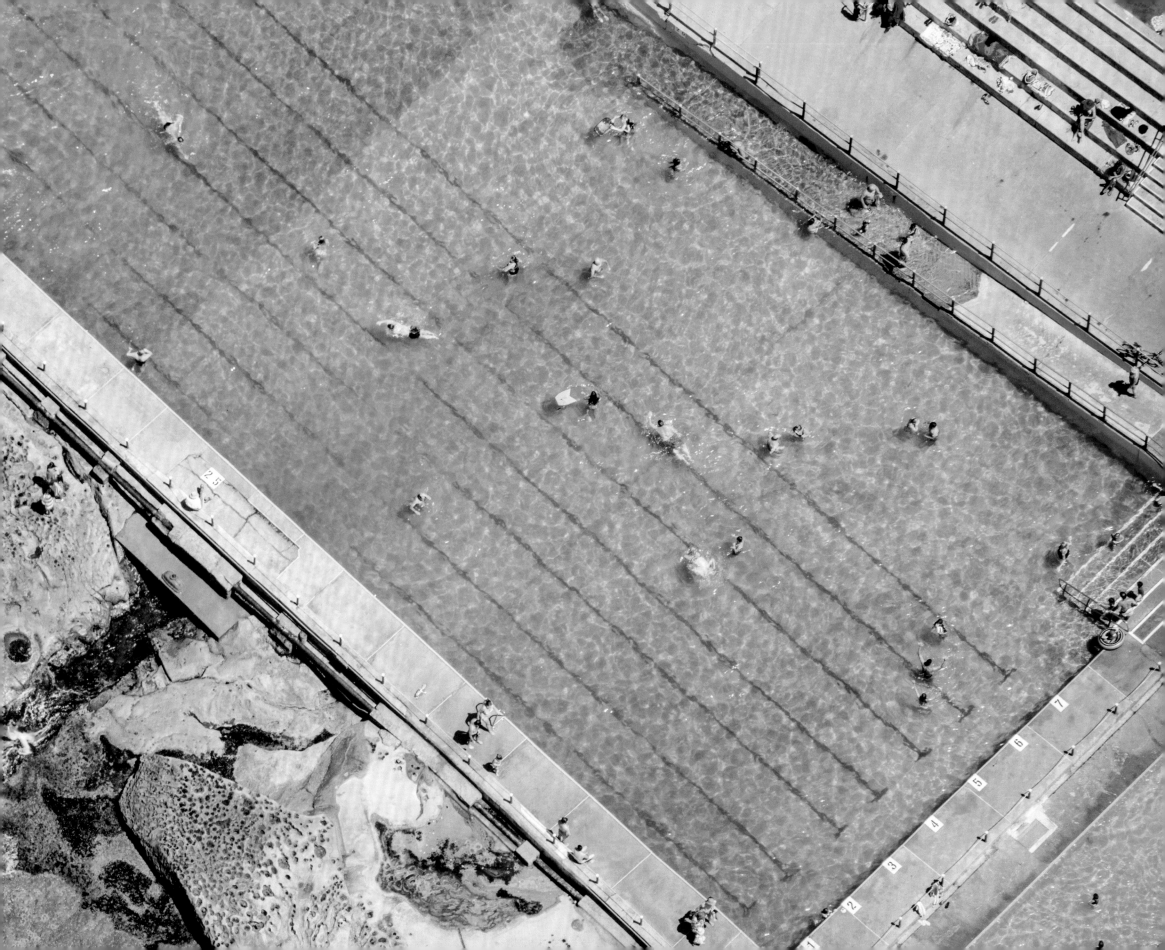

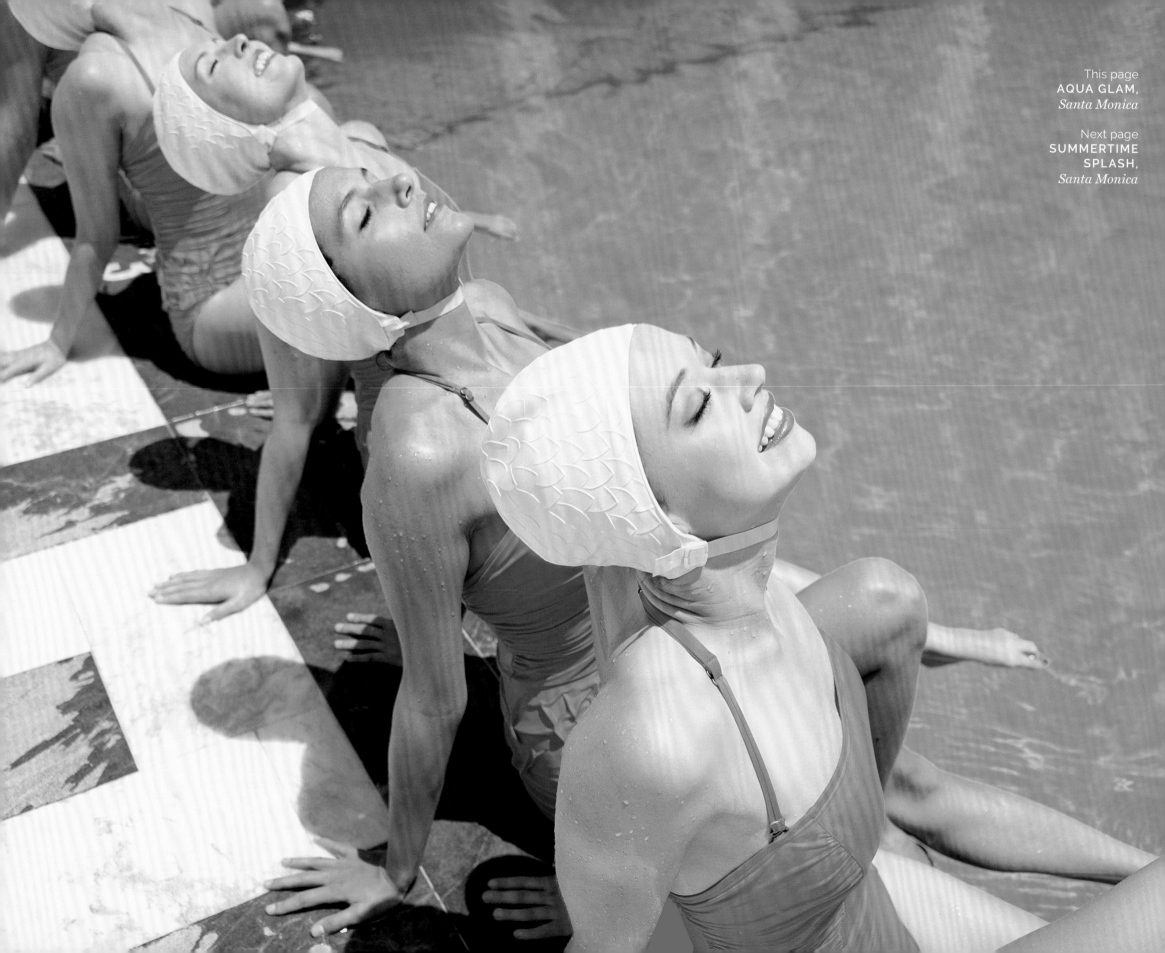

This page
AQUA GLAM,
Santa Monica

Next page
**SUMMERTIME
SPLASH,**
Santa Monica

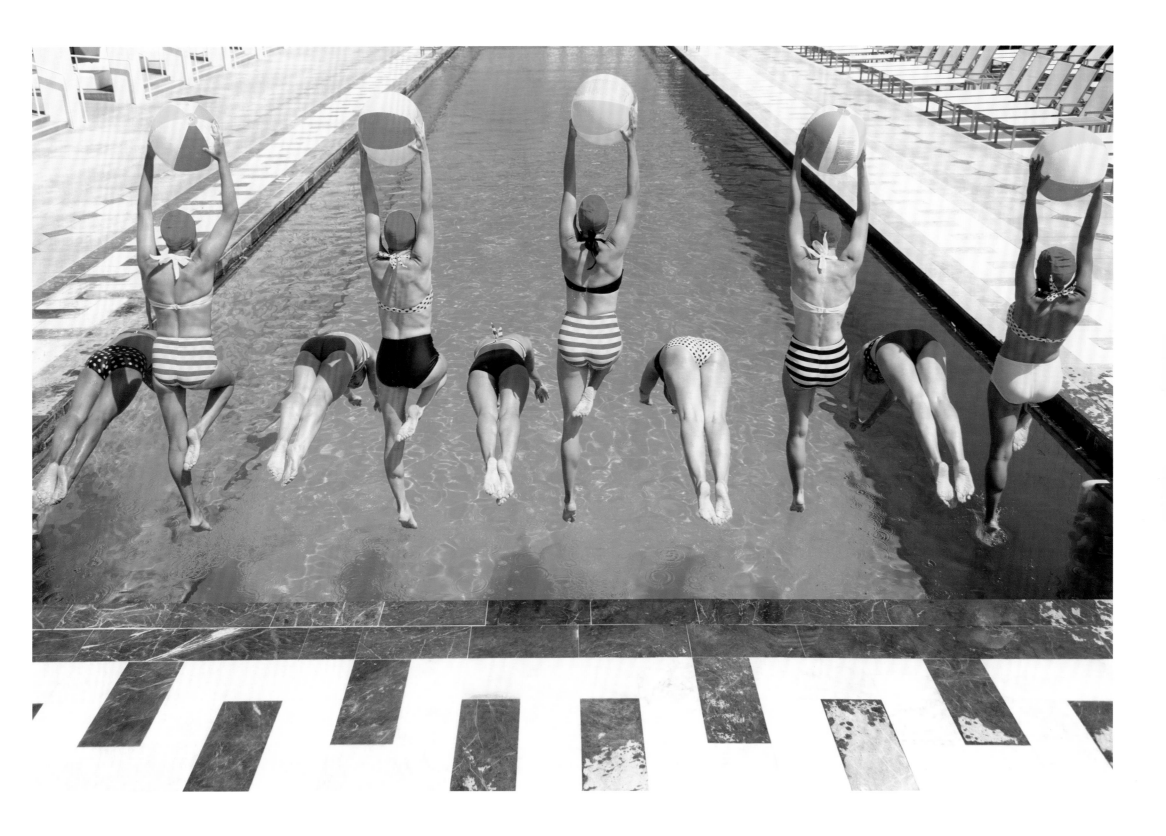

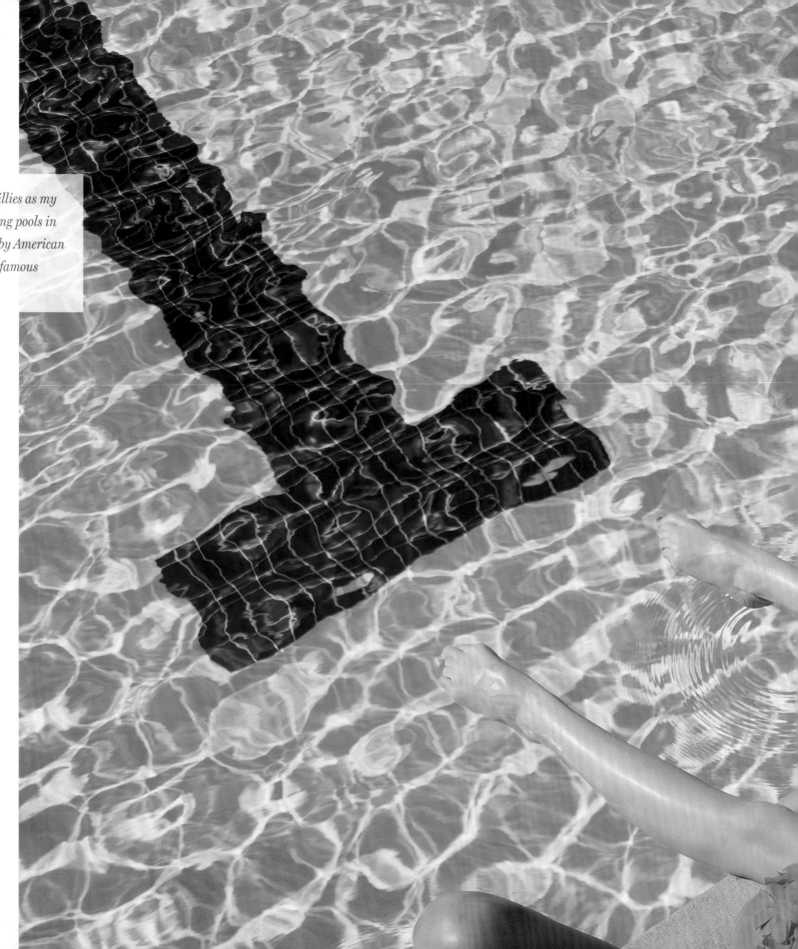

Aqua Glam

Capturing the essence of a timeless American summer, the Aqua Glam series was inspired by the classic elegance and glamour of synchronized swimming in the early twentieth century.

Working with the incredible water-ballet team the Aqualillies as my muses, I photographed this series at two historic swimming pools in Los Angeles—one of which, the Annenberg, was designed by American architect Julia Morgan, who is best known for her world-famous Neptune pool at Hearst Castle.

Combining two of my favorite subjects, the escape of a day at the pool and the vintage glamour of old Hollywood, Aqua Glam transports me to the glittery times of yesteryear. Once belonging to film actress and philanthropist Marion Davies, the historic Annenberg pool located on the sandy shoreline of Santa Monica has been a longtime backdrop to many luxurious events, attended by the who's who of the time, both industry leaders and Hollywood's brightest stars.

Unique in comparison to some of my other work, Aqua Glam offers viewers an escape into a world created joyfully for their amusement—witnessing a mesmerizing performance of ethereal water dancers, beckoning you to let them entertain you, if only for a moment.

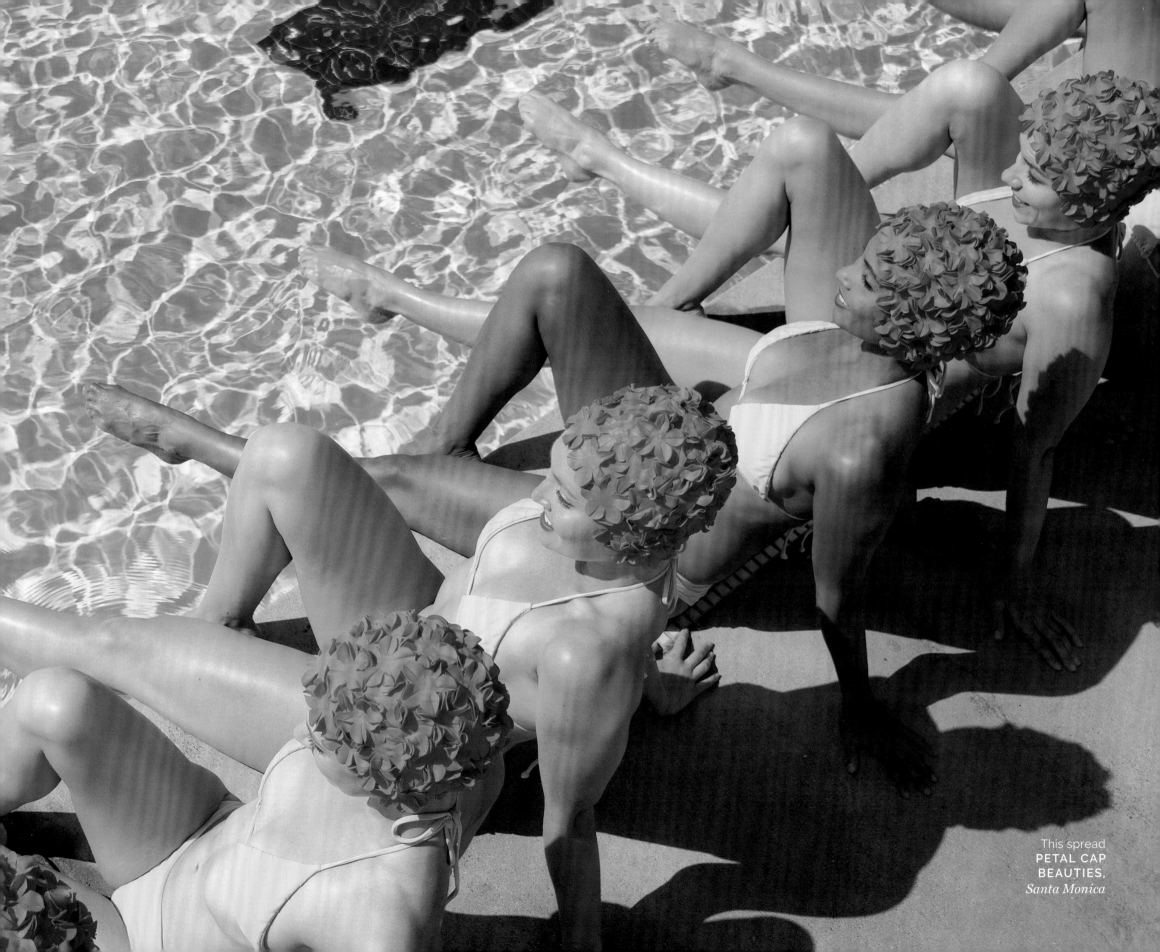

This spread
PETAL CAP
BEAUTIES,
Santa Monica

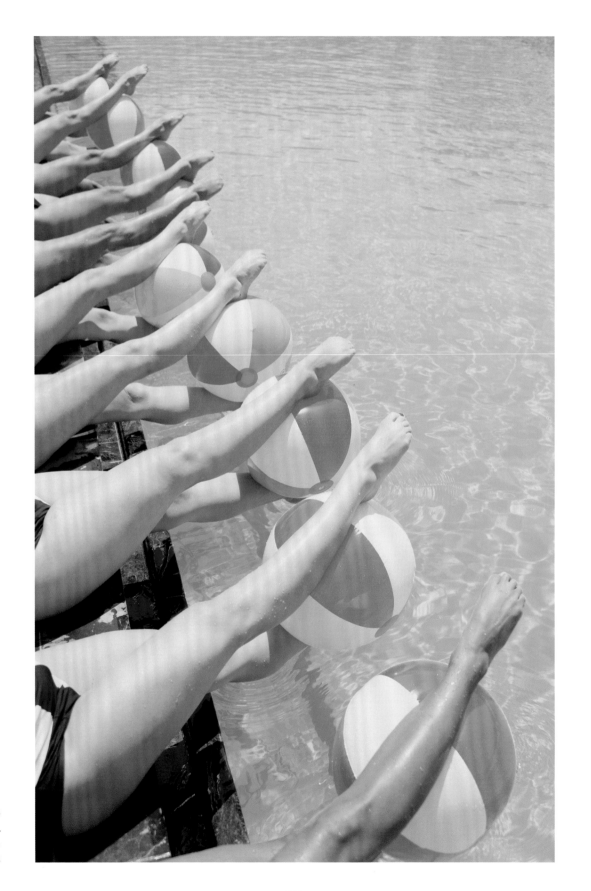

This page
**BEACH BALL
GLAM,**
Santa Monica

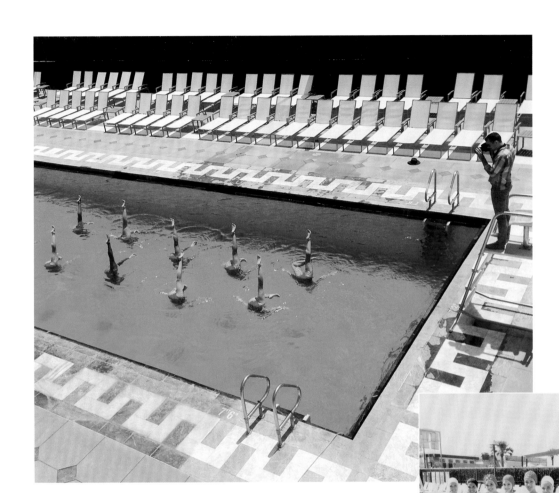

Everything about creating this series was a dream—the perfect weather, the talented cast, and the best part . . . picking out the wardrobe. It was simply the epitome of Hollywood Glam.

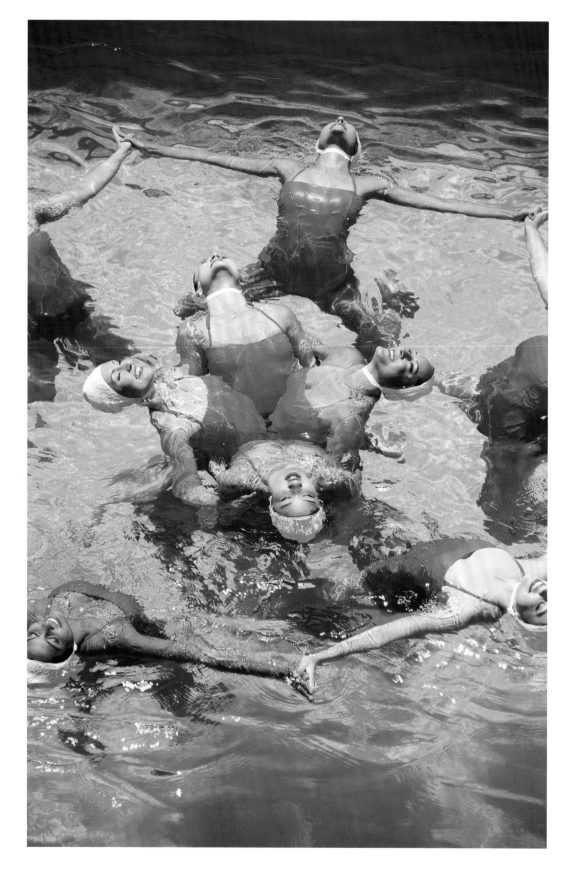

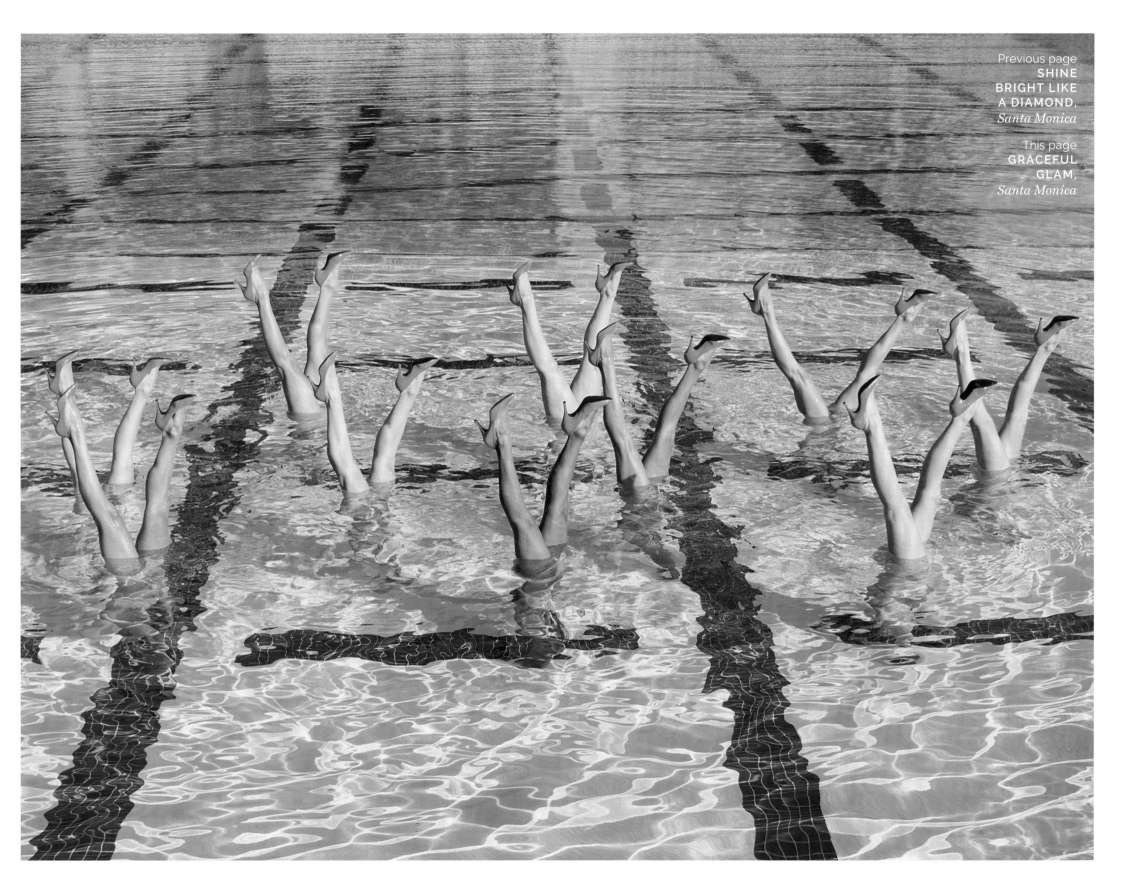

SAND

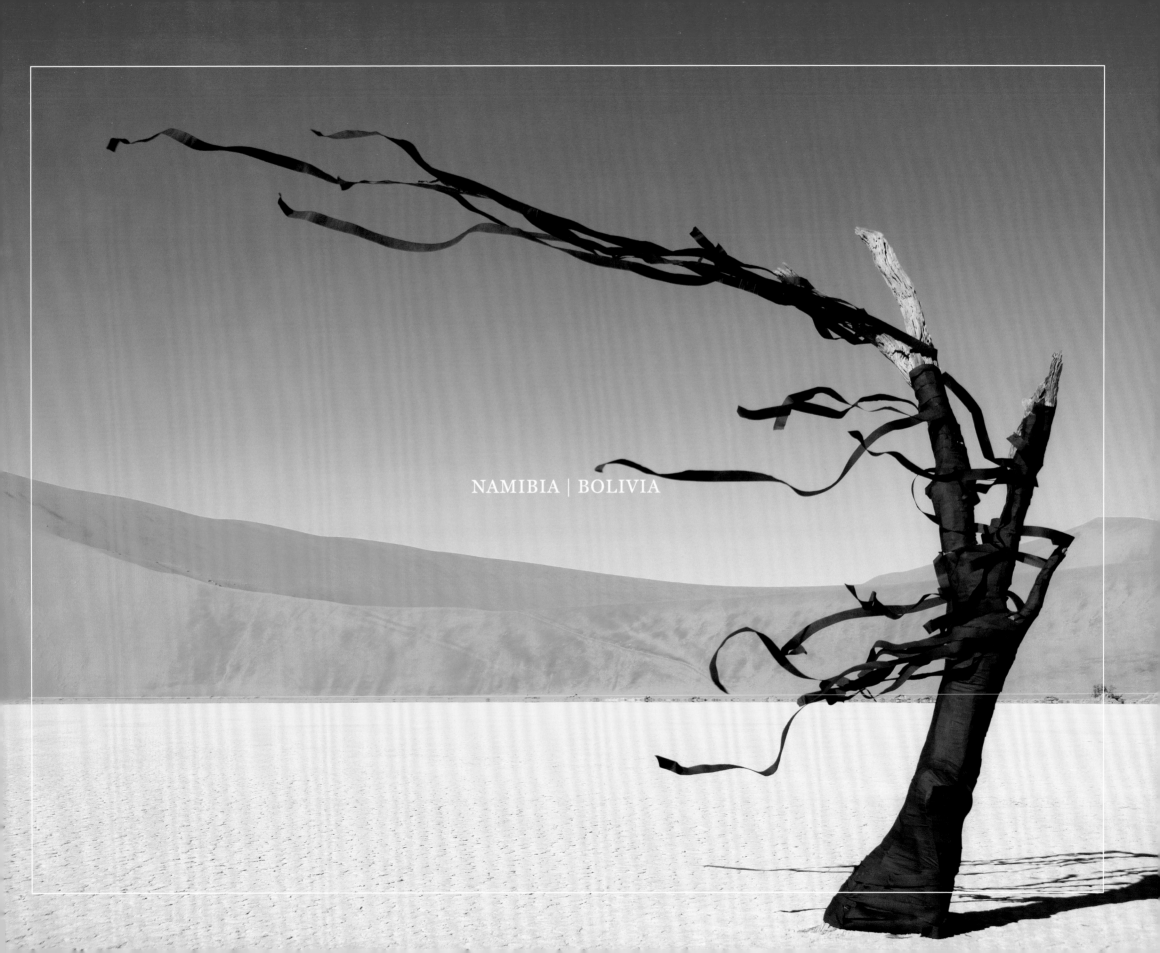

NAMIBIA | BOLIVIA

Having photographed many of the world's most beautiful beaches, I have realized that the sand is just as remarkable as the water. Furthermore, sand, in all its glorious variety, is found many places in this world where water is not. With deserts making up almost one-third of the earth's surface, there is a mystique about this arid landscape that has always entranced me. Regardless of the location, it's those first steps across the sandy grains beneath you that often mark the beginning of a great escape.

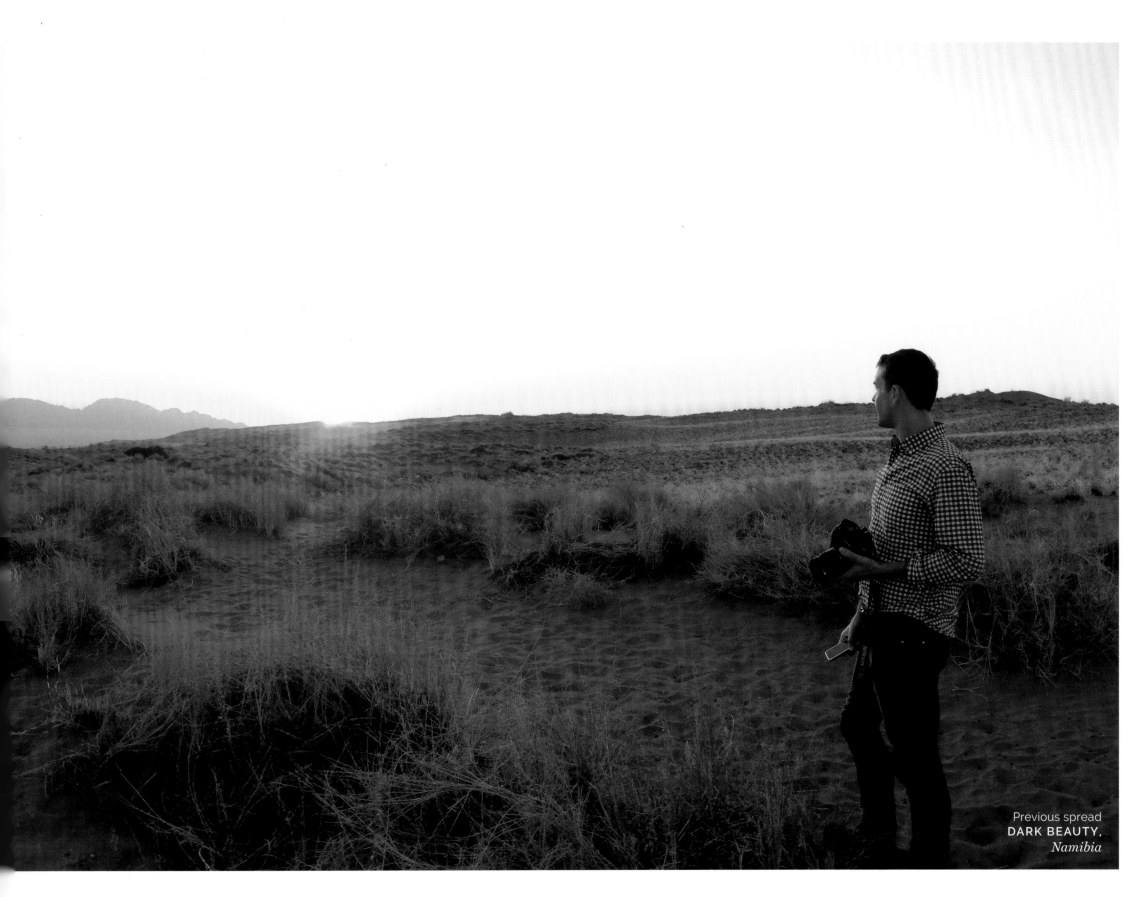

Previous spread
DARK BEAUTY,
Namibia

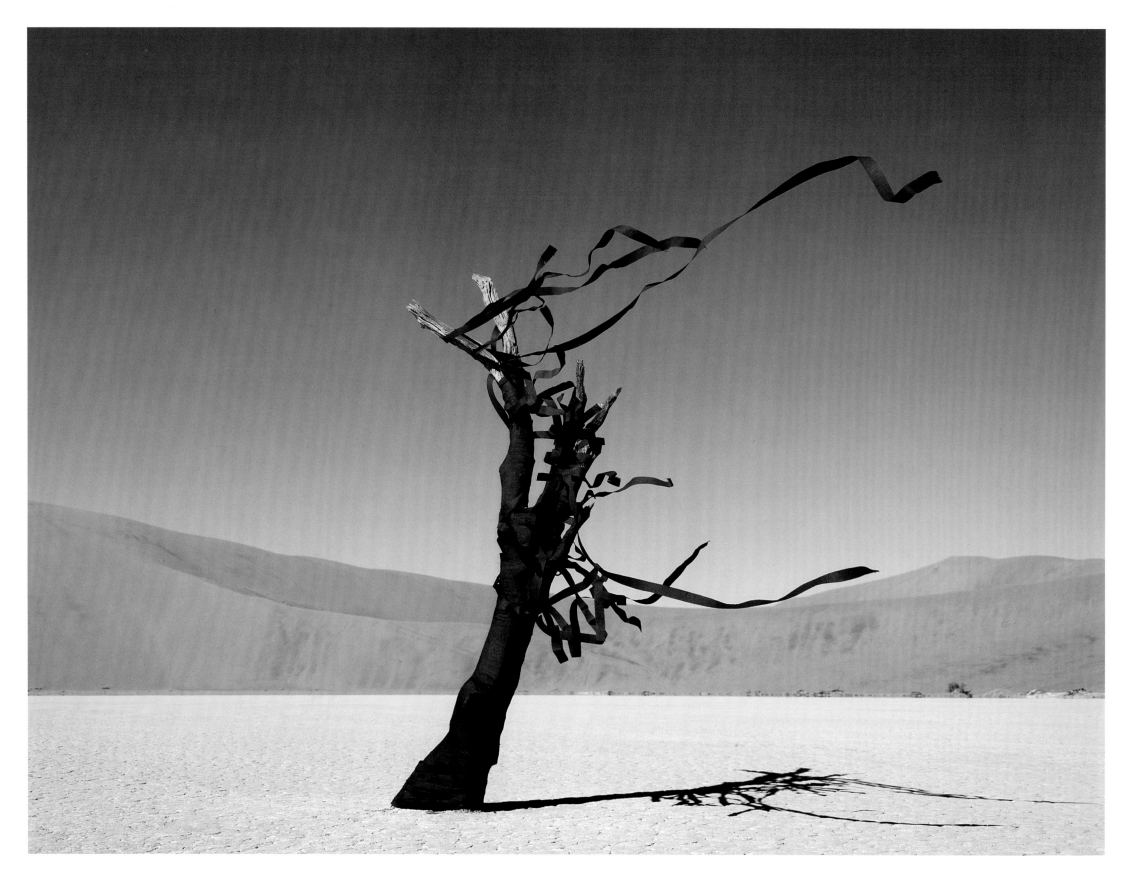

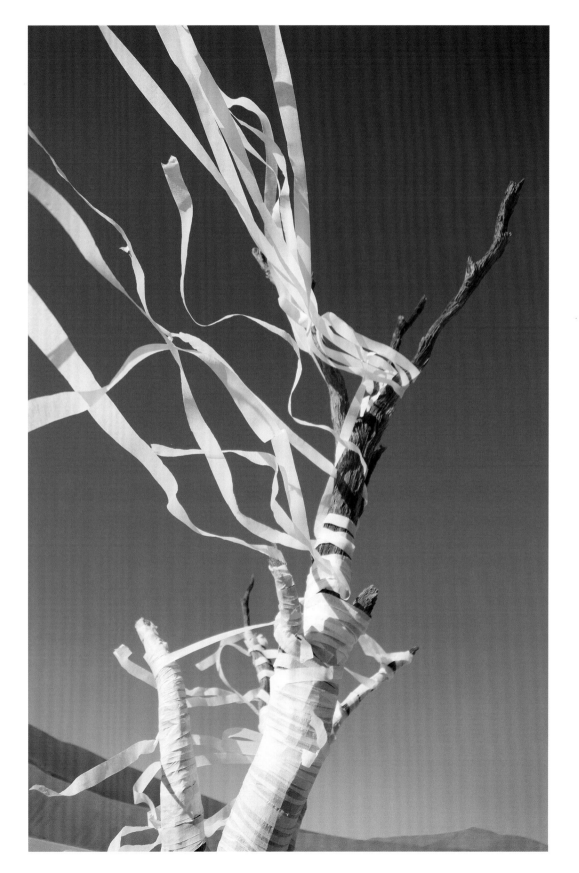

Previous page
DANCING
DESIRE,
Namibia

This page
COMBING
THE SKY,
Namibia

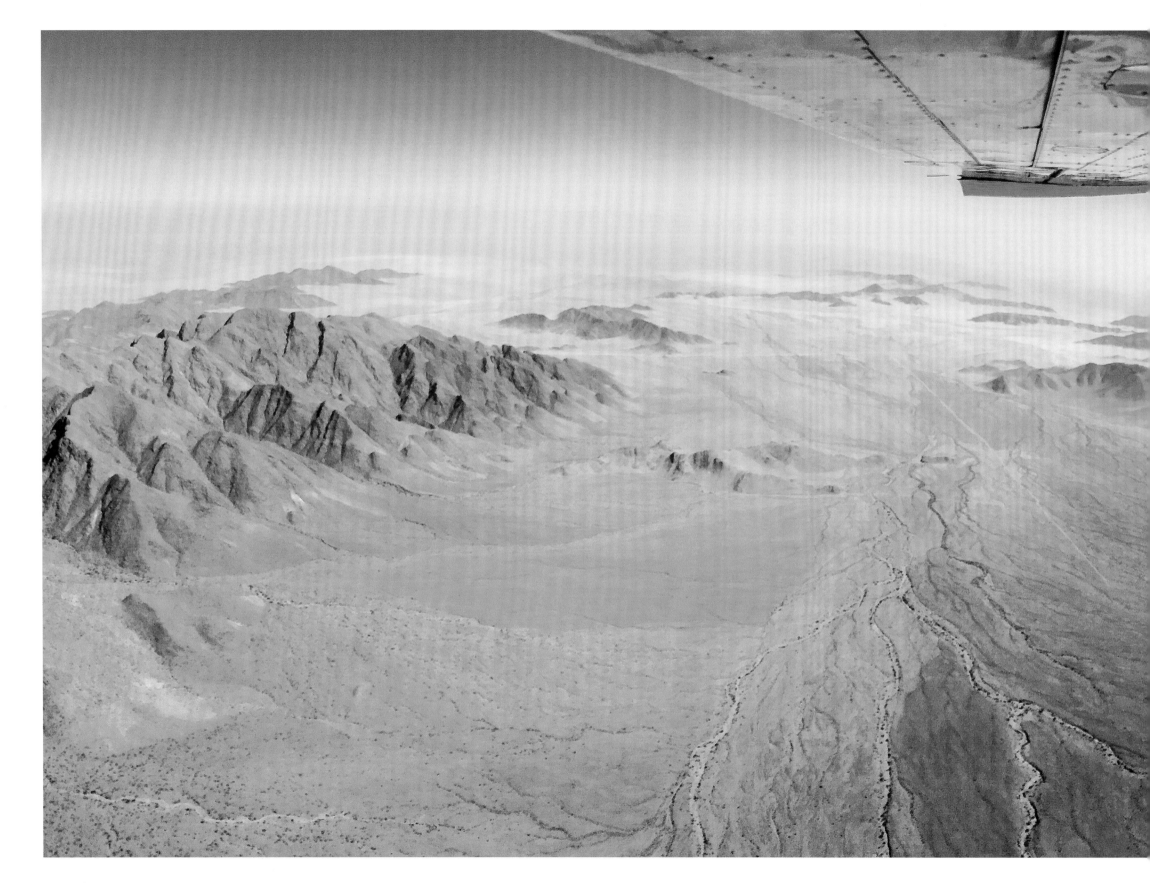

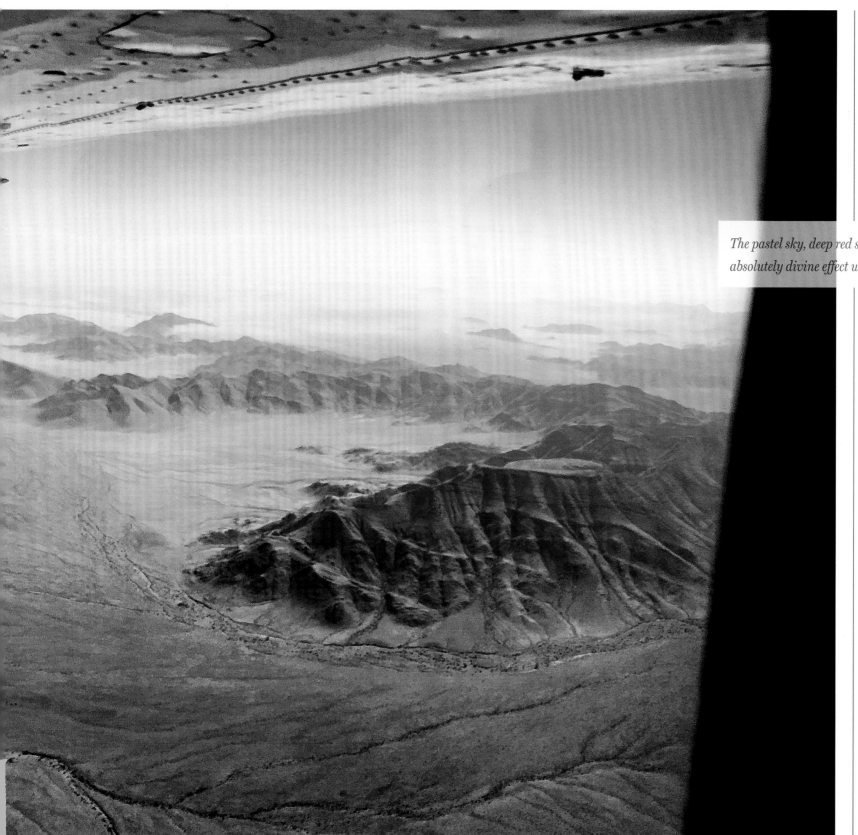

Mirage

I had planned this shoot for nearly six months, but nothing could have prepared me for first driving into Sossusvlei in the Namib-Naukluft National Park in the early hours of the morning. It was like entering an exotic cousin of the Sahara desert— gigantic, steep, red sand dunes curved along the horizon on either side of the vehicle. Each dune projected gradual purple shadows which were not yet fully lit by the rising sun.

The pastel sky, deep red sands, purple shadows, and amber grass were an absolutely divine effect unlike anything I had ever seen!

We watched with fascinated eyes as we soon arrived at the largest sand dune in the area, "Big Daddy."

Dried to a crisp, the white salt-and-clay pan is filled with 900-year-old skeletons of old camel thorn trees that ceased to decompose due to the lack of moisture. These trees were the muses for my series Mirage, and the shining stars of our day.

As the sun started its descent, an unbelievable transformation began to unfold. The boulders all around us glowed orange and pink. A white, leafless tree stood in the foreground, glowing in the evening light. The sun became a beautiful orange disk floating through the desert dust in the open sky. Once the sun descended behind the final sand dune the show went on. The sky remained pink for nearly forty-five minutes, and the full moon began to glow behind us along with the stars of the southern sky sparkling above in the unpolluted atmosphere.

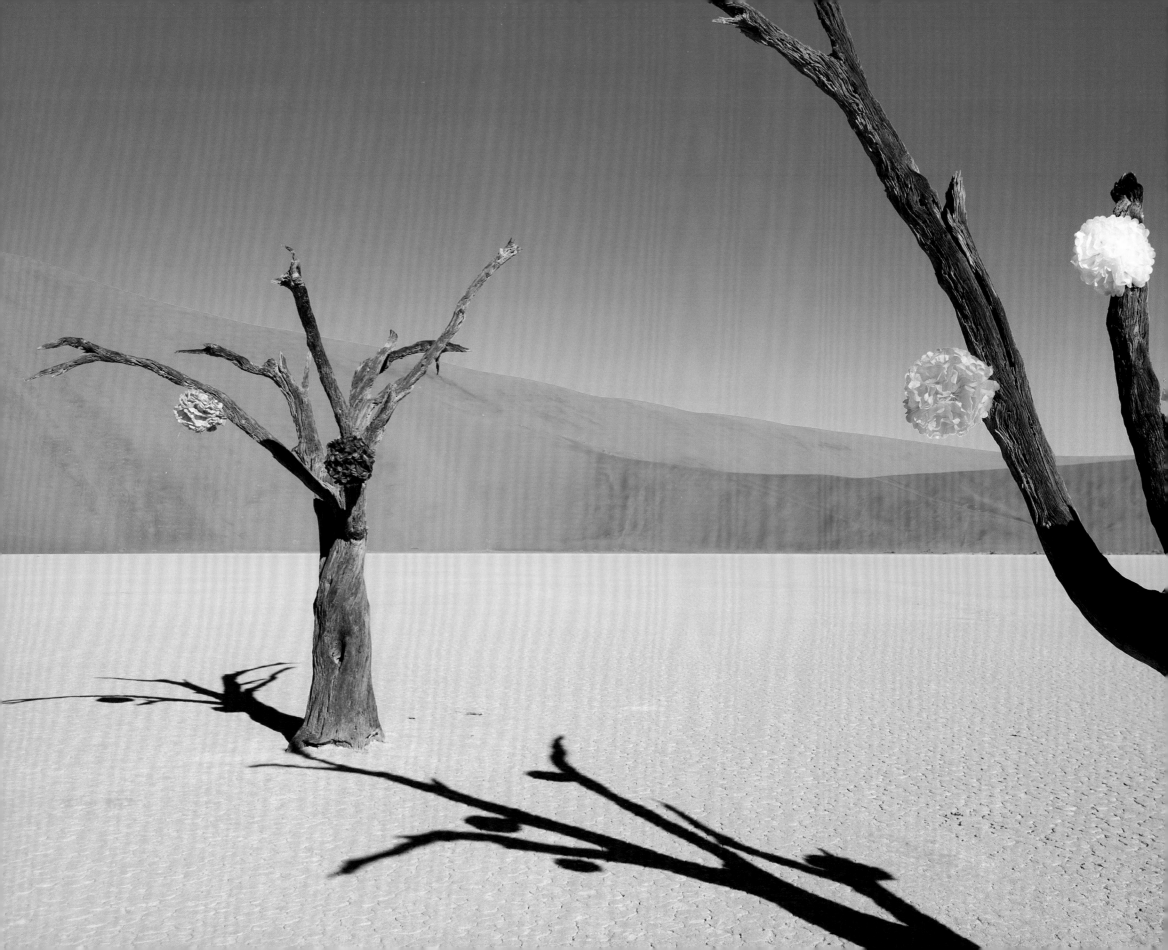

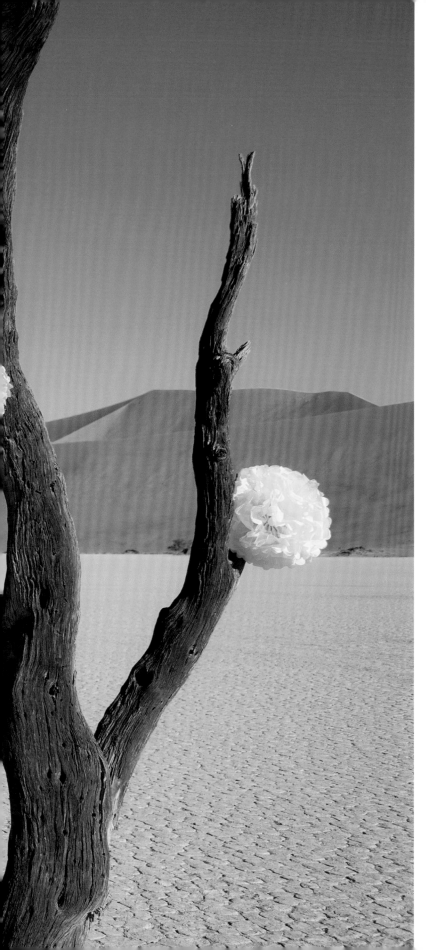

This spread
POM TREES,
Namibia

With absolutely no cell reception, Namibia is the quietest escape I have ever experienced; it was a complete departure from the outside world.

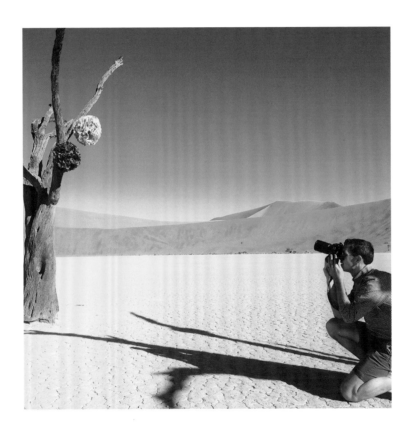

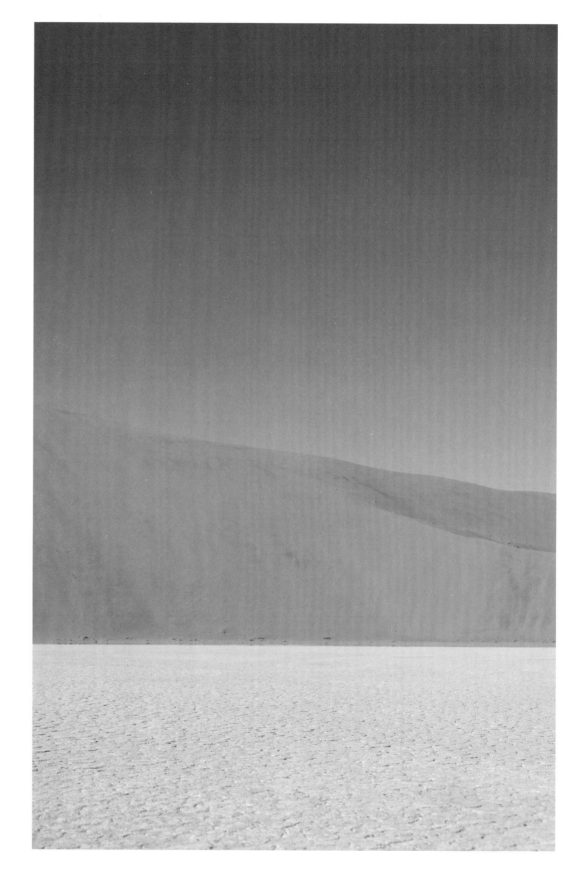

This spread
HIGH NOON TRIPTYCH, *Namibia*

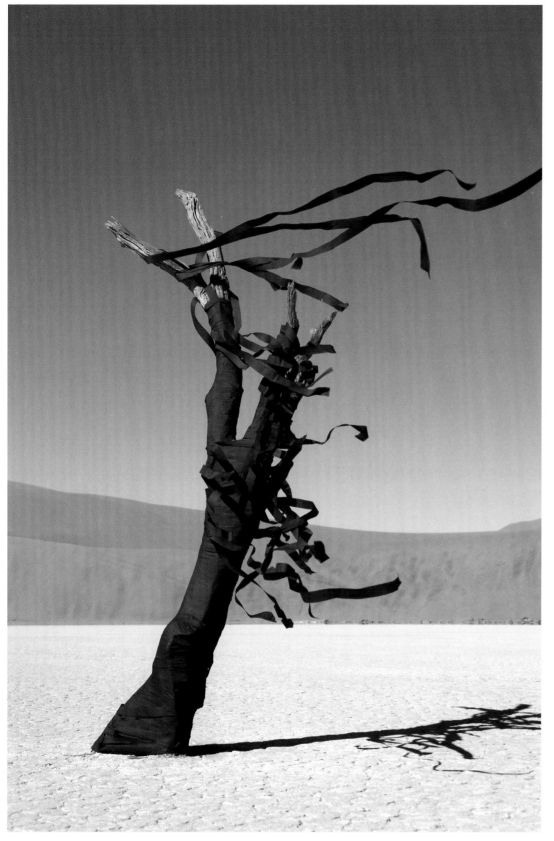
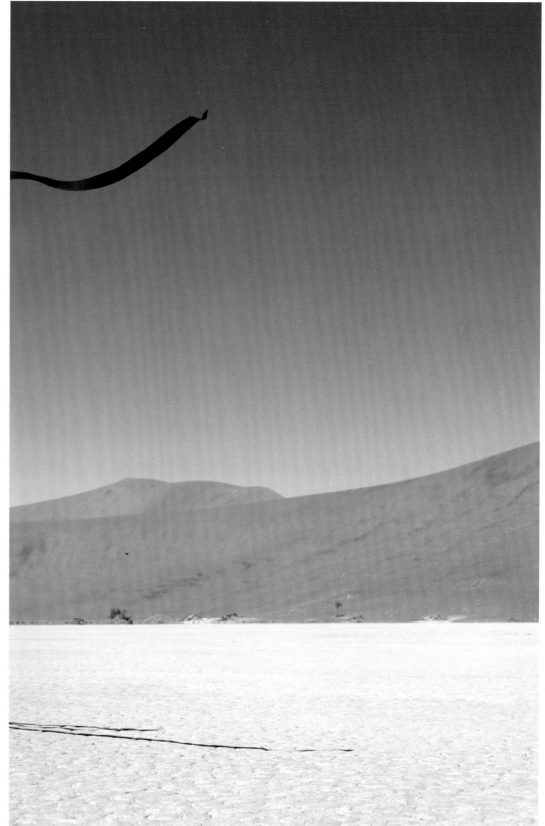

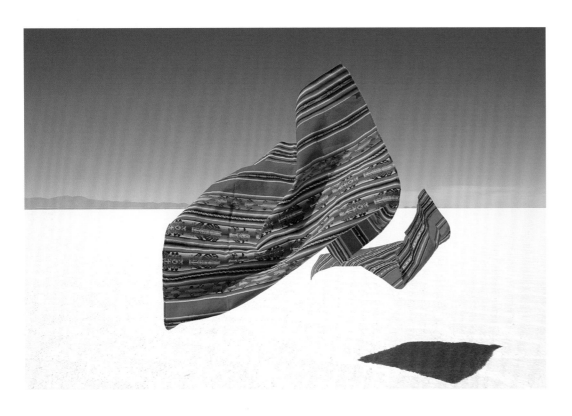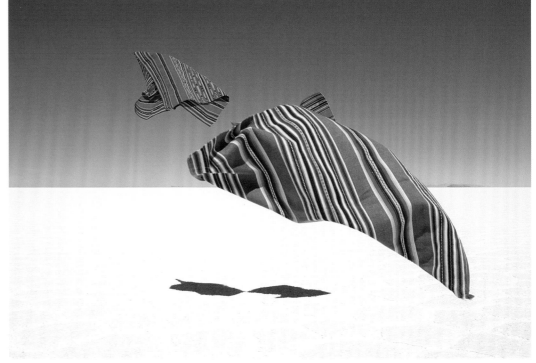

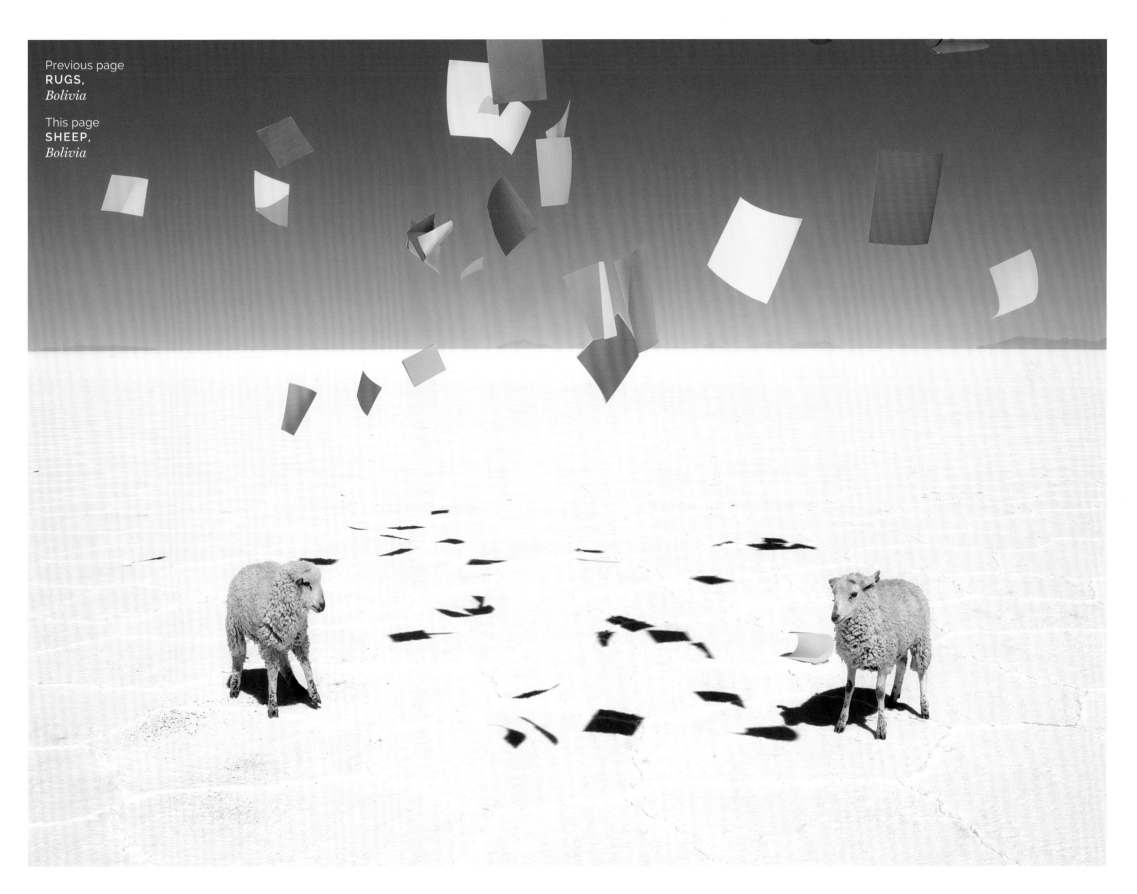

Previous page
RUGS,
Bolivia

This page
SHEEP,
Bolivia

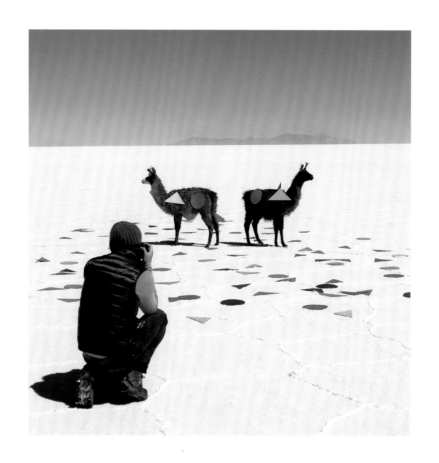

SALAR DE UYUNI
BOLIVIA

Although not your traditional desert, the **Salar de Uyuni in Bolivia** is the **world's largest salt flat** where I shot my series Far Far Away under the mentorship of Gastón Ugalde. The geography of this South American country exhibits a great variety of terrain, but the **salt-cracked 4,000-square-mile piece of land, sitting 12,000 feet in elevation,** is really what captured my attention. The result is a body of work that celebrates a **whimsical escape to an unworldly place** inviting the viewer to interpret the imagery in his or her own way.

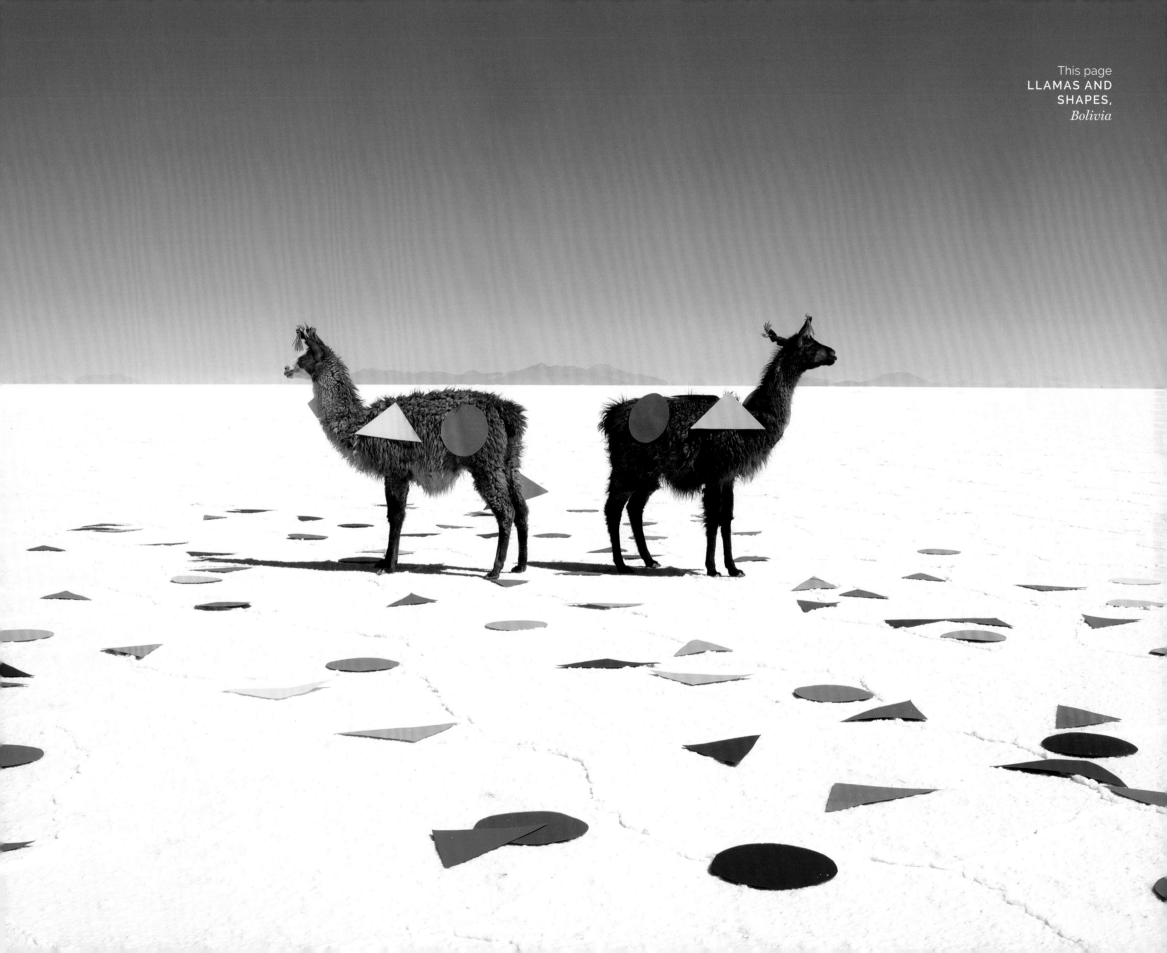

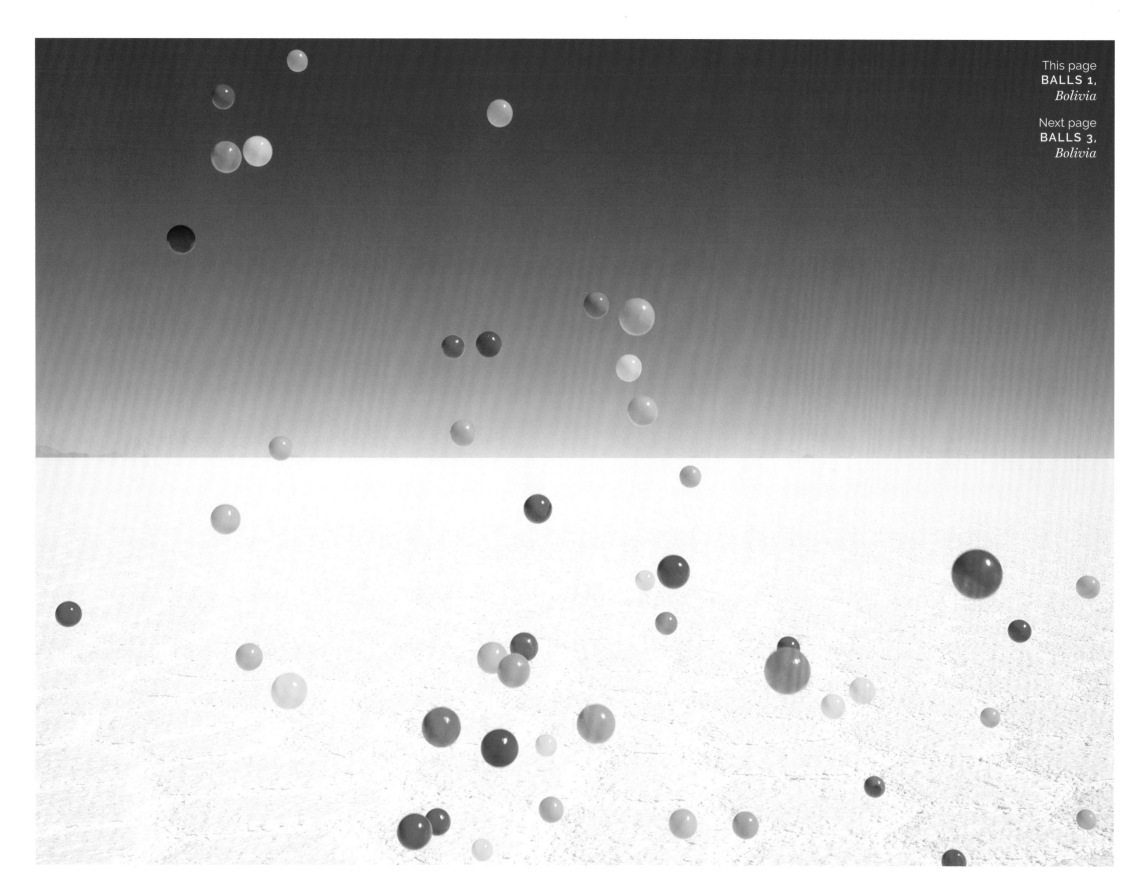

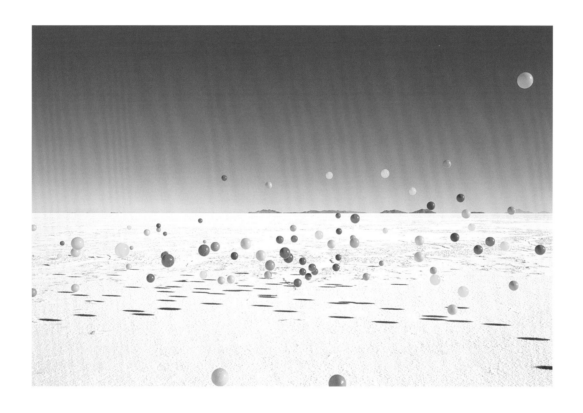

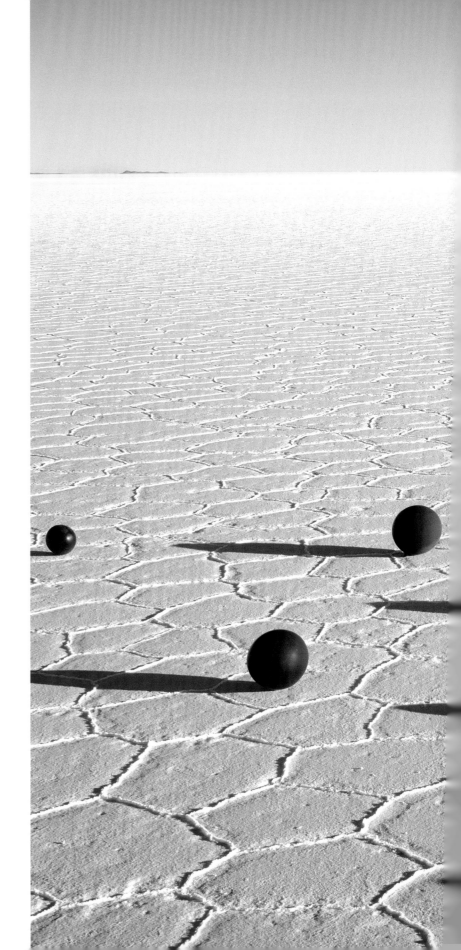

This spread
BLACK ORBS,
Bolivia

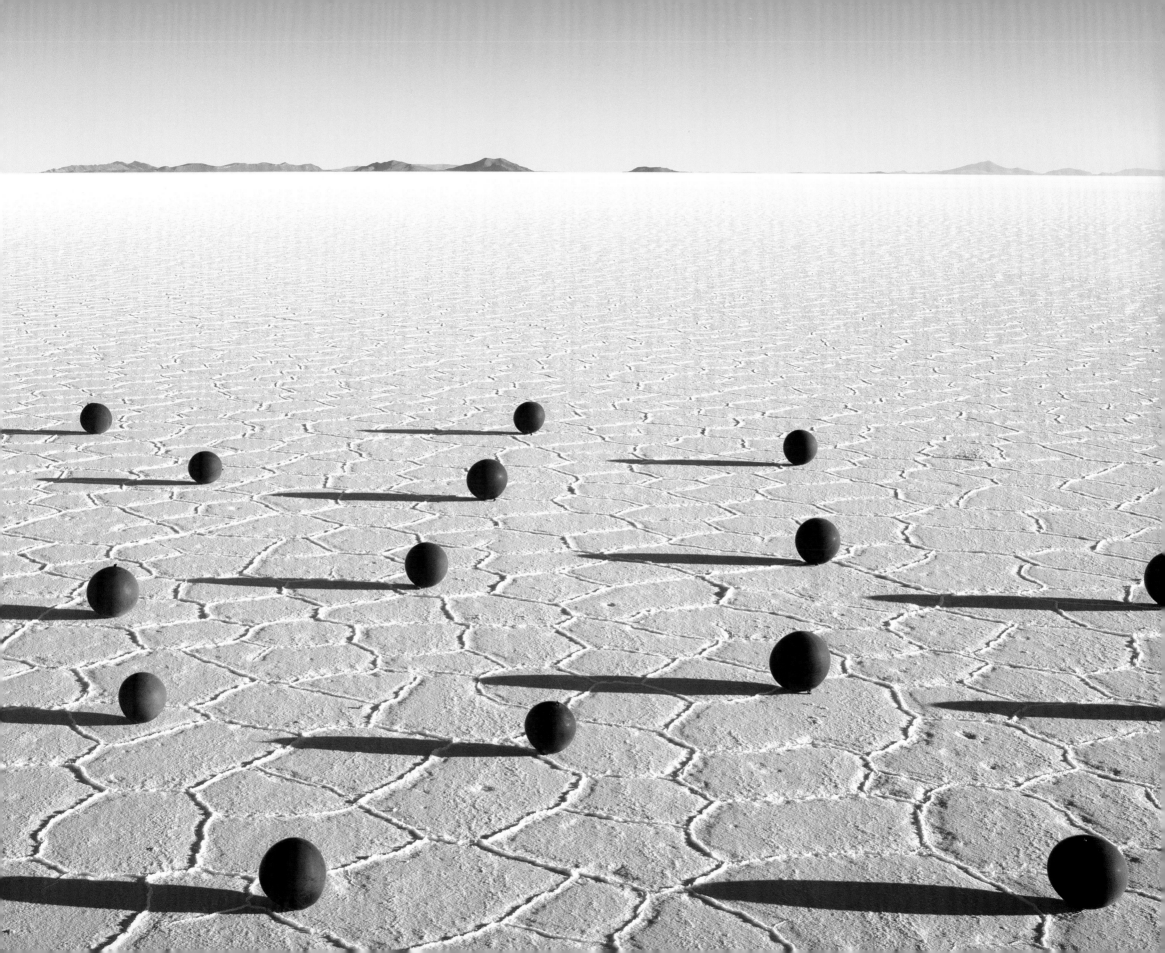

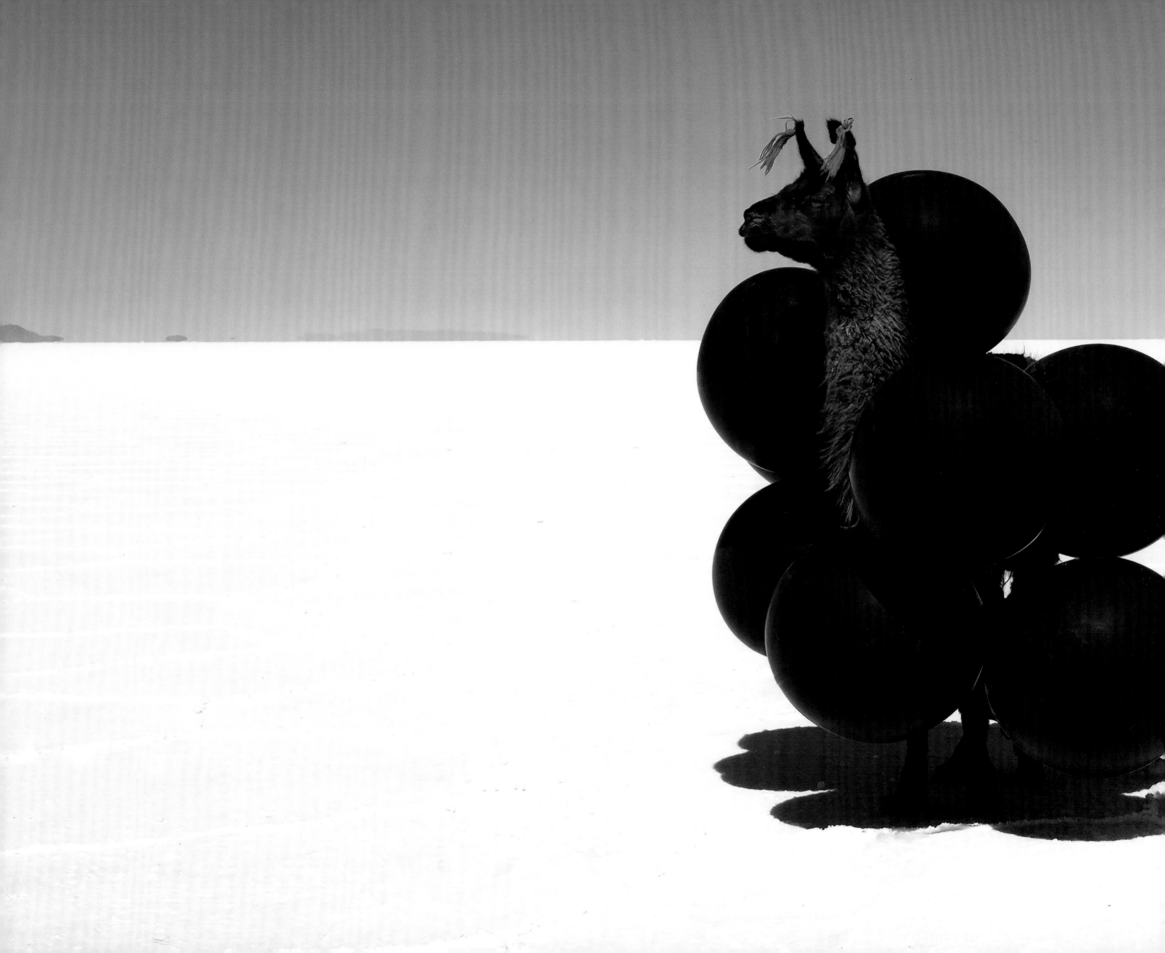

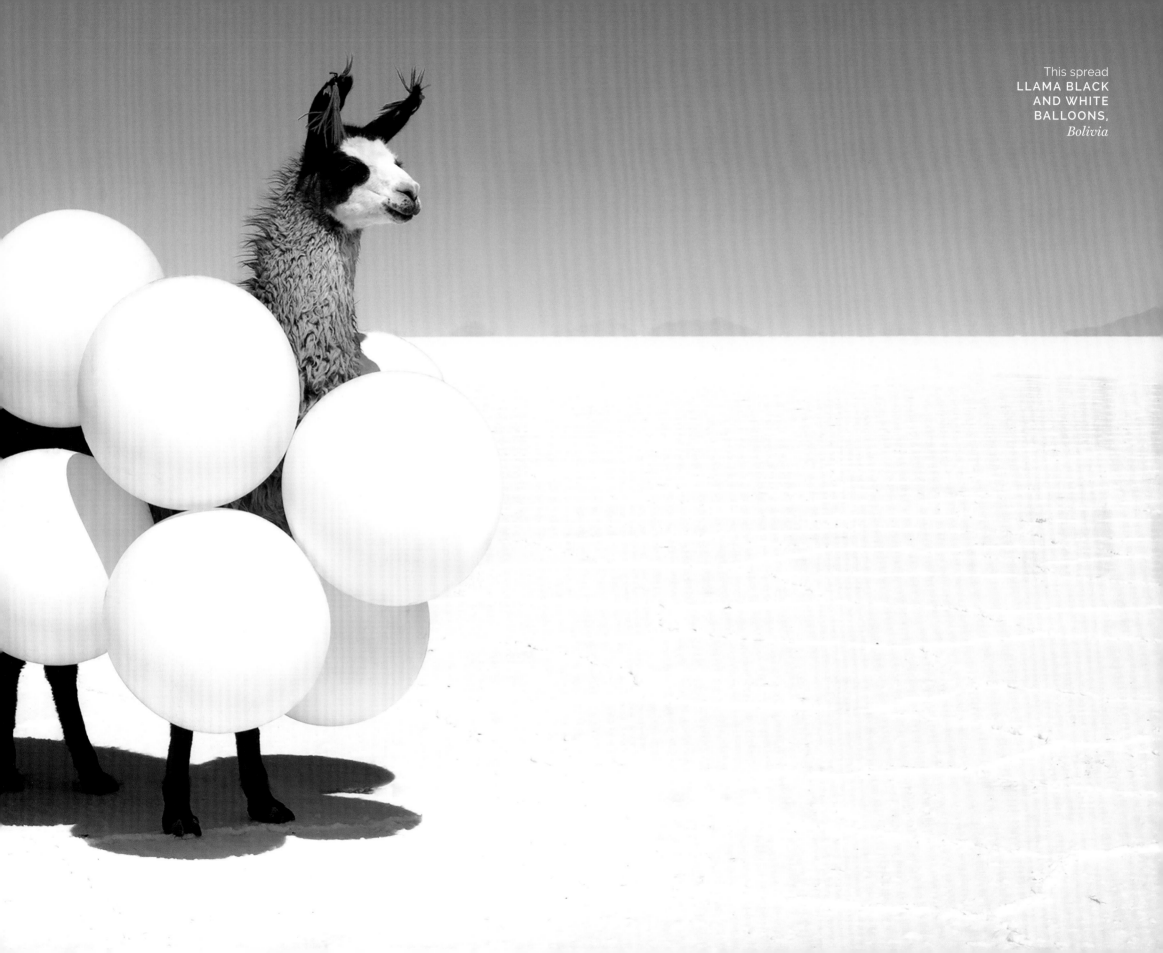

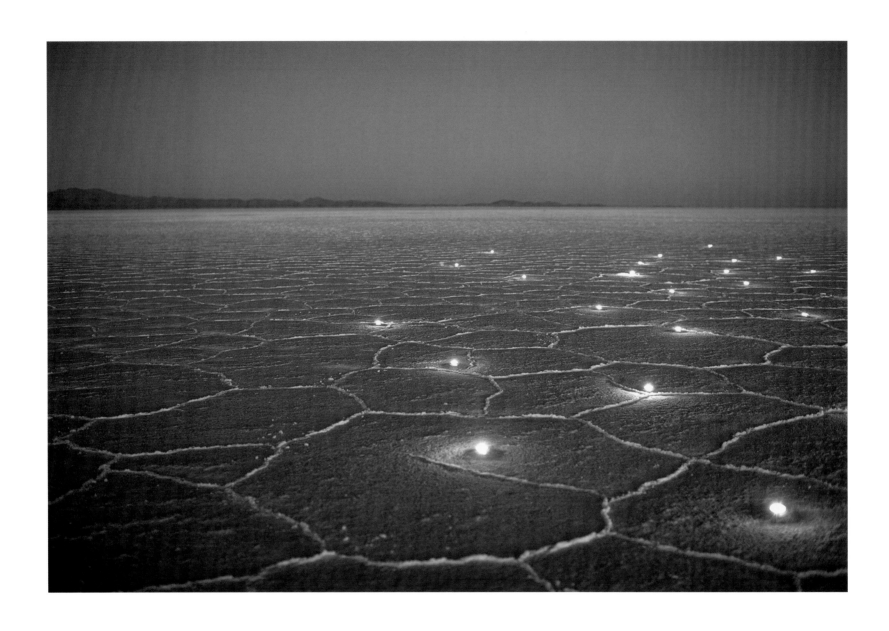

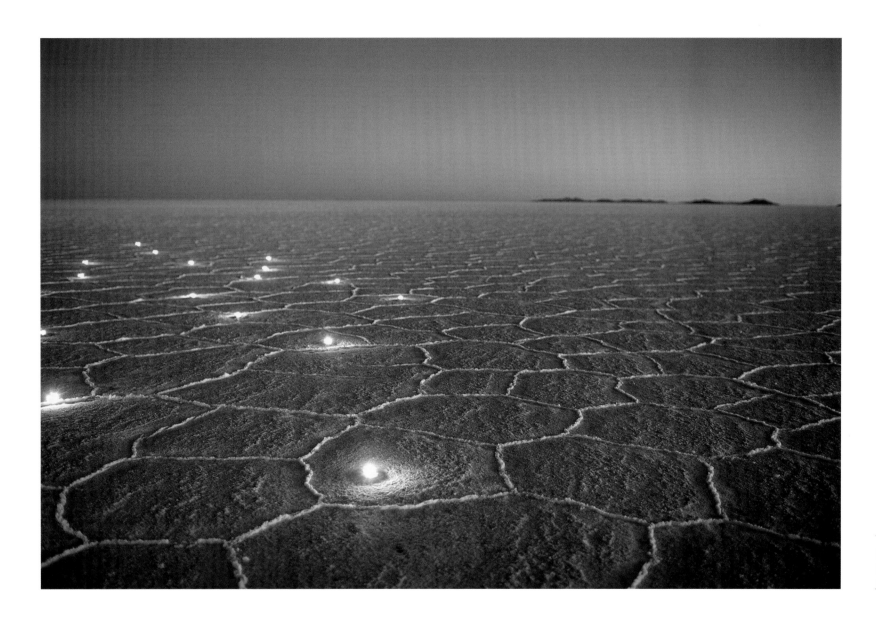

This spread
**LIGHTS
DIPTYCH,**
Bolivia

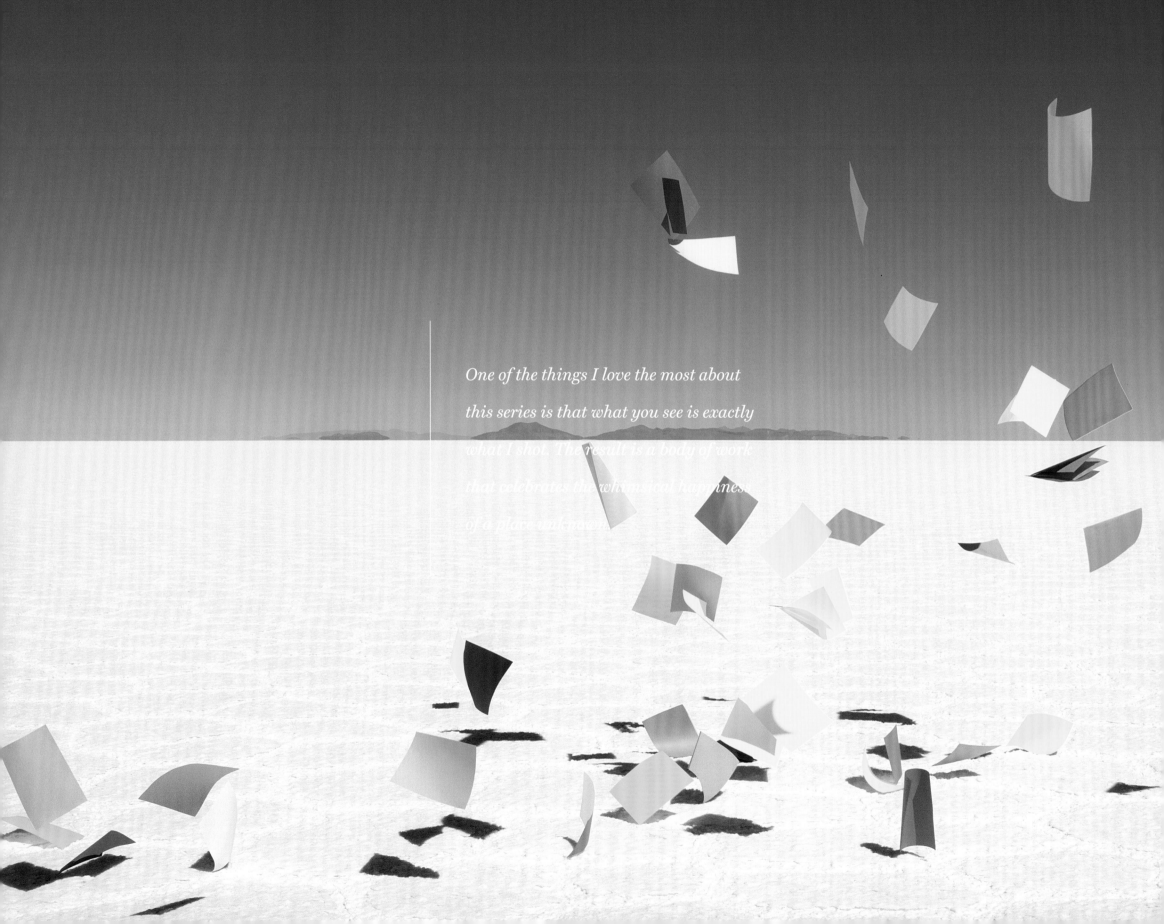

One of the things I love the most about
this series is that what you see is exactly
what I shot. The result is a body of work
that celebrates the whimsical happiness
of a place unknown.

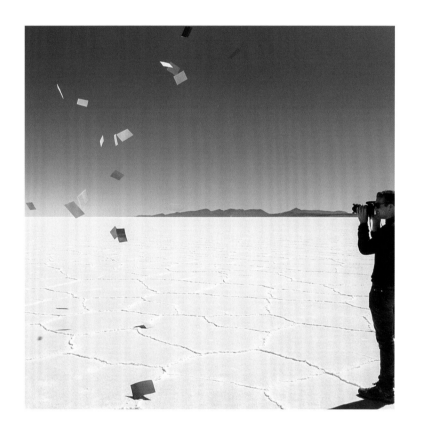

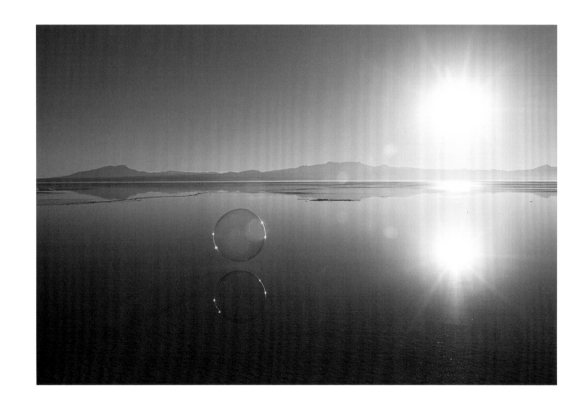

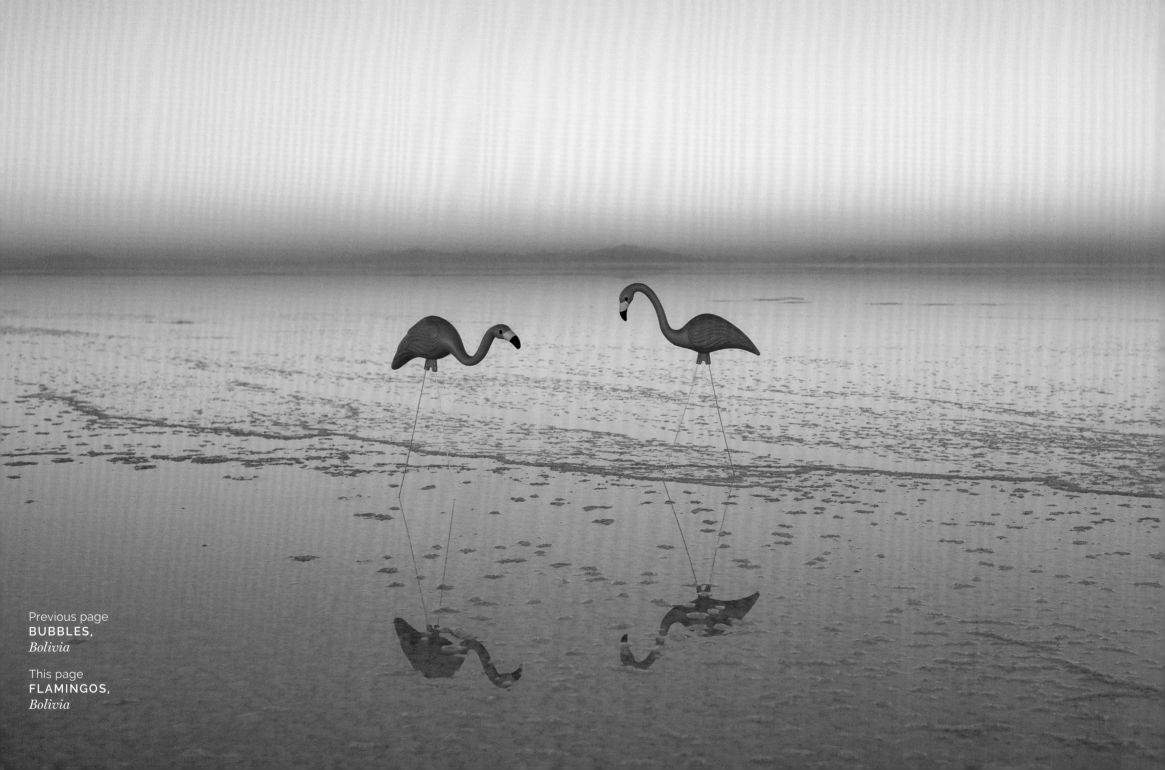

Previous page
BUBBLES,
Bolivia

This page
FLAMINGOS,
Bolivia

BORA BORA | NANTUCKET | MARTHA'S VINEYARD | HAWAII | WHITSUNDAY ISLANDS

ISLES

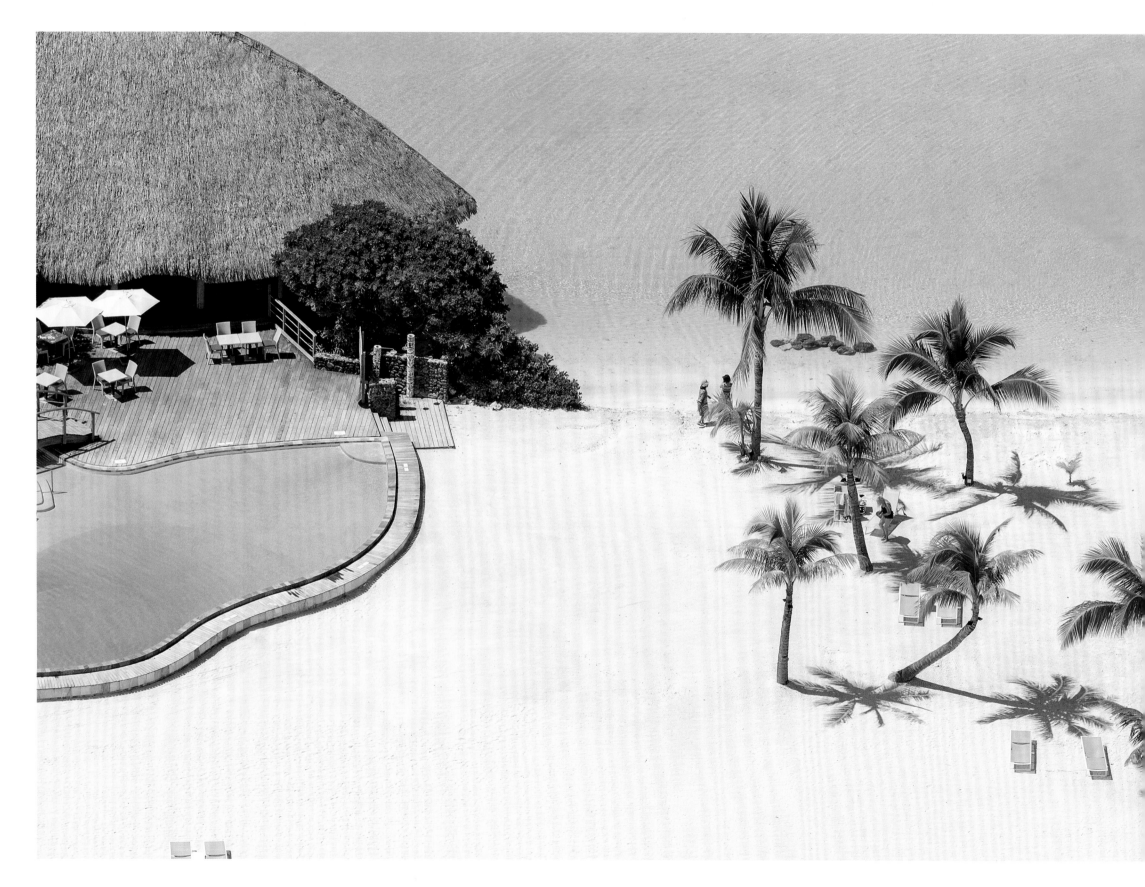

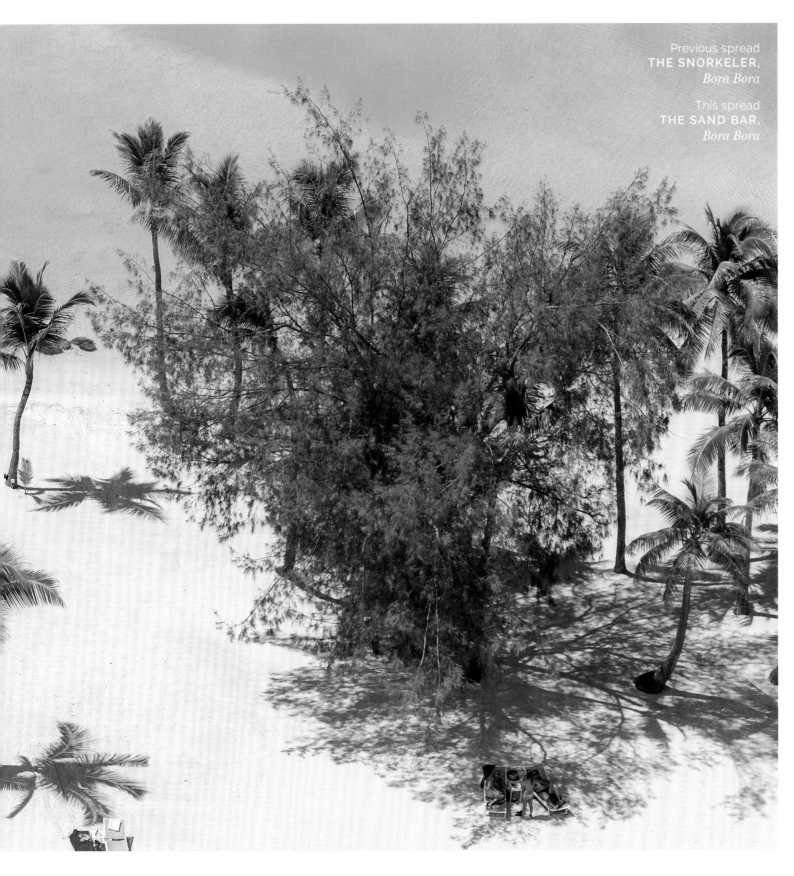

There is something truly magical about being on a piece of land that is completely surrounded by water. It is as if that physical break from a larger body of land provides an added mental break, helping a visitor to quickly adjust from their day-to-day life to their getaway.

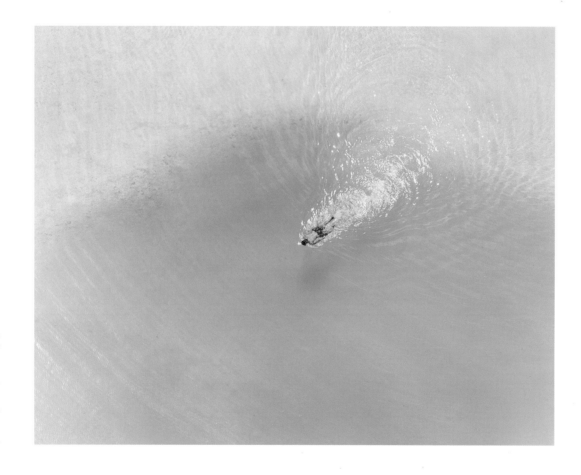

This page
**THE YELLOW
FIN SWIMMER,**
Bora Bora

Next page
MATIRA BEACH,
Bora Bora

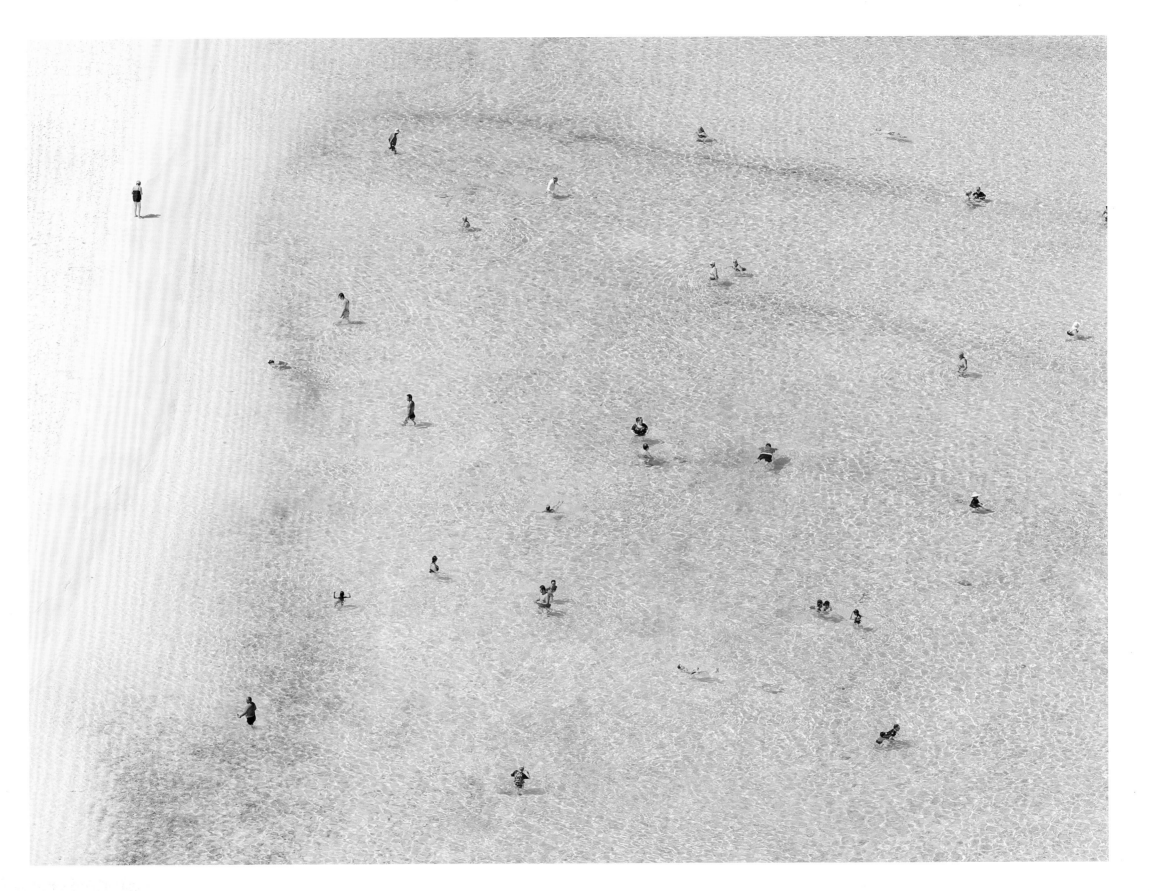

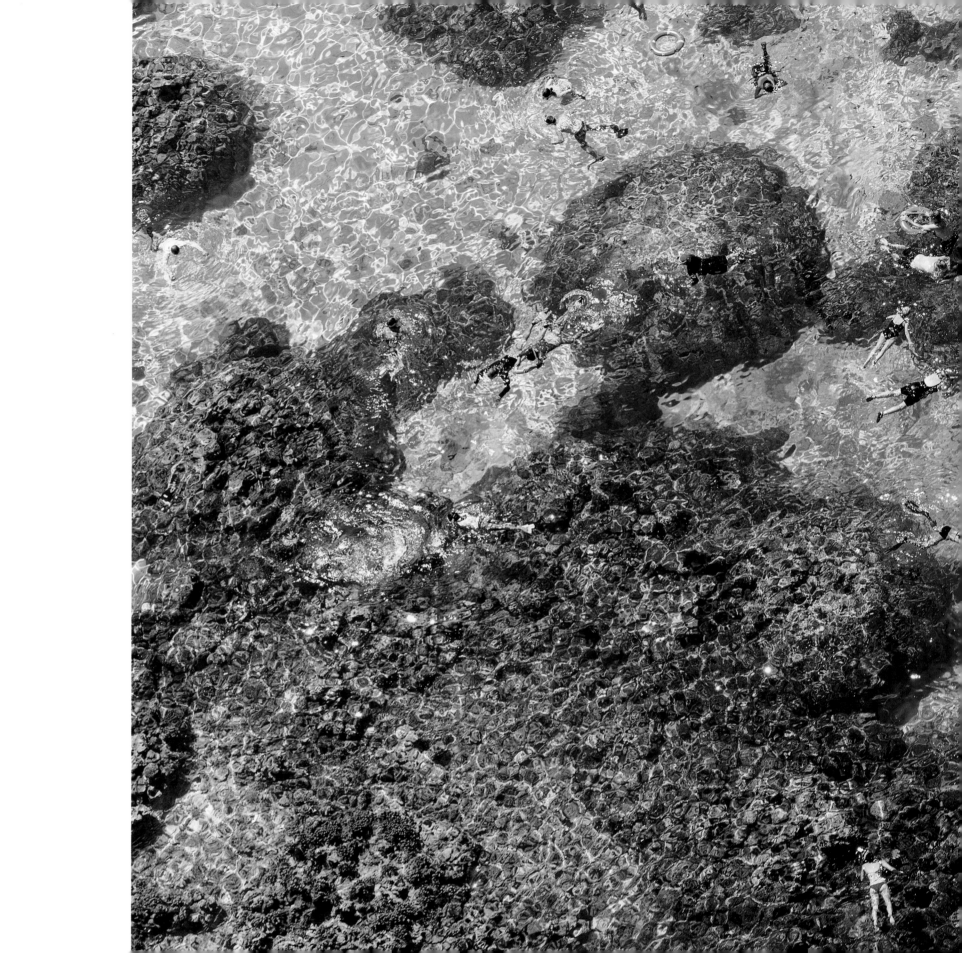

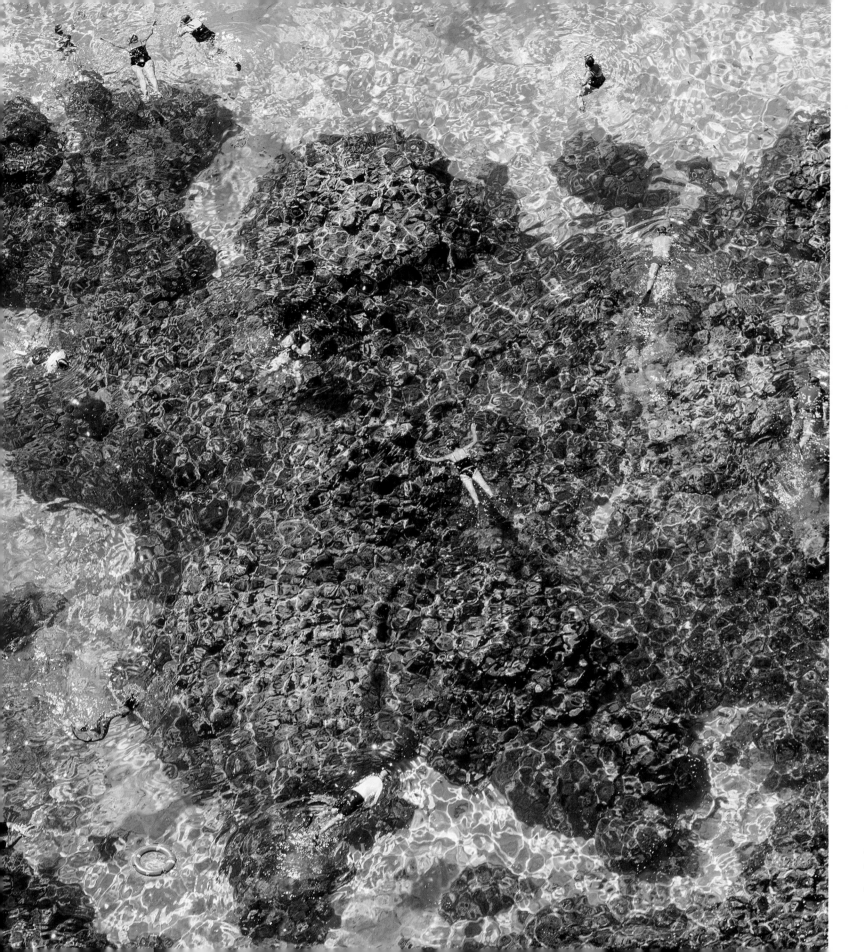

This spread
THE REEF,
Bora Bora

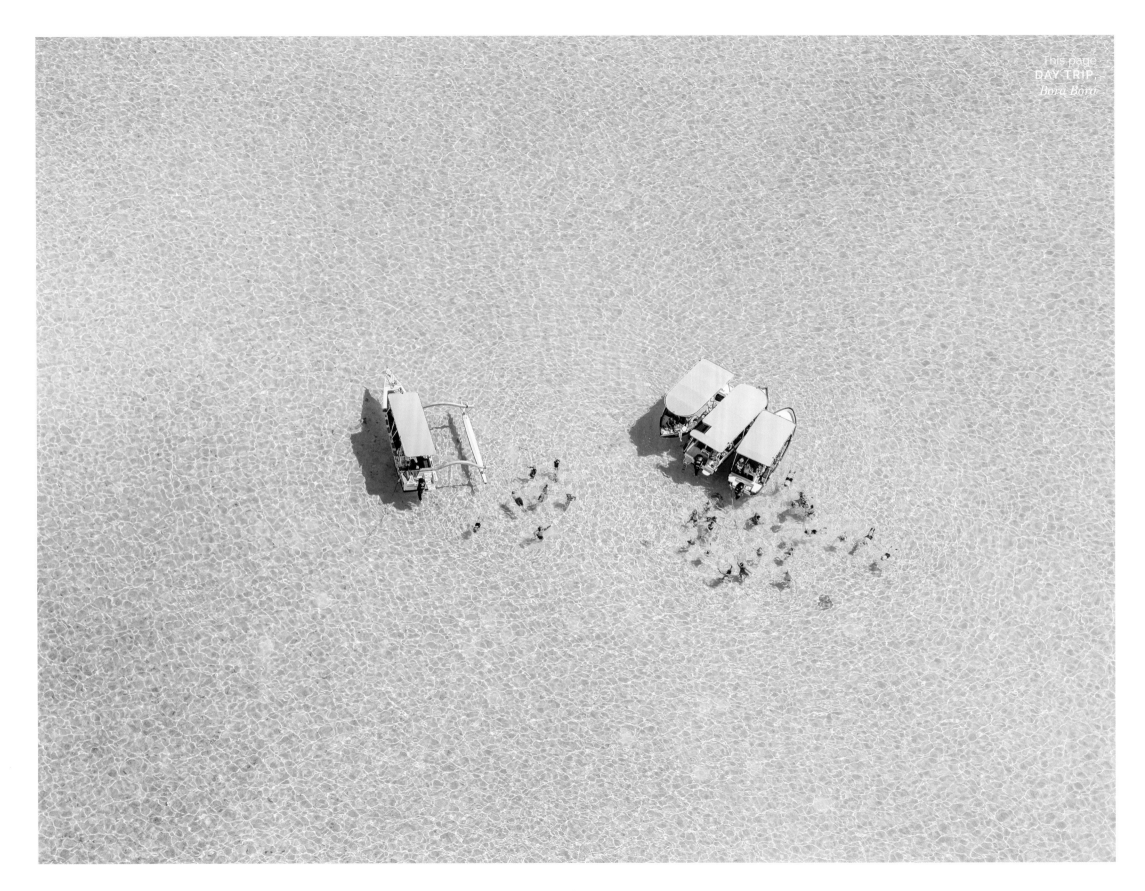

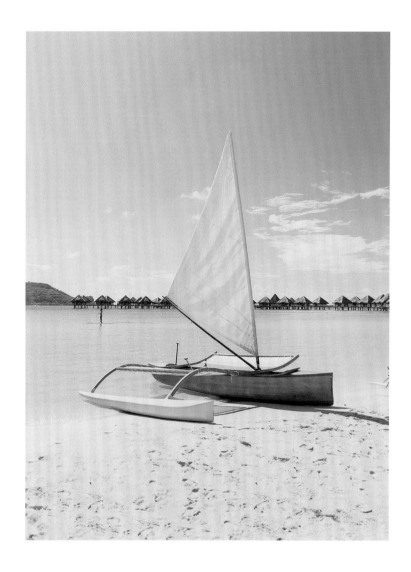

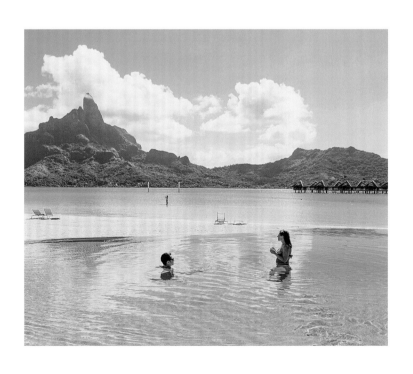

The Bora Bora aerials express
a calm tone, conveying a serene,
dreamlike quality that transports
you to paradise.

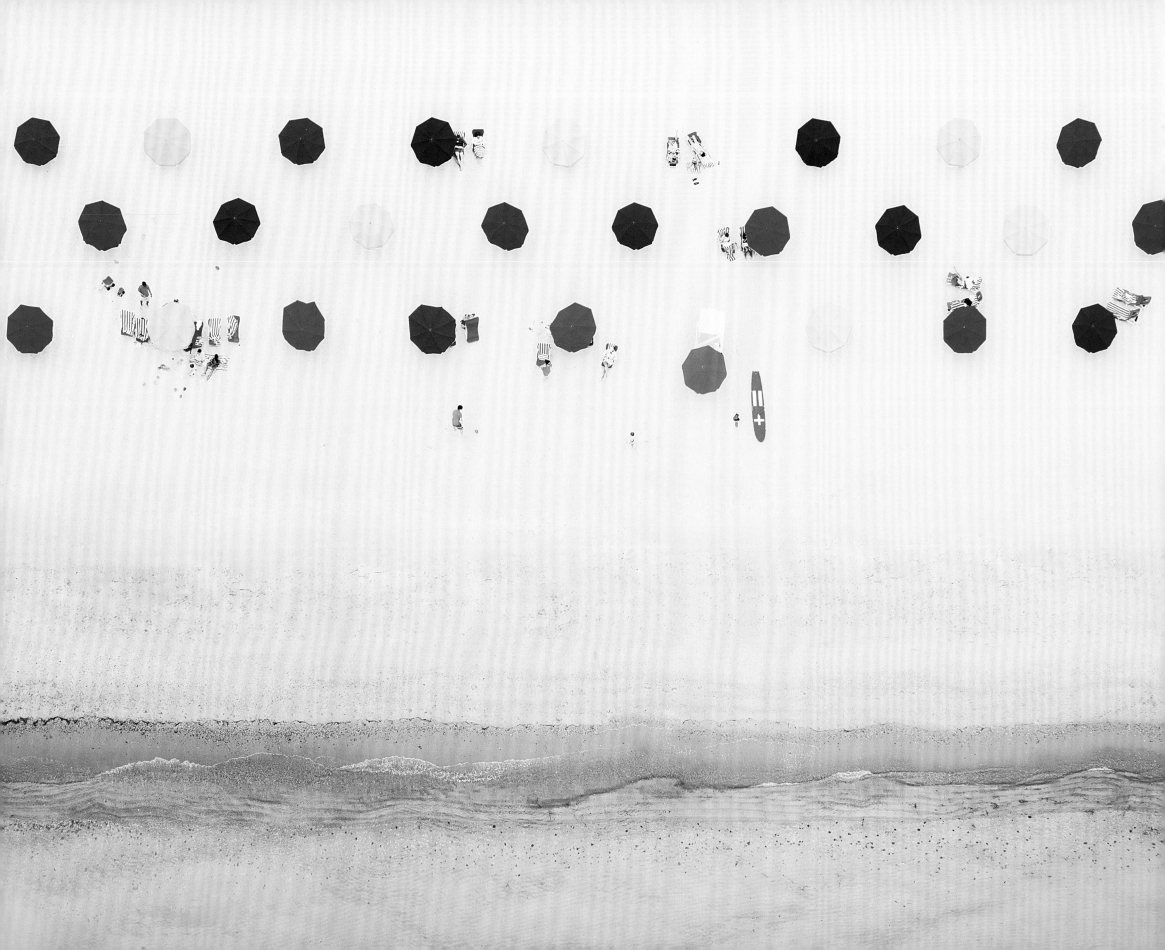

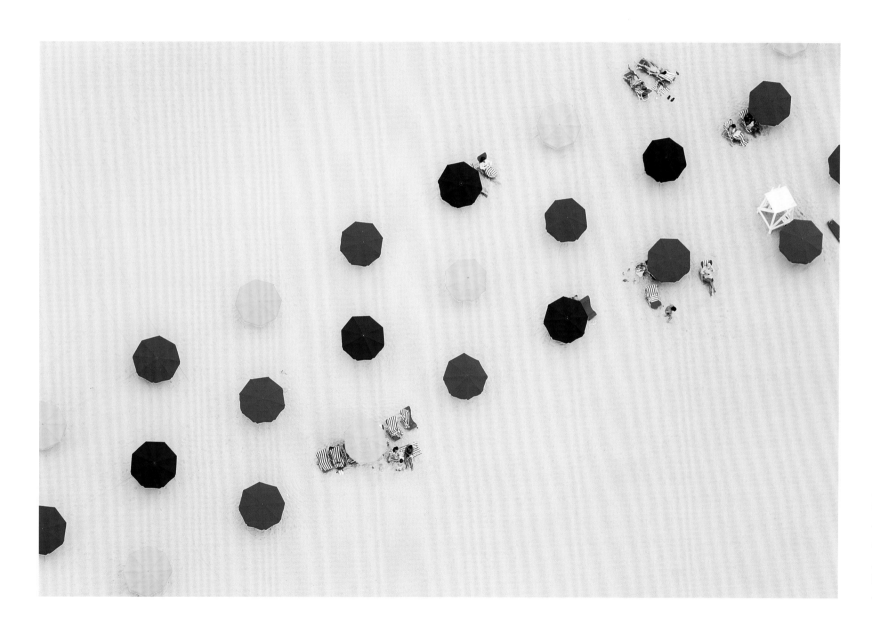

Previous page
**JETTIES
BEACH II,**
Nantucket

This page
**JETTIES
BEACH,**
Nantucket

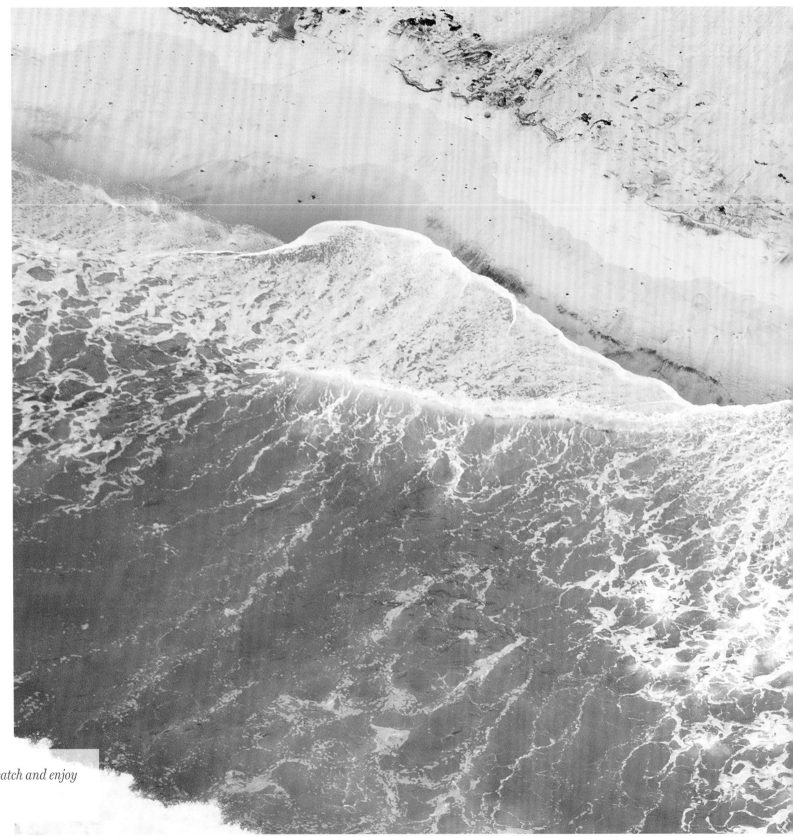

Martha's Vineyard

For a relatively small island, Martha's Vineyard is extremely rich in history as well as chock full of fun "must-sees and do's." If I were to recommend a few highlights to someone visiting the island for the first time, in no particular order, I would suggest the following:

Beach

- **Light House Beach in Edgartown -** This iconic beach is also a great place to go crabbing!

- **Aquinnah Beach -** Famous for its red cliffs, this beach is a must-see on Martha's Vineyard.

- **South Beach Bridge -** Dubbed "the *Jaws*" bridge and located at Joseph Sylvia State Beach, this is perfect for the film buff in us all, especially those who love scary movies! Take in some movie-magic history and visit the beach where *Jaws* was filmed.

Eat

- **Nancy's Restaurant -** Serving up tasty seafood since the 1960s.

- **Scoop Shack -** Literally, the best ice cream I've ever had. Cool Mint Oreo is 70 percent Oreo cookies and 30 percent Mint Chocolate Chip ice cream. Homemade daily!

- **The Atlantic Restaurant -** During the day they serve bacon at the bar instead of nuts or other bar snacks. People love it! Then, at night, it becomes a big bar scene. Definitely a happening spot to go any time of day.

Just Because

- **Menemsha -** Tucked at the western end of Martha's Vineyard, Menemsha is an old fishing village located in the town of Chilmark that is quintessentially New England.

Wherever you end up, just be sure to eat a lot of the local catch and enjoy this beautiful slice of American heaven.

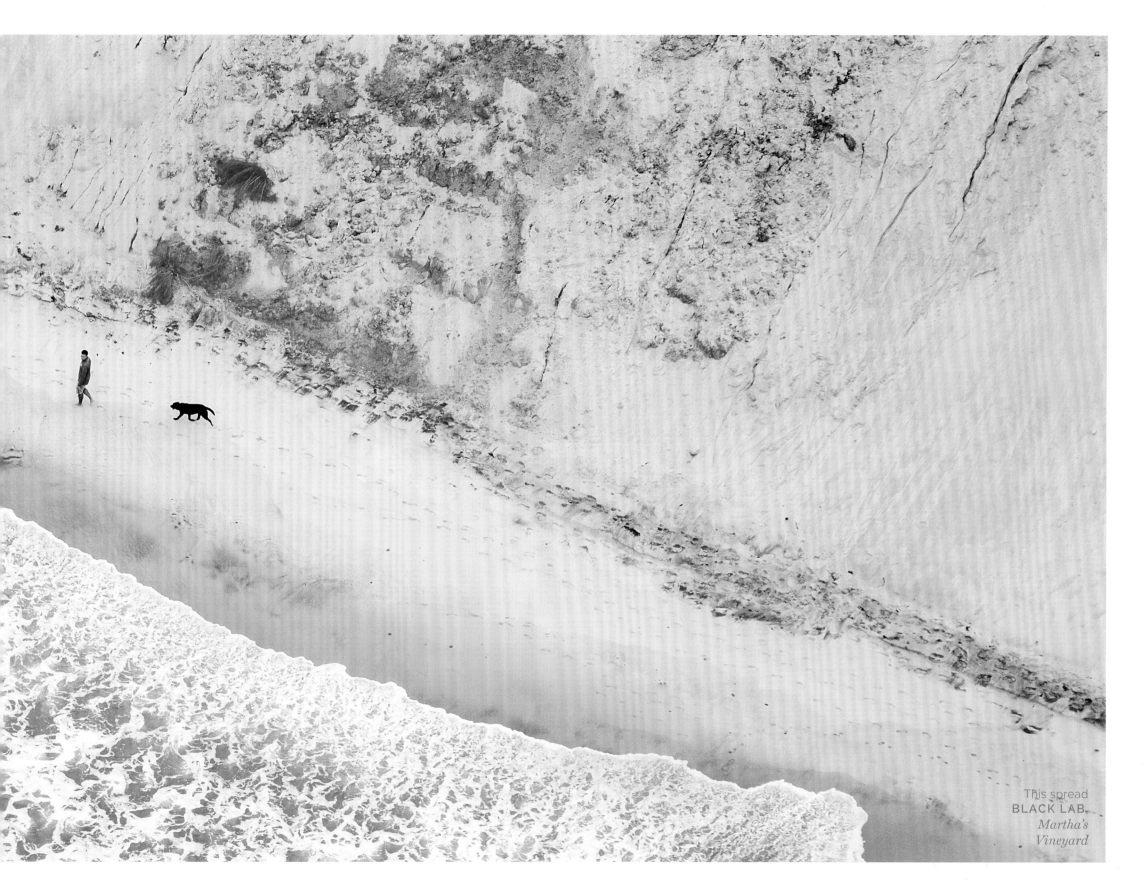

This spread
BLACK LAB,
*Martha's
Vineyard*

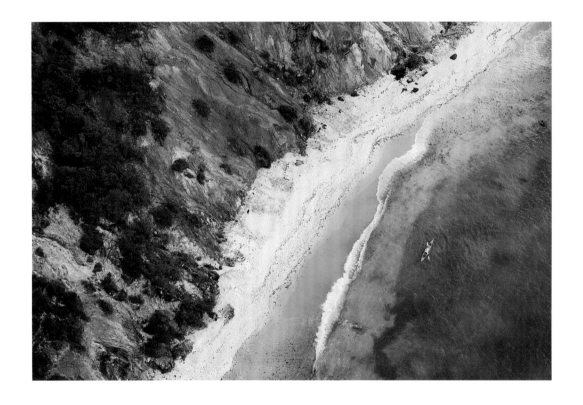

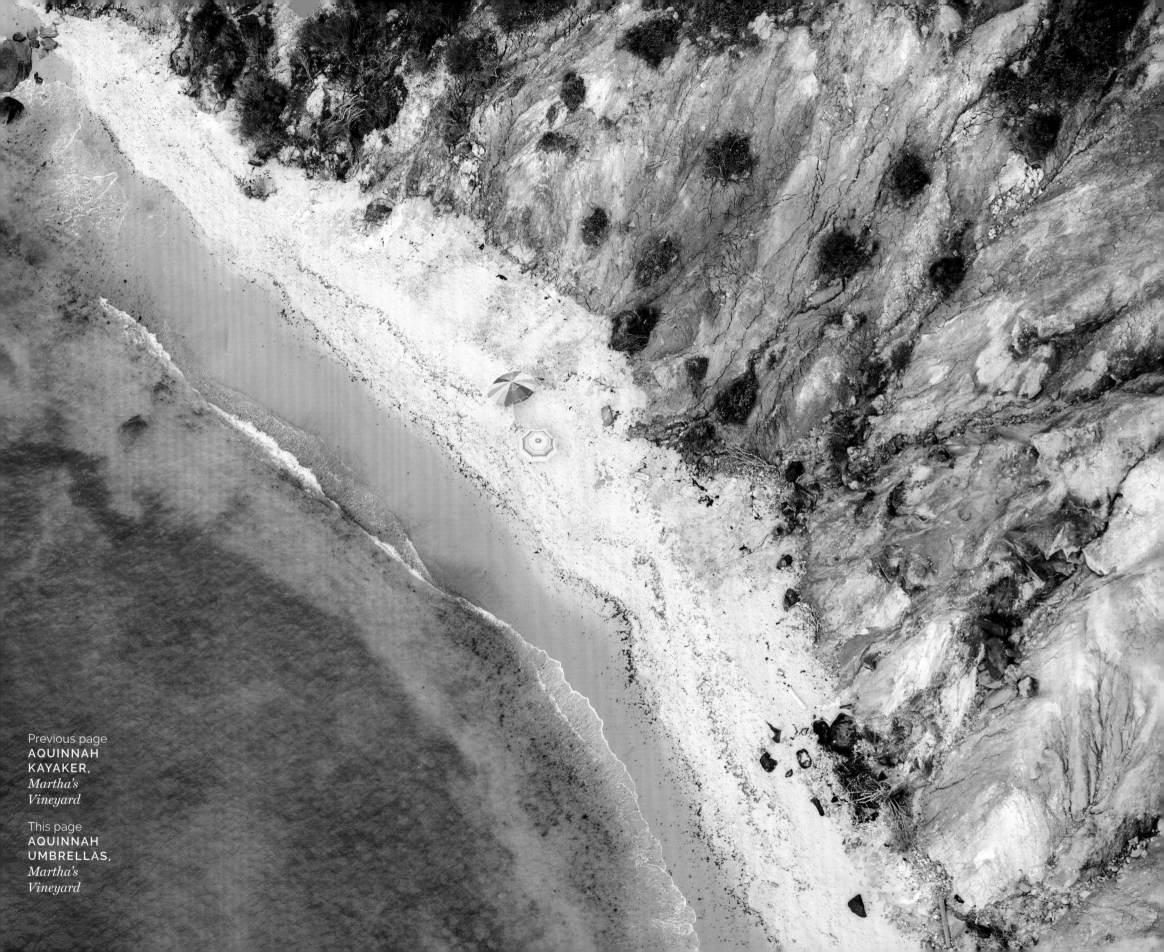

Previous page
AQUINNAH
KAYAKER,
*Martha's
Vineyard*

This page
AQUINNAH
UMBRELLAS,
*Martha's
Vineyard*

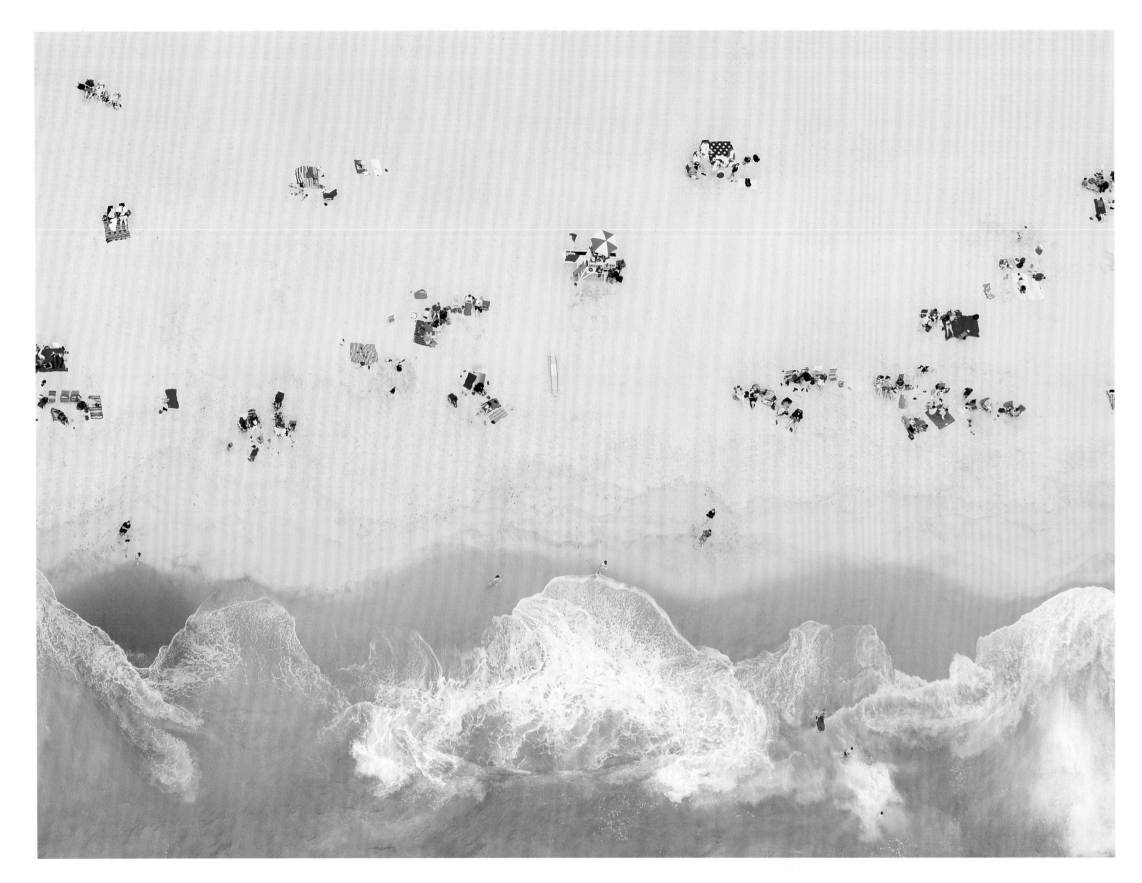

Previous page
SURFSIDE BEACH,
Nantucket

This page
OCEAN RAIN,
Nantucket

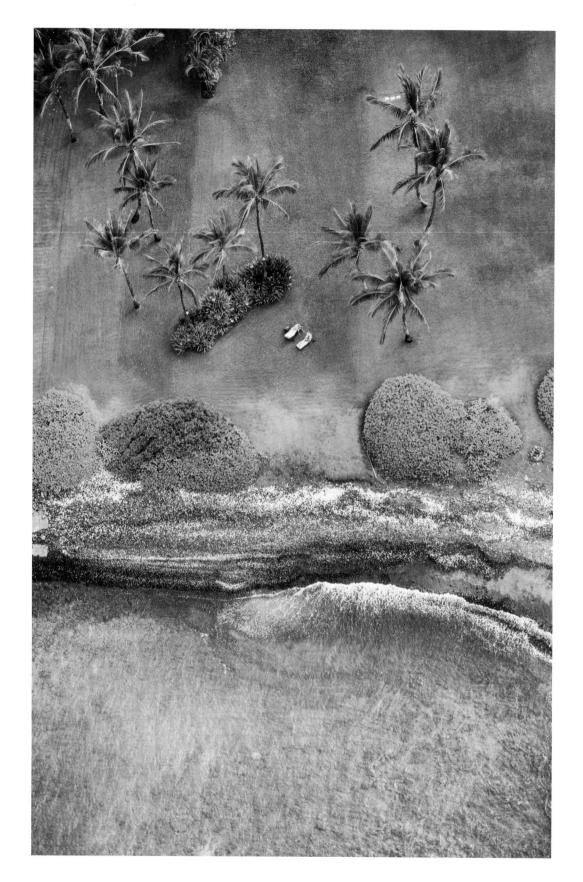

This page
BLACK SAND BEACH,
Maui

Next page
KAPALUA SUNBATHERS,
Maui

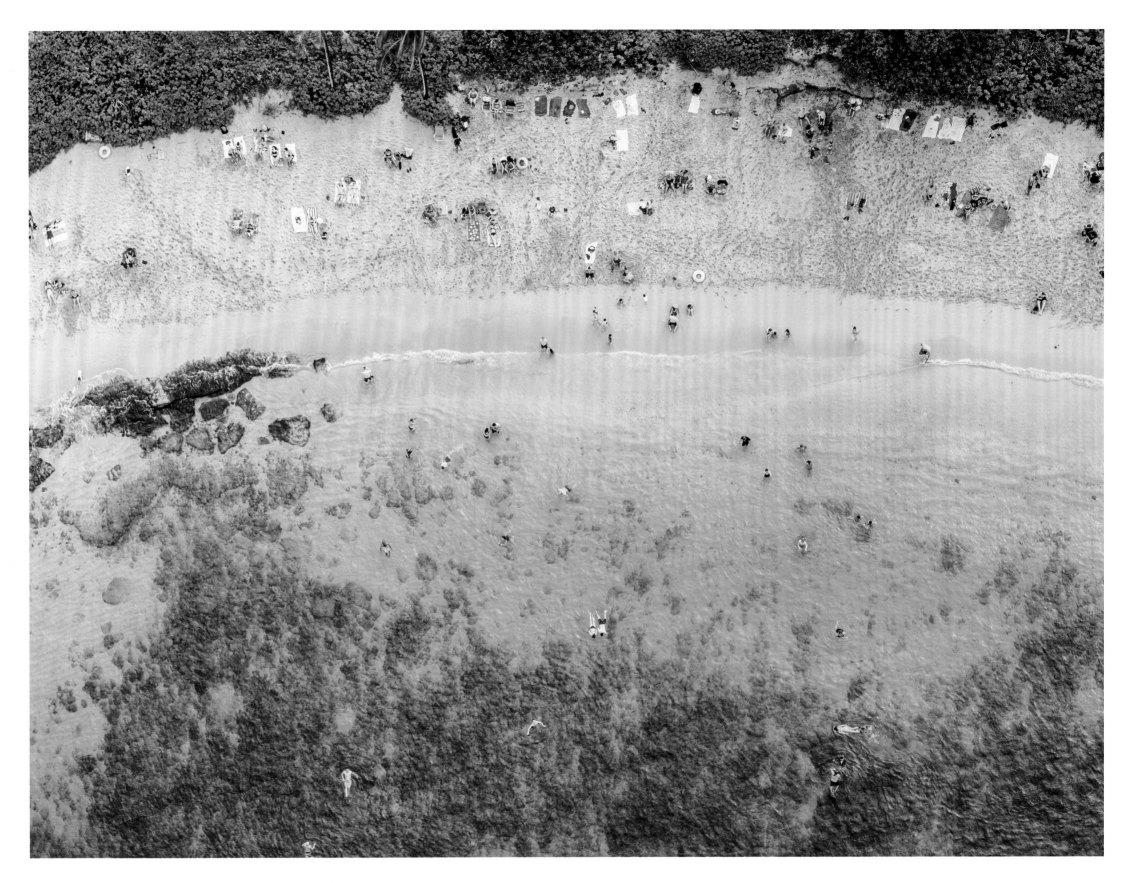

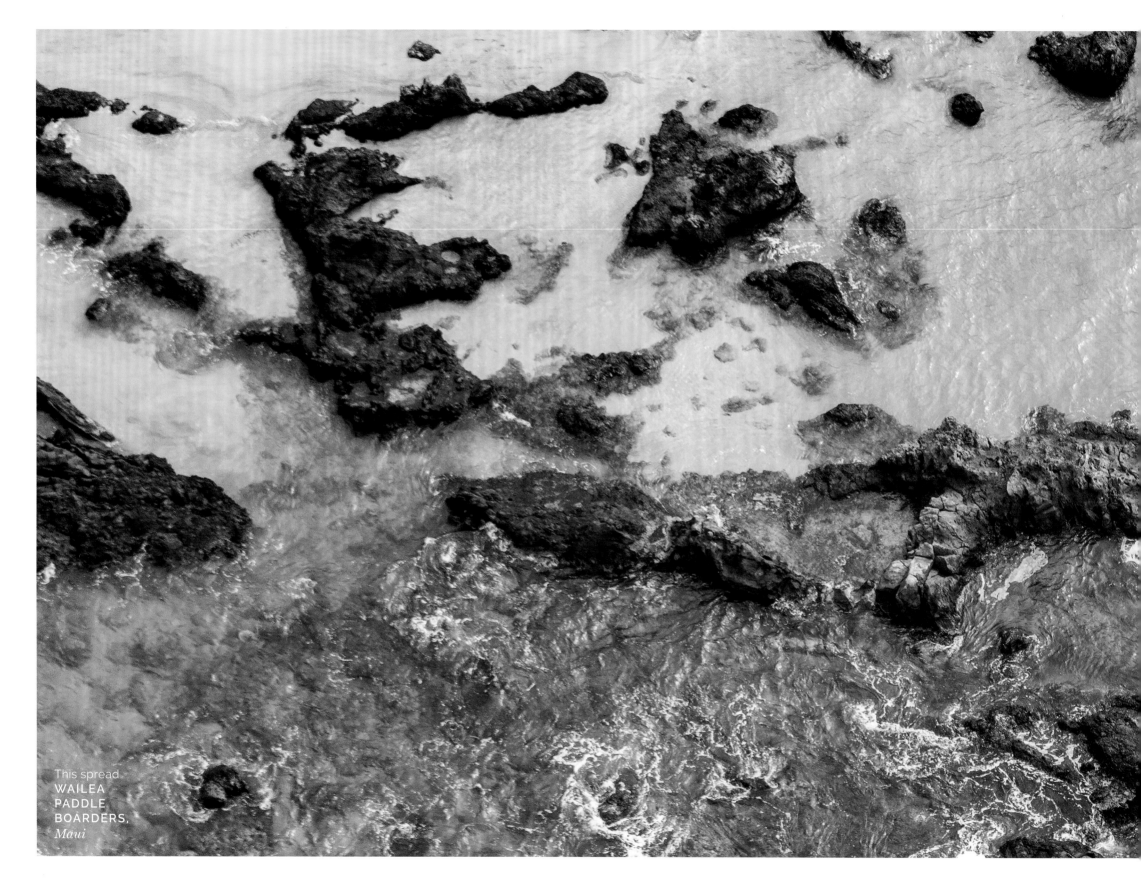

This spread
WAILEA
PADDLE
BOARDERS,
Maui

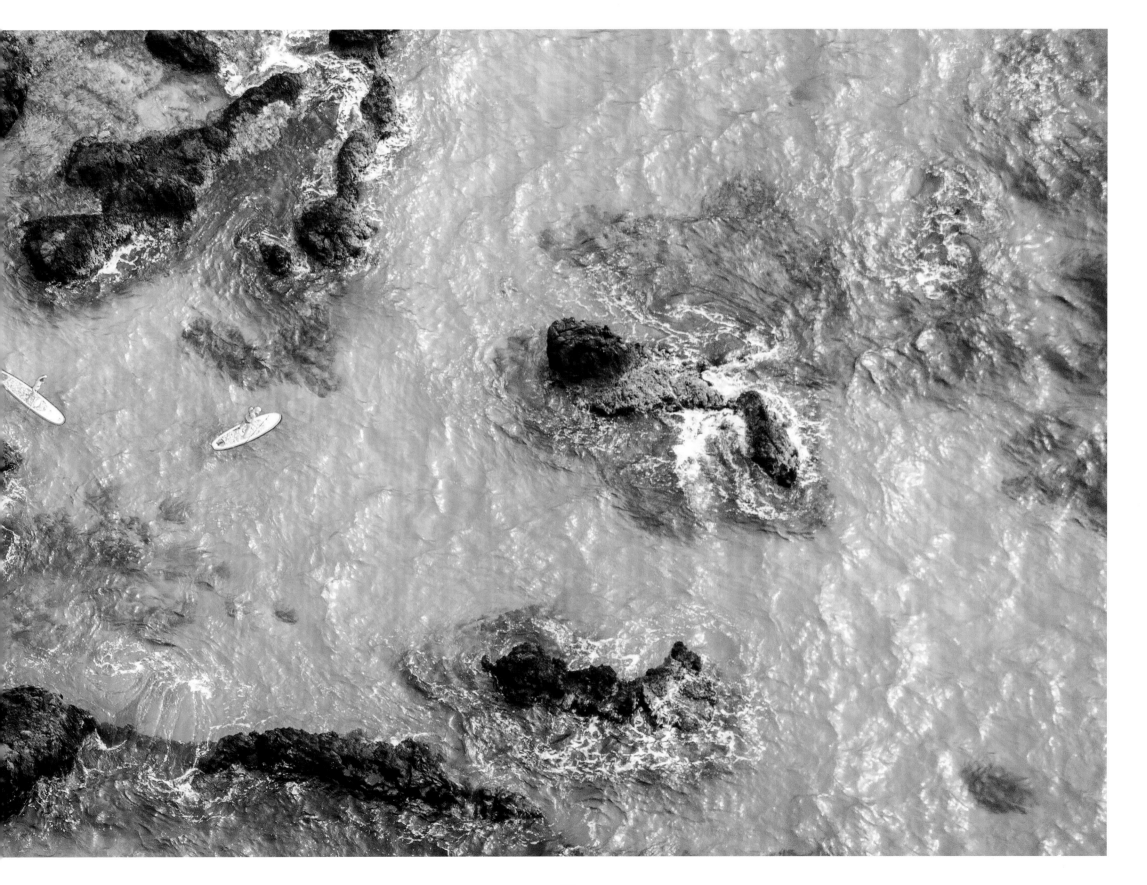

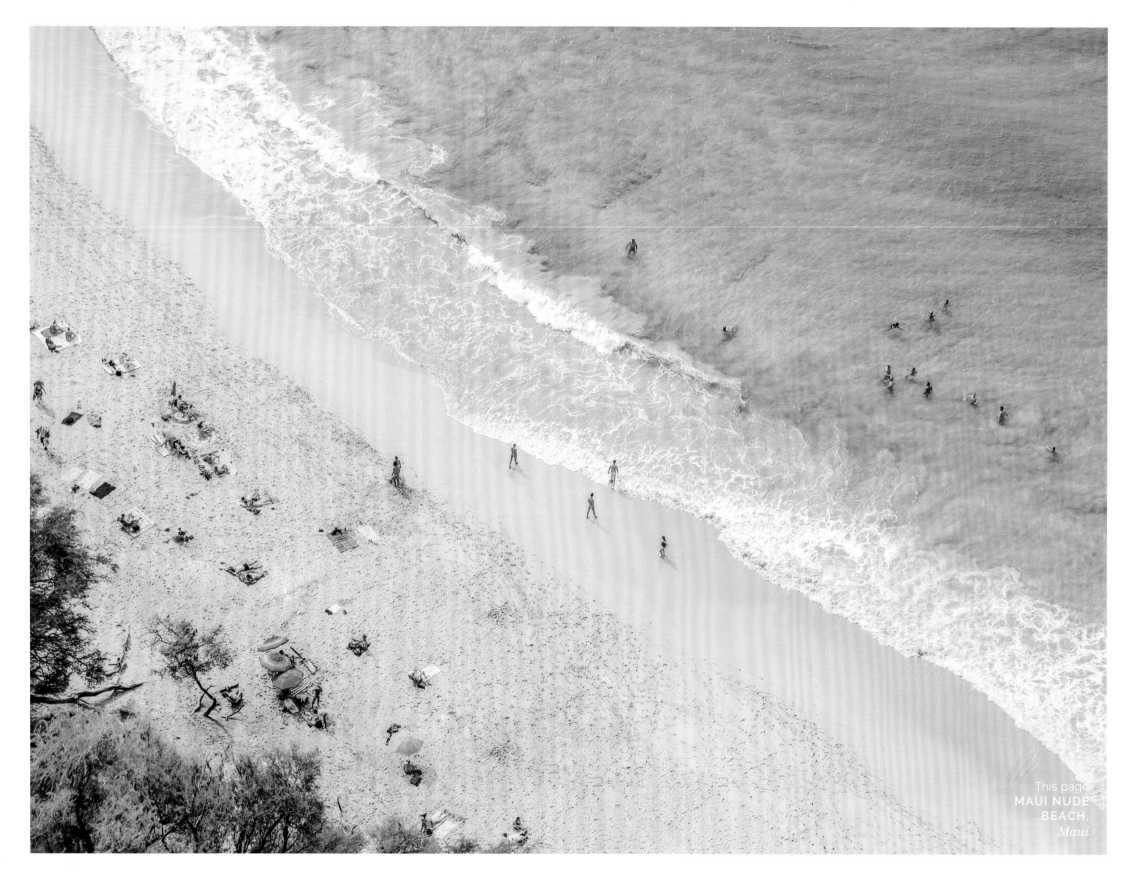

This page
MAUI NUDE
BEACH,
Maui

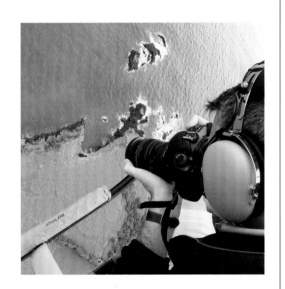

Flying above Maui, our pilot let me in on a secret: *"The beach below is a nude beach, but only on Sundays."* Taking a second to look, I realized that not only was it Sunday, but there was in fact a group of *nude swimmers* below us! Talk about a total escape.

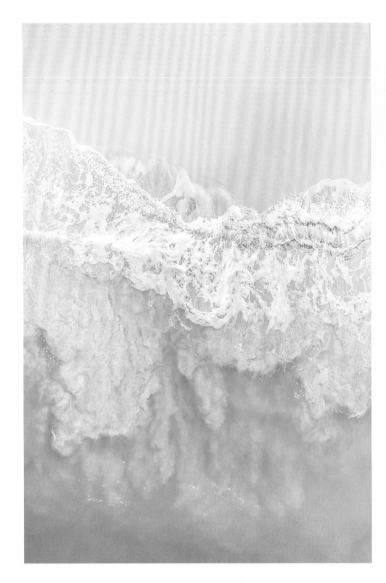
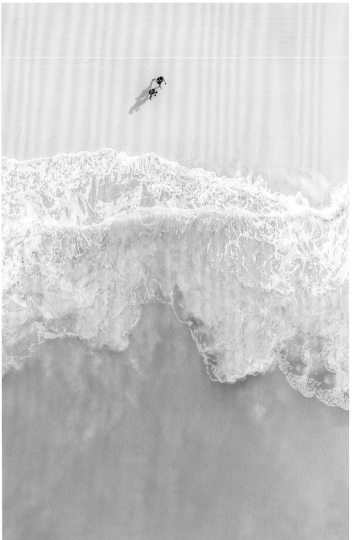
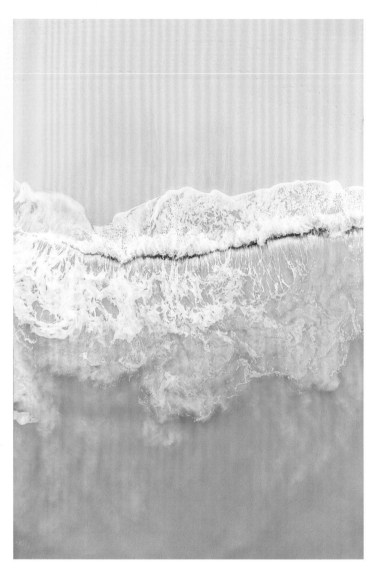

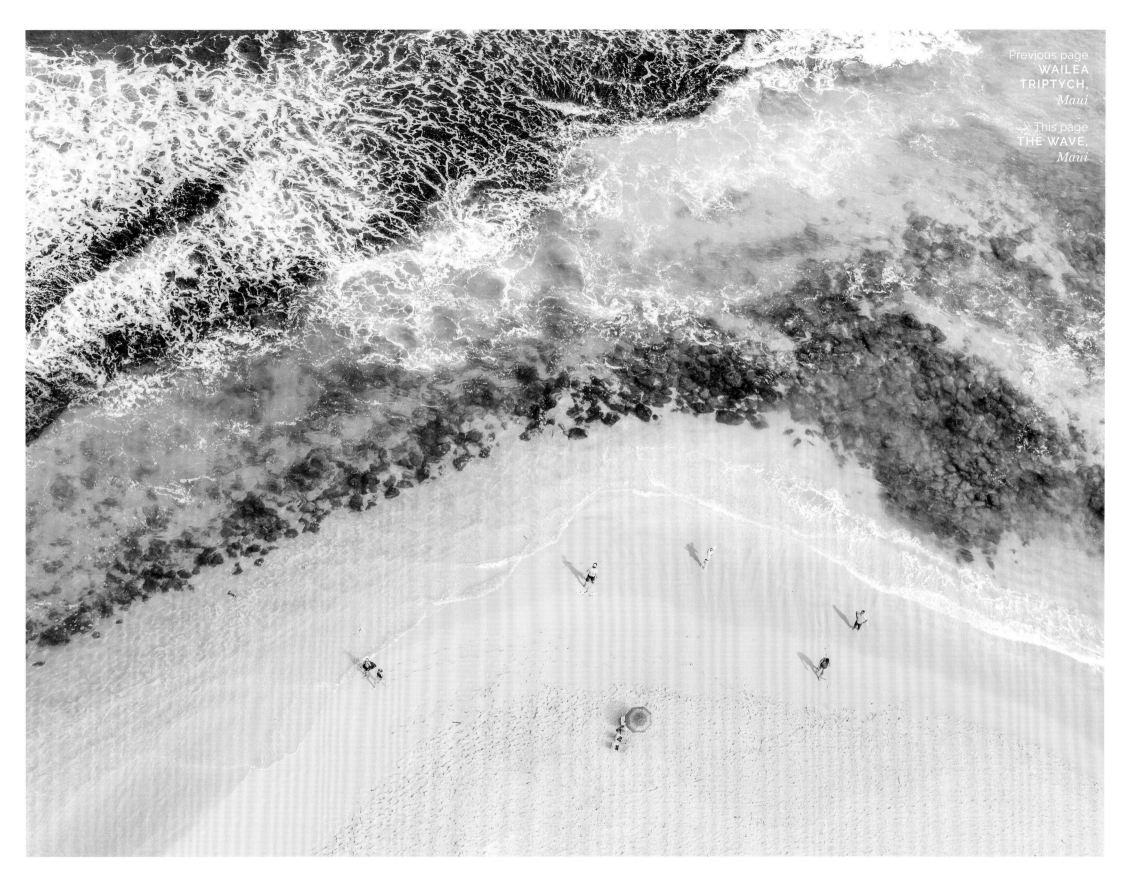

Previous page
WAILEA TRIPTYCH,
Maui

This page
THE WAVE,
Maui

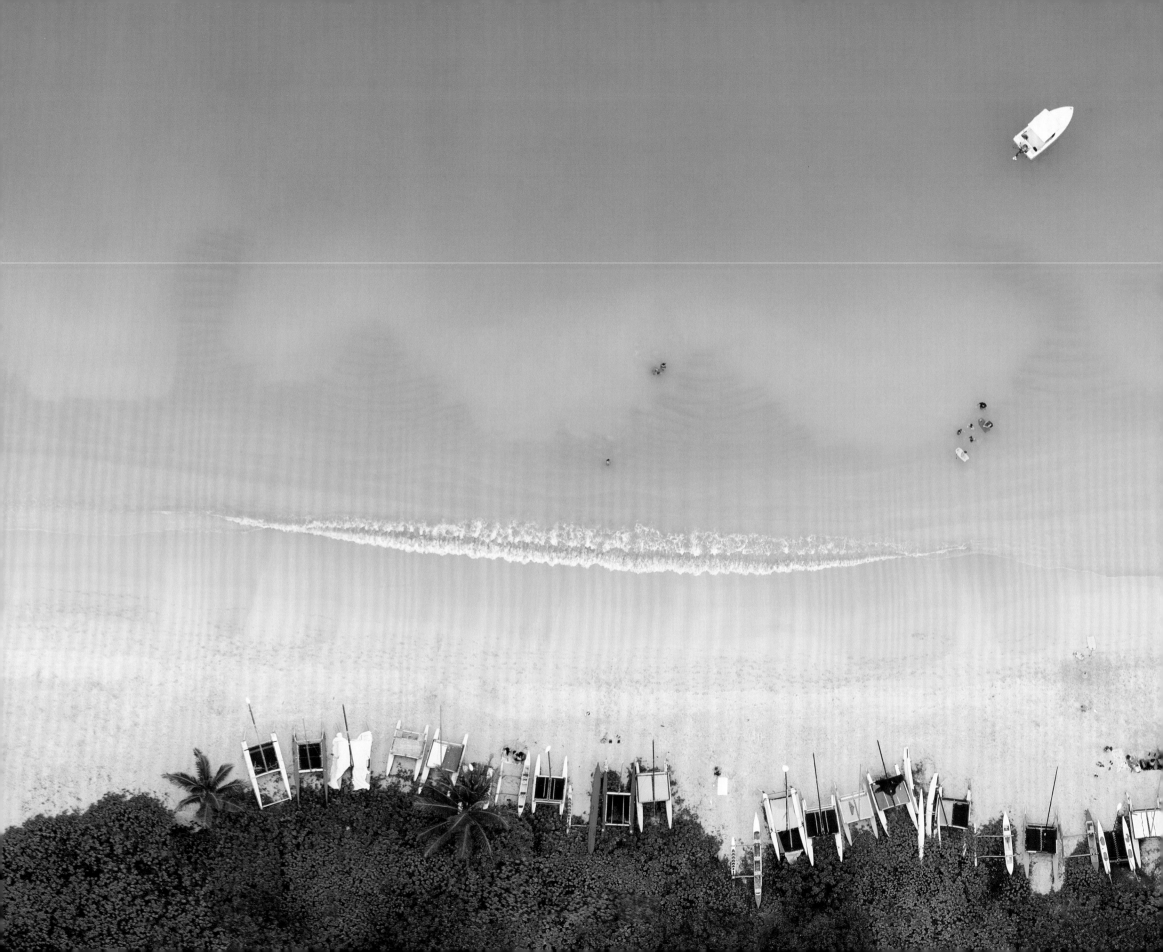

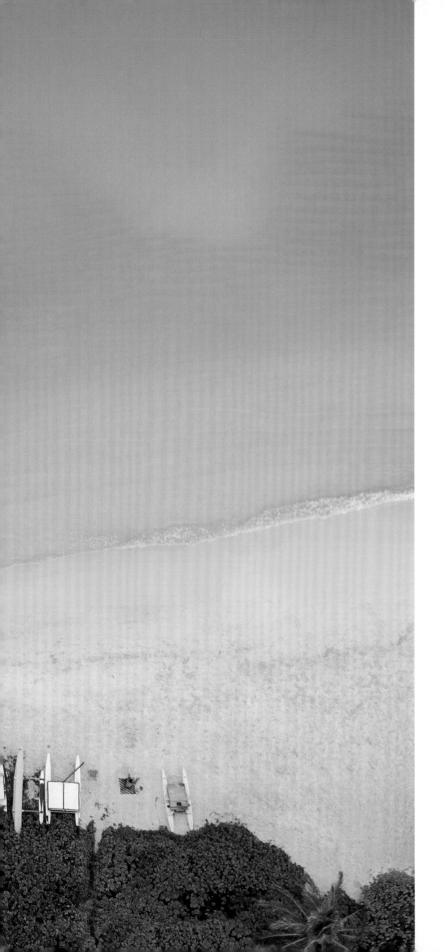

This spread
RAINBOW
SAILBOATS,
Oahu

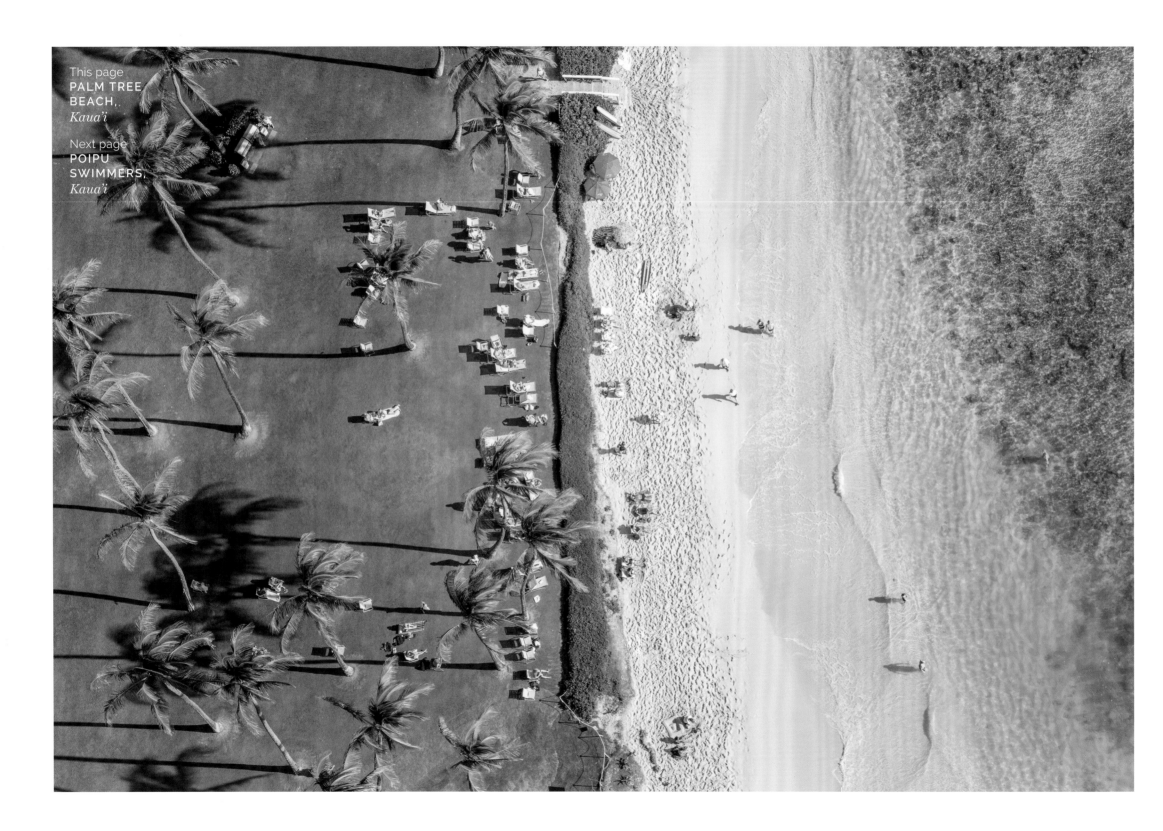

This page
PALM TREE BEACH,
Kaua'i

Next page
POIPU SWIMMERS,
Kaua'i

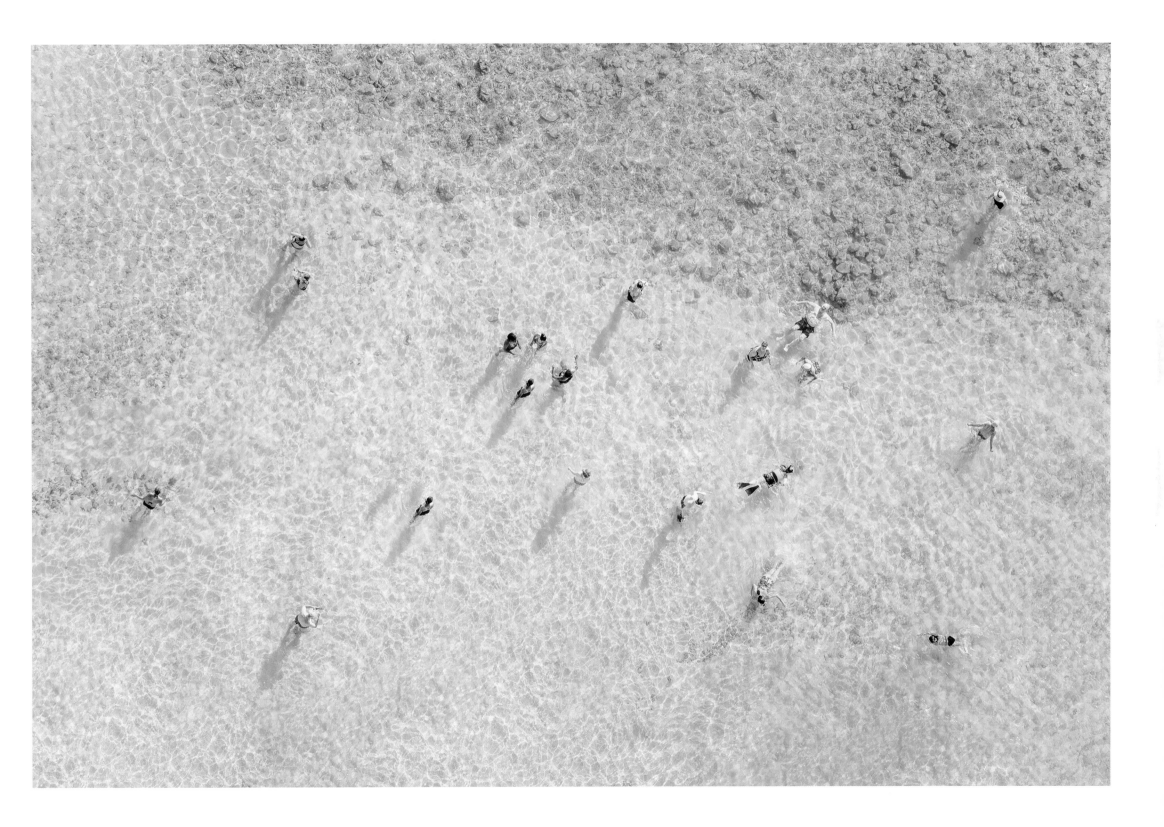

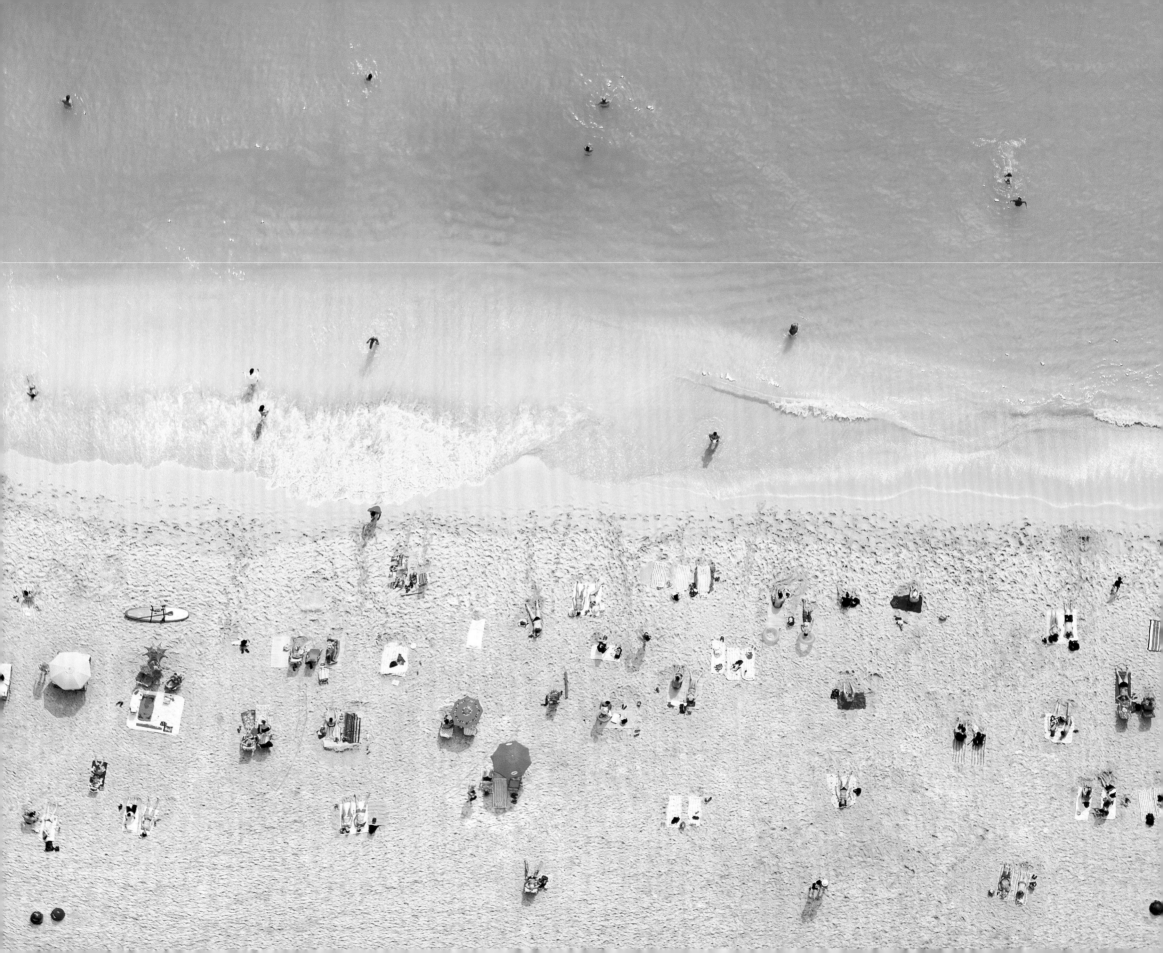

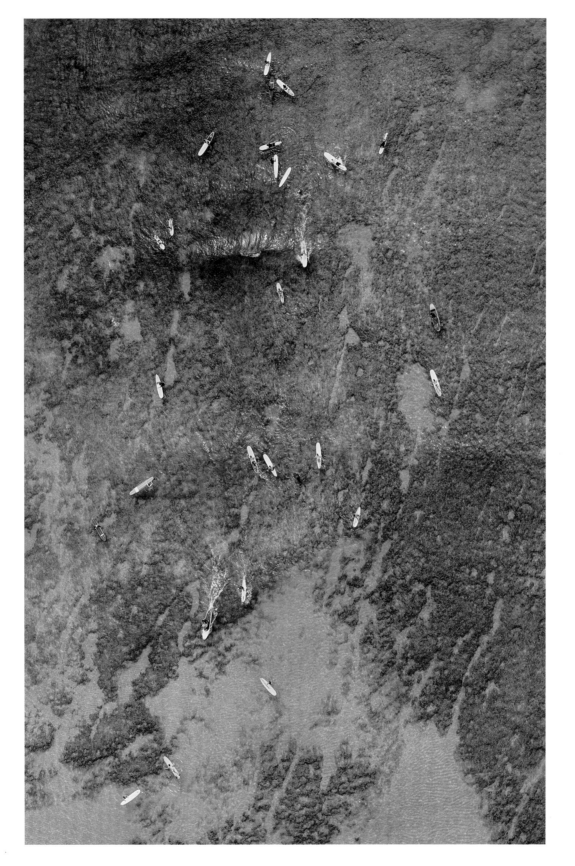

Previous page
WAIKIKI
BEACH,
Oahu

This page
WAIKIKI
SURFERS
VERTICAL,
Oahu

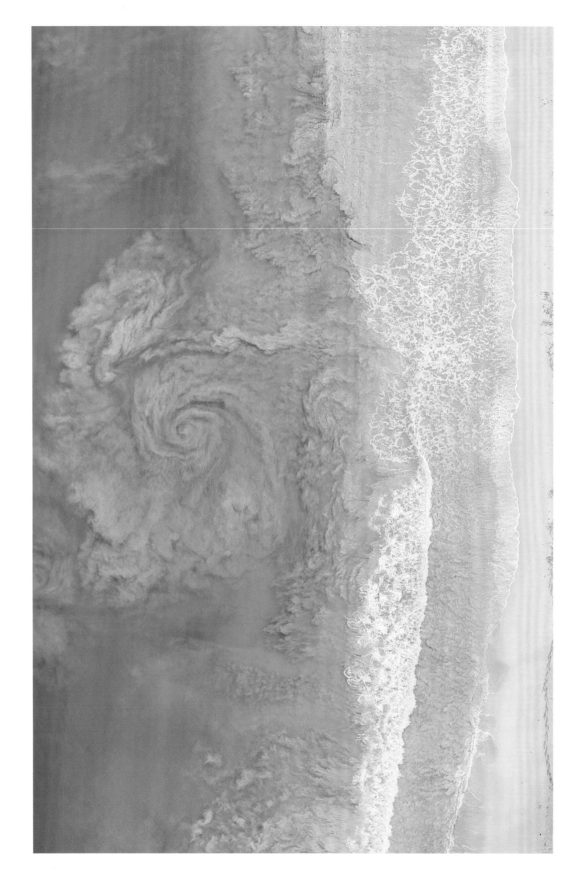

This page
KAILUA BAY SWIRL,
Oahu

Next page
WAIKIKI HORIZONTAL,
Oahu

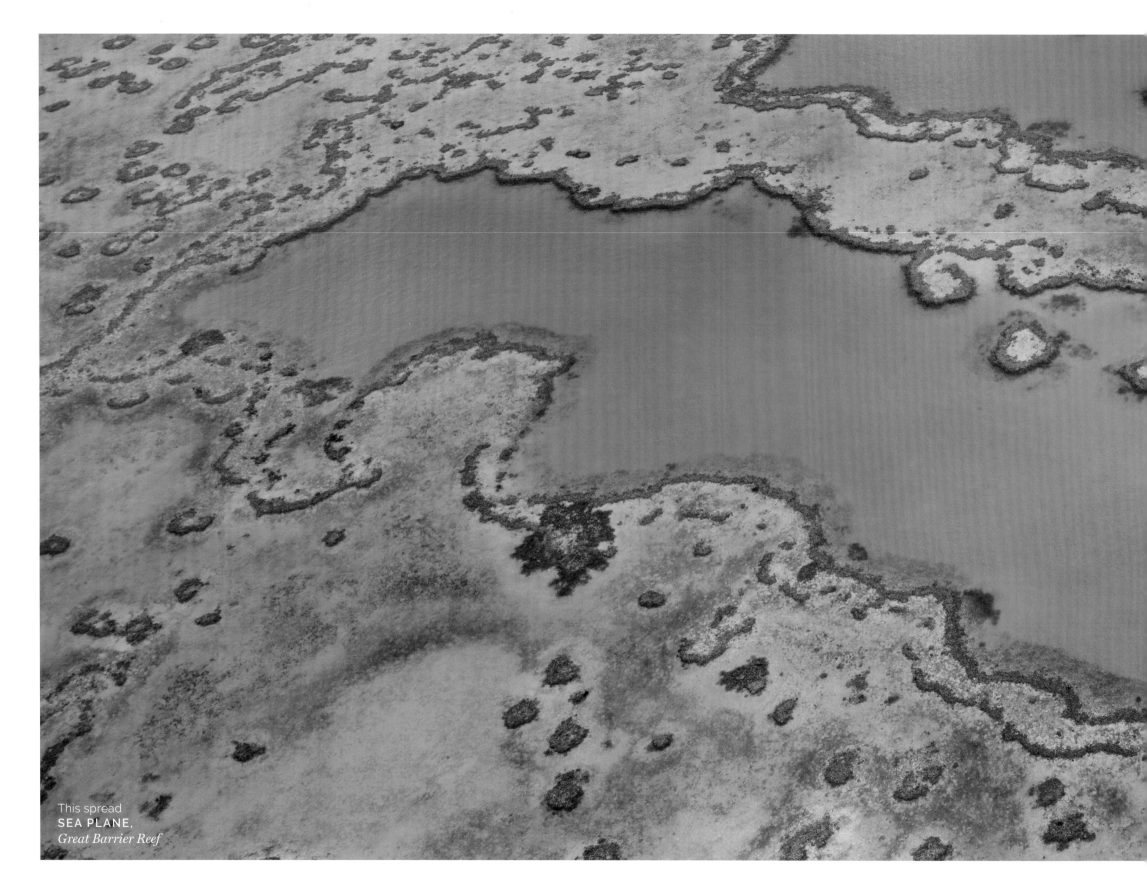

This spread
SEA PLANE,
Great Barrier Reef

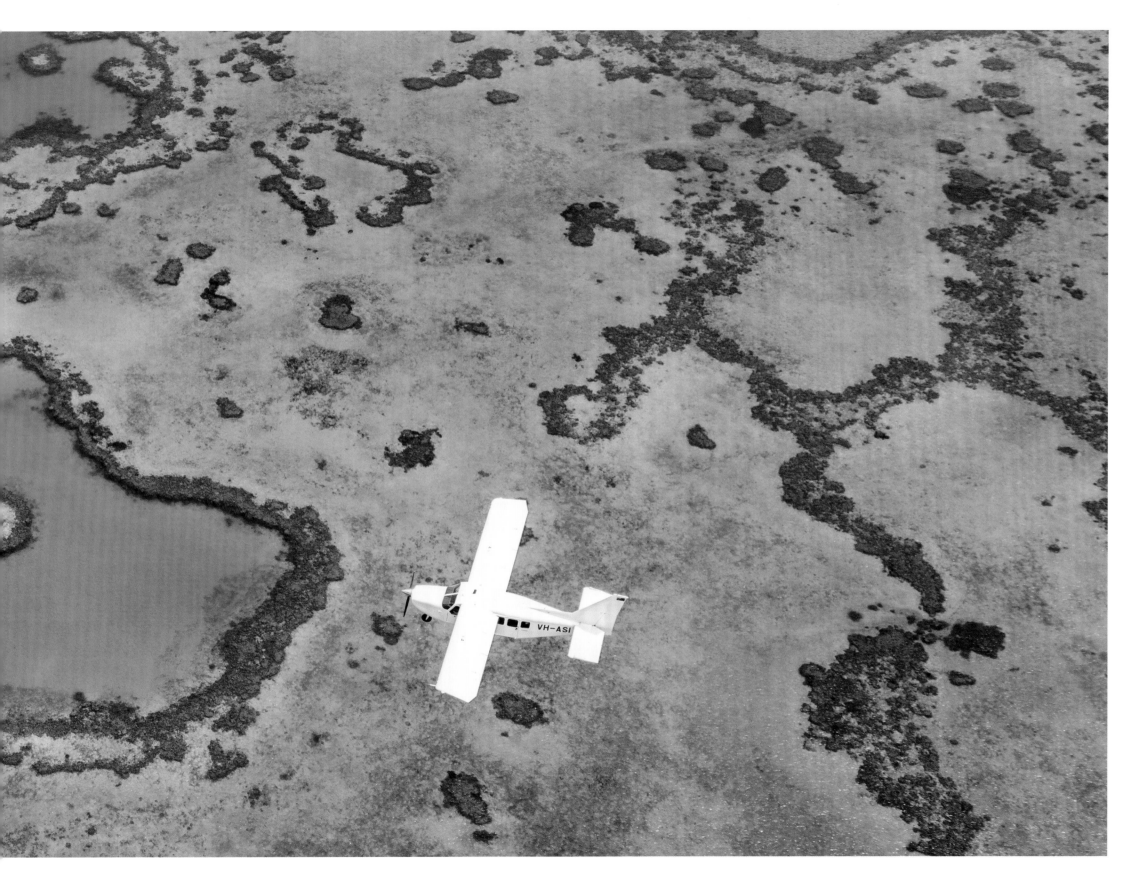

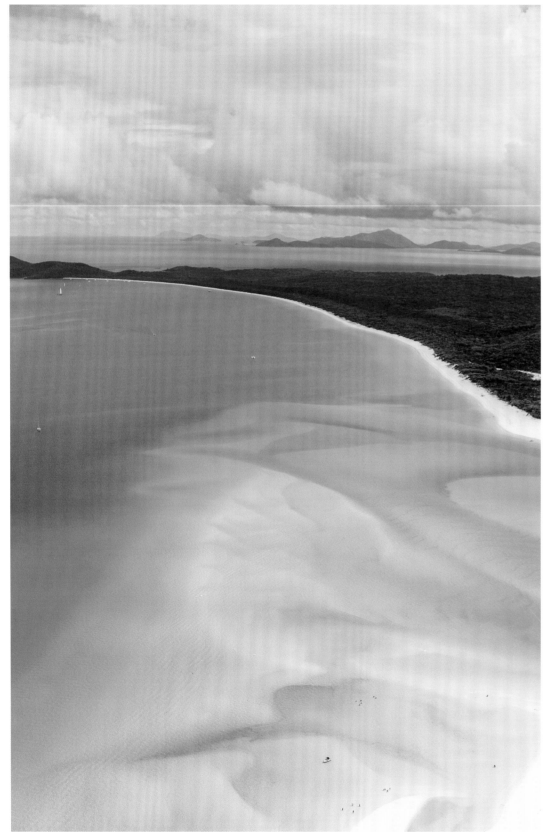
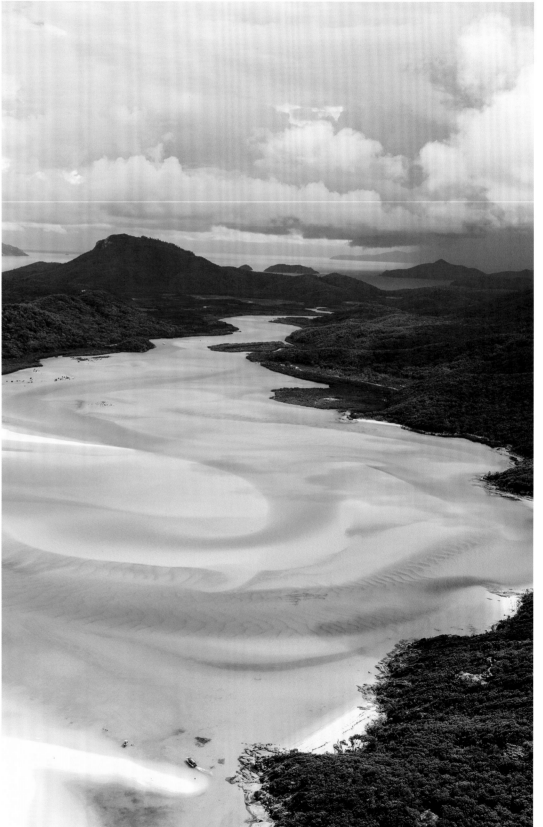

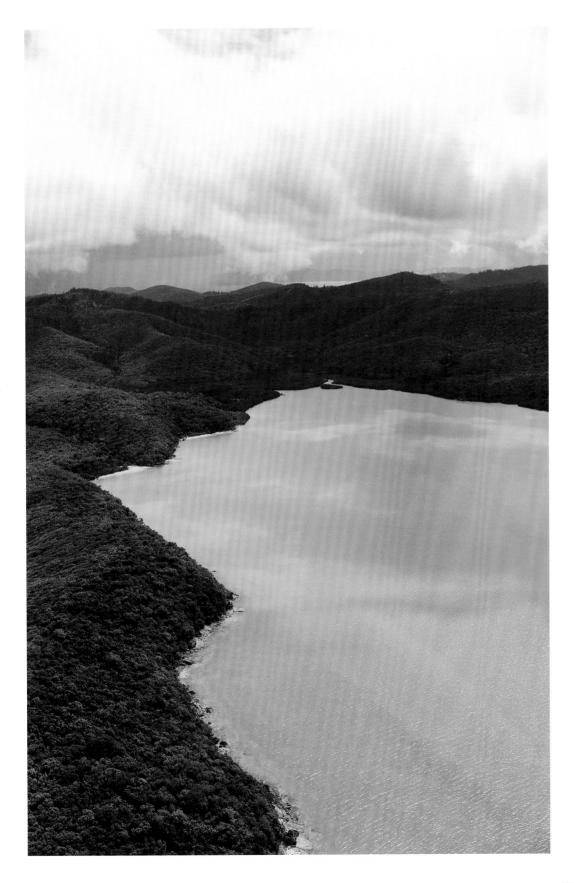

This spread
**WHITSUNDAY
ISLAND
TRIPTYCH,**
*Whitsunday
Islands*

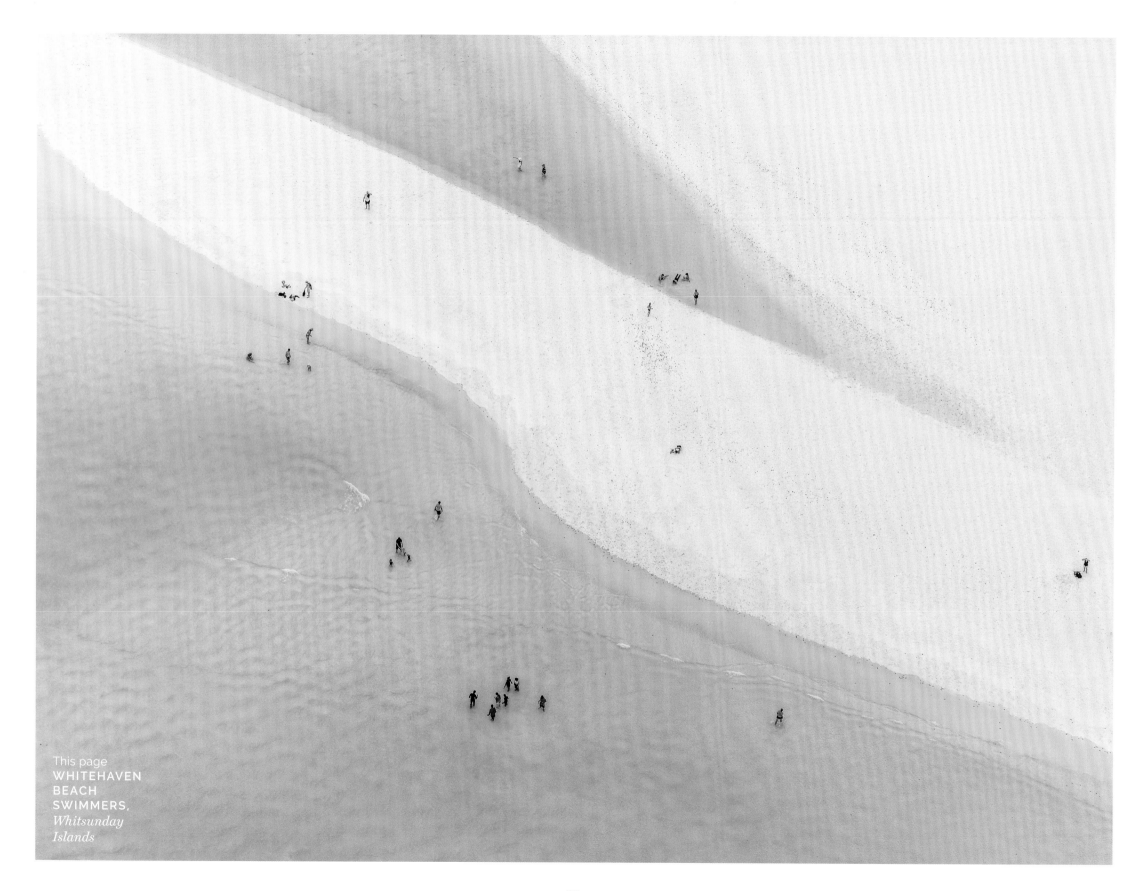

This page
WHITEHAVEN
BEACH
SWIMMERS,
*Whitsunday
Islands*

Located between Queensland, Australia, and the Great Barrier Reef, the **Whitsunday Islands** are home to the **Holy Grail of beaches, Whitehaven.** With its soft, unbelievably white sand and *swirly turquoise water*, it is simply *heaven on earth*. I recommend seeing Whitehaven by helicopter to witness the *tide shifting over the sand*, creating a striking mixture of beautiful aqua colors.

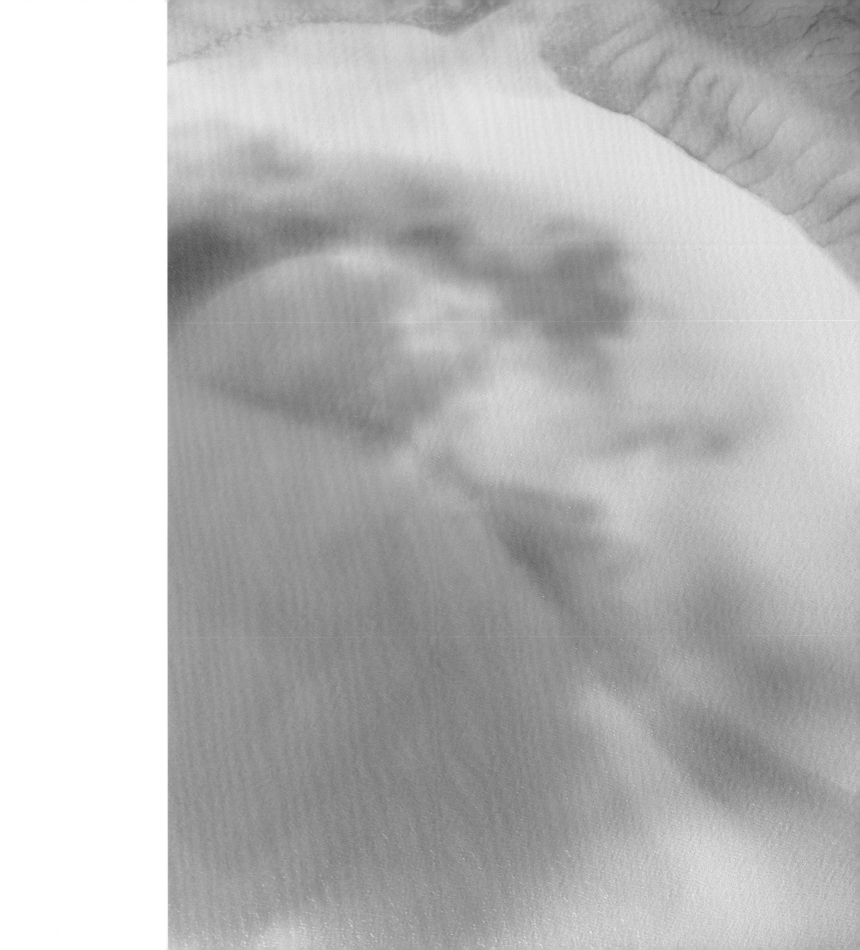

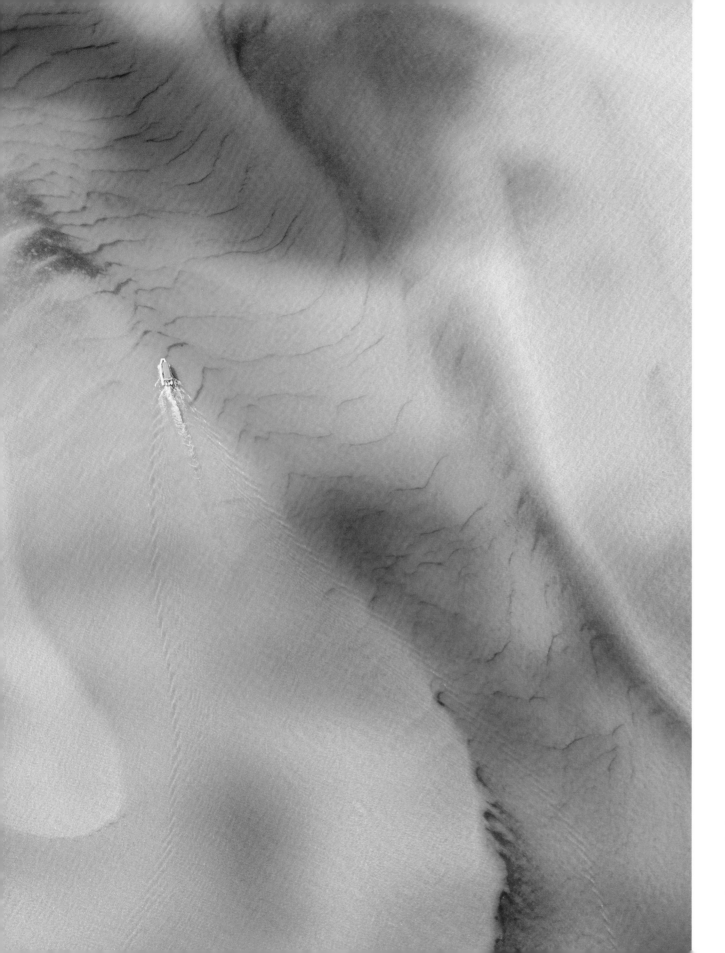

This spread
**WHITSUNDAY
ISLAND WAVES,**
*Whitsunday
Islands*

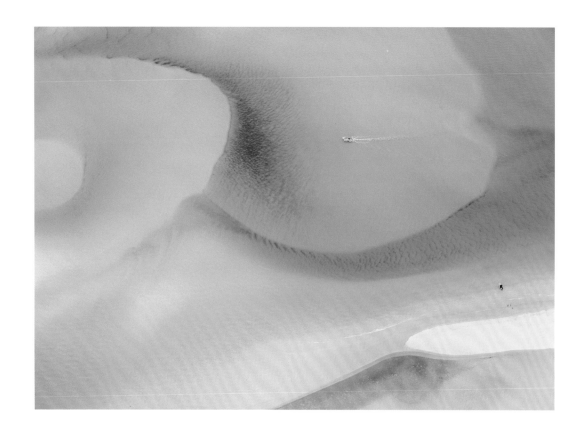

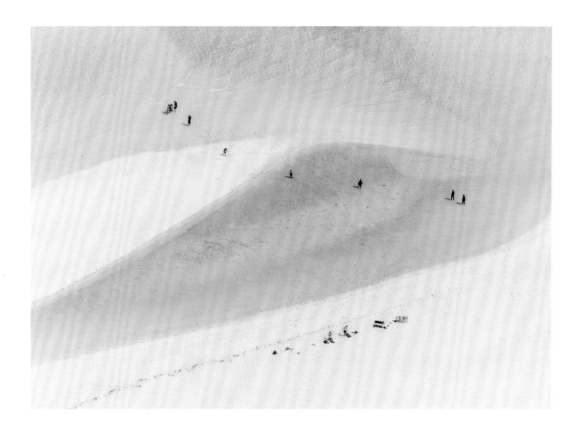

Previous page
AQUA WATER,
Whitsunday Islands

This page
**WHITEHAVEN
BEACH,**
Whitsunday Islands

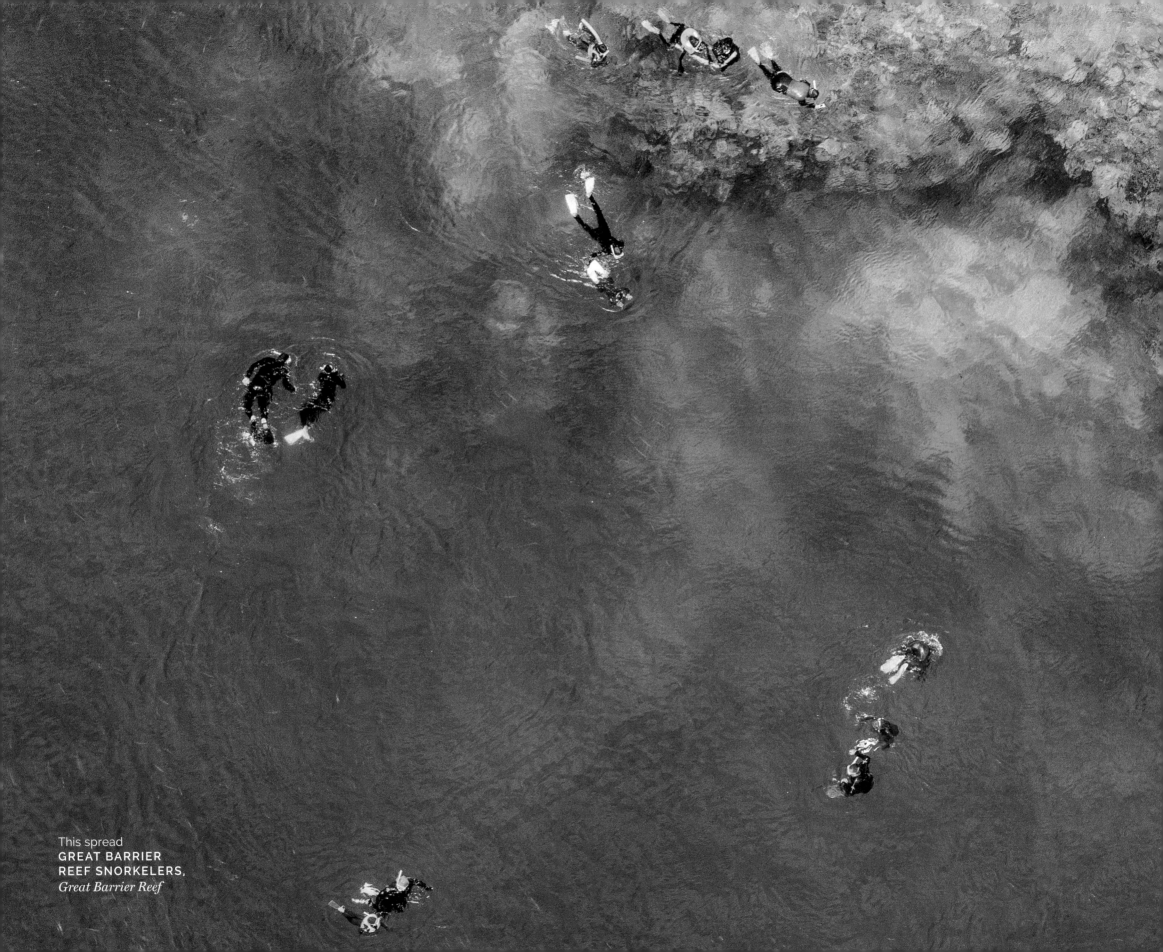

This spread
**GREAT BARRIER
REEF SNORKELERS,**
Great Barrier Reef

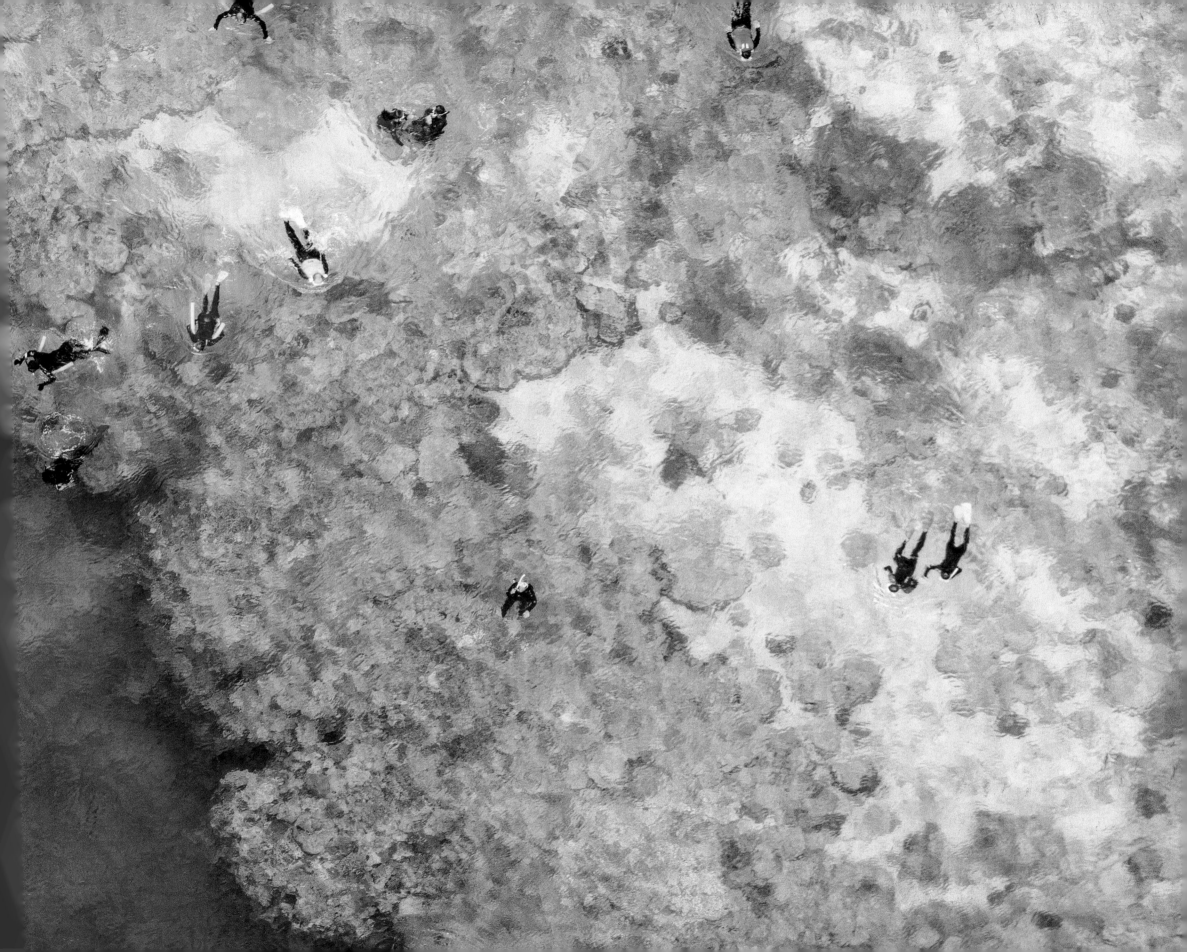

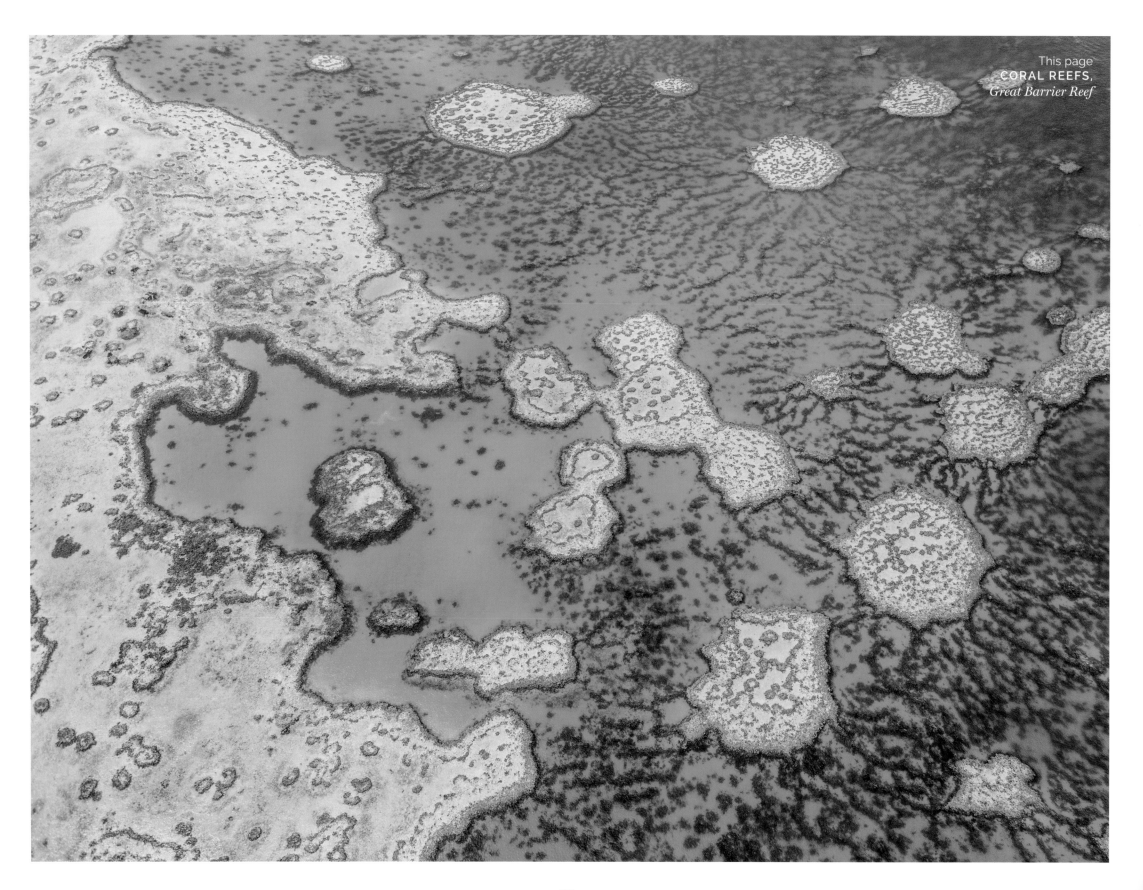

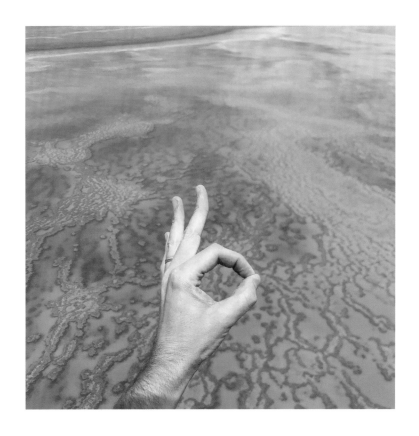

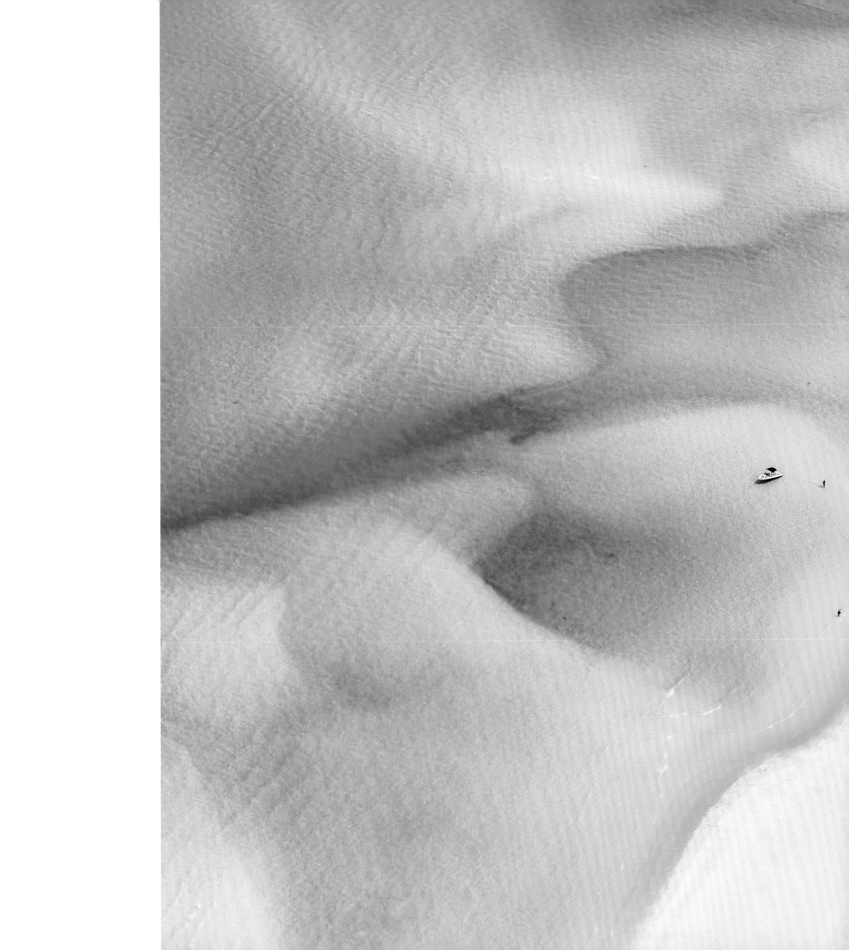

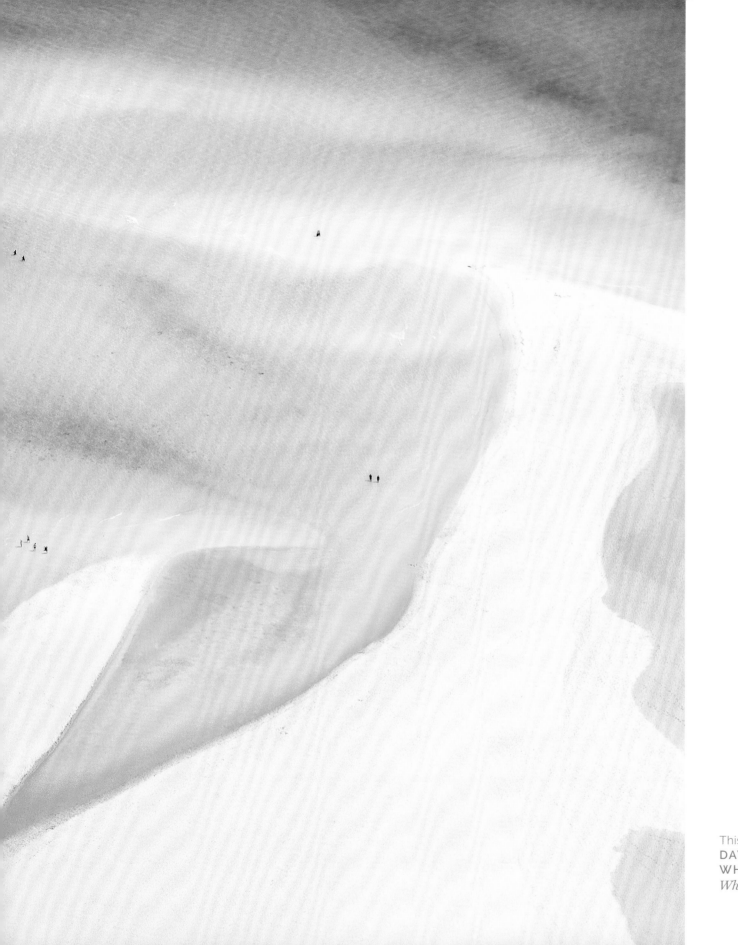

This spread
DAY TRIP,
WHITEHAVEN,
Whitsunday Islands

PARKS

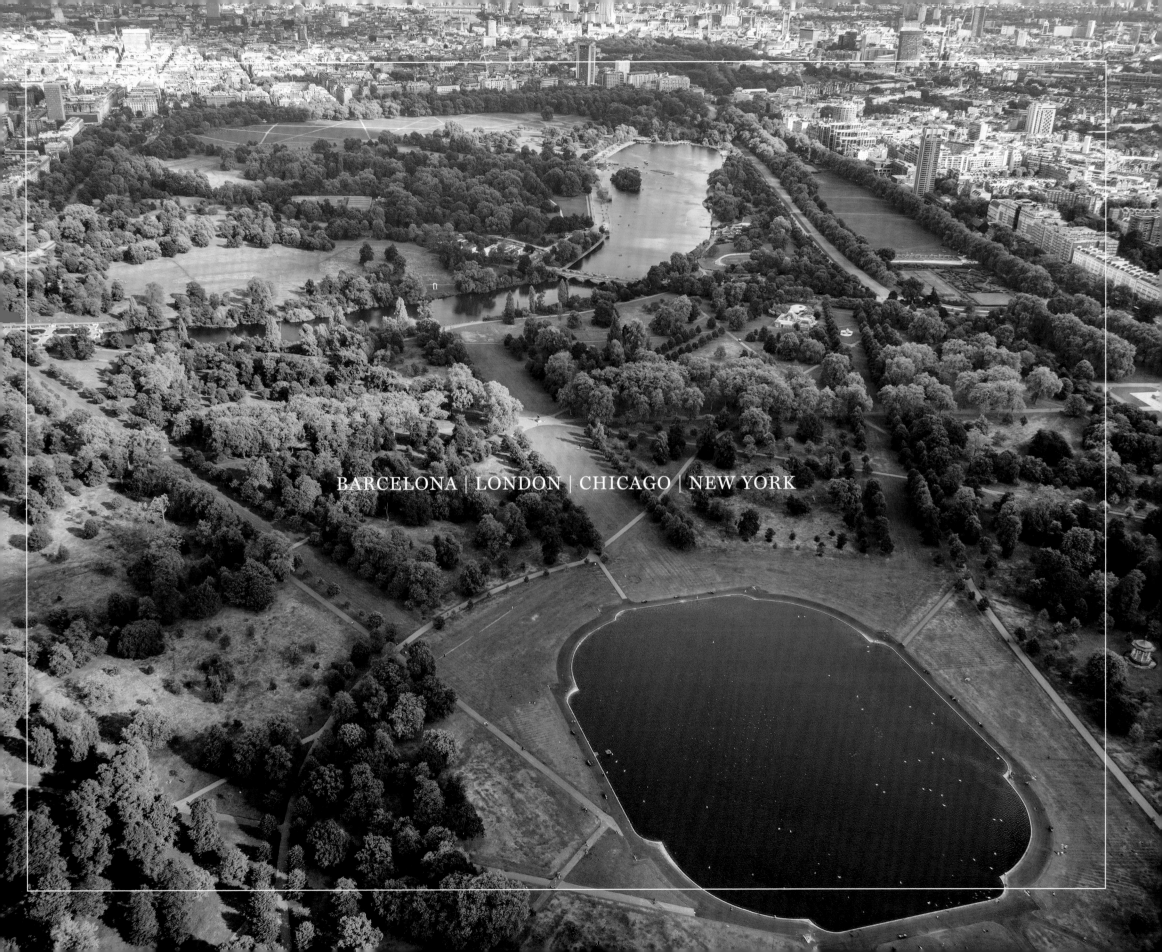

BARCELONA | LONDON | CHICAGO | NEW YORK

Often a great escape can be found just around the corner. City parks have always served as places of relaxation and retreat for urban dwellers and tourists alike. When I think of a perfect day in the park, my mind wanders to Georges Seurat's pointillism masterpiece, A Sunday on La Grande Jatte. For me, this painting has always emphasized how parks offer a romance that transcends time. Seeking to capture a modern-day expression of the mystique of some of the world's most famous city parks, I realized that these shared spaces can transform even the busiest of cities into calm and tranquil places of escape.

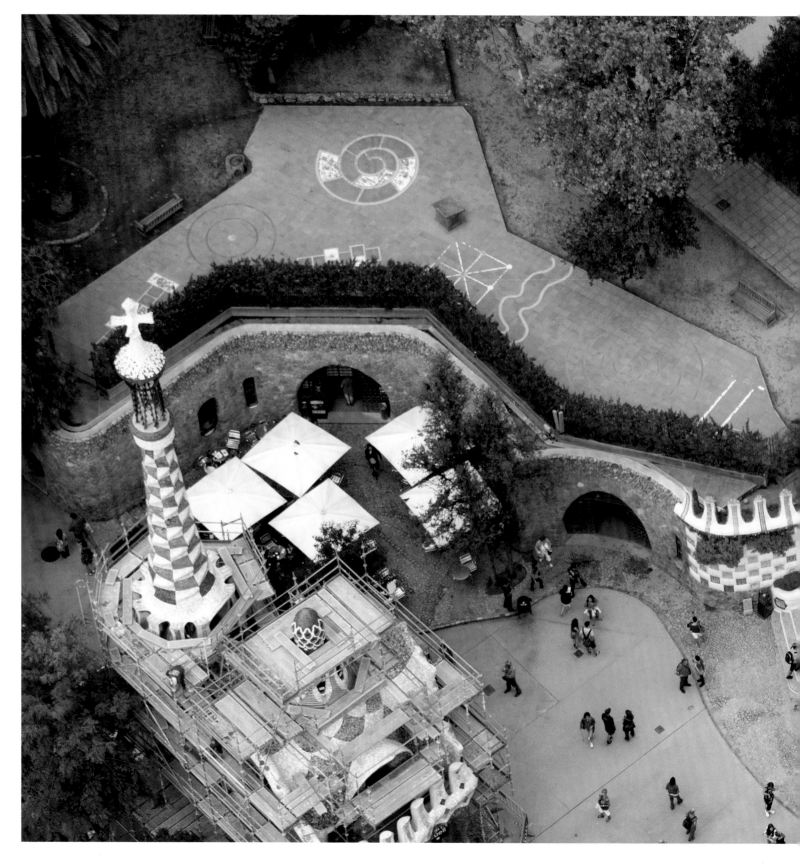

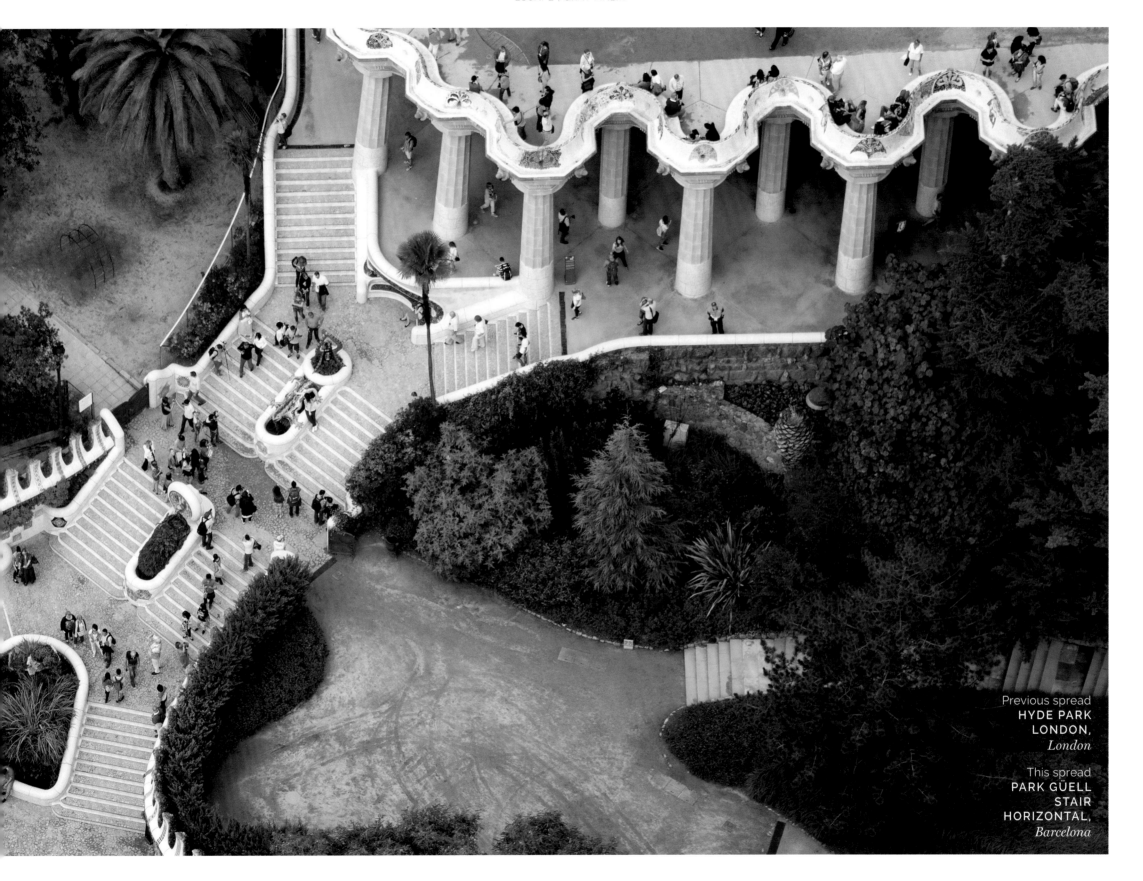

Previous spread
**HYDE PARK
LONDON,**
London

This spread
**PARK GÜELL
STAIR
HORIZONTAL,**
Barcelona

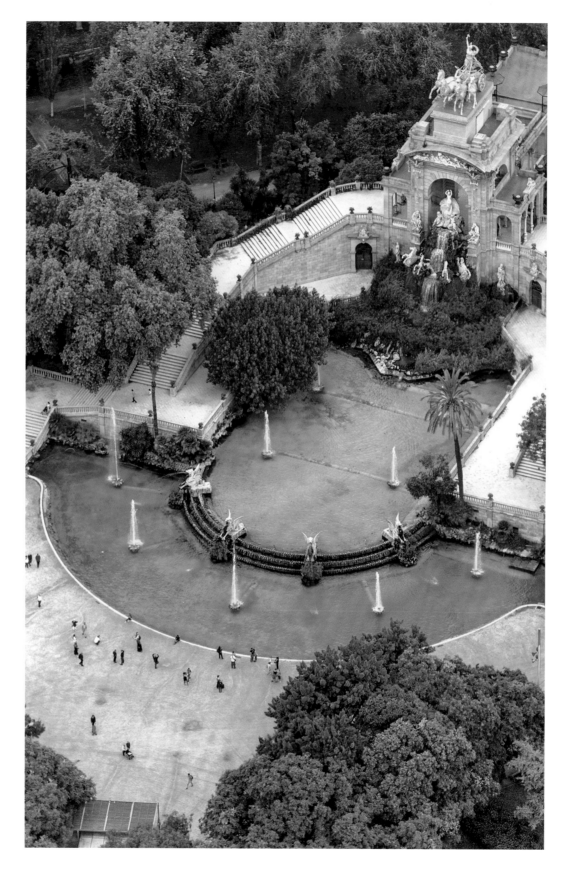

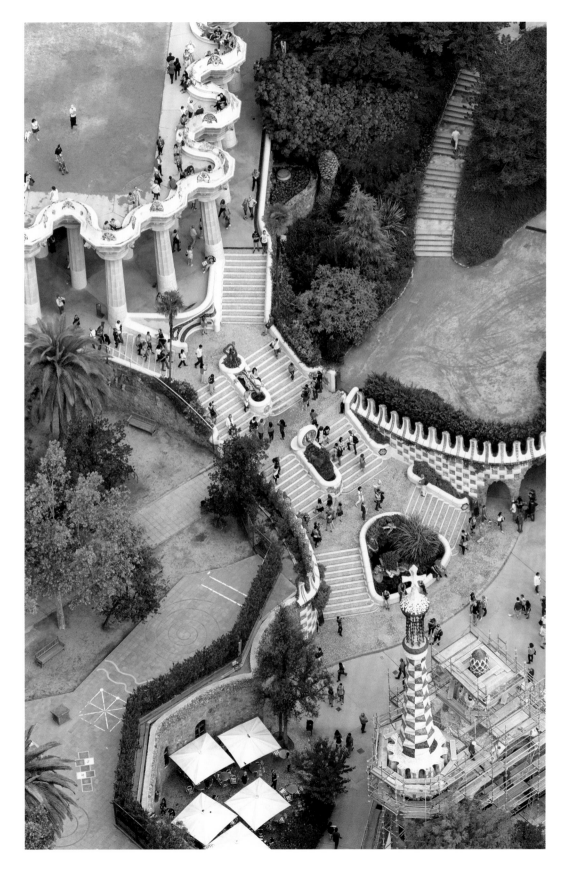

Previous page
CASCADA
FOUNTAIN,
Barcelona

This page
PARK GÜELL
STAIRWAY,
Barcelona

This spread
LA SAGRADA
FAMILIA
Barcelona

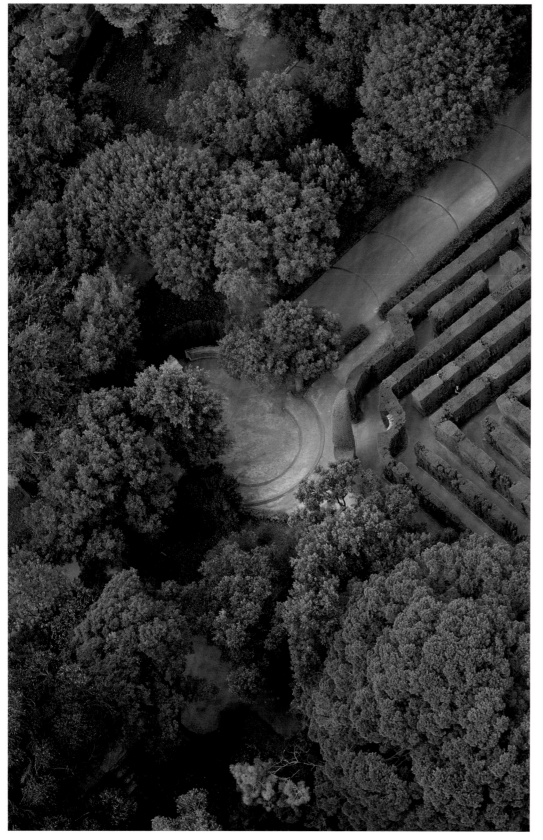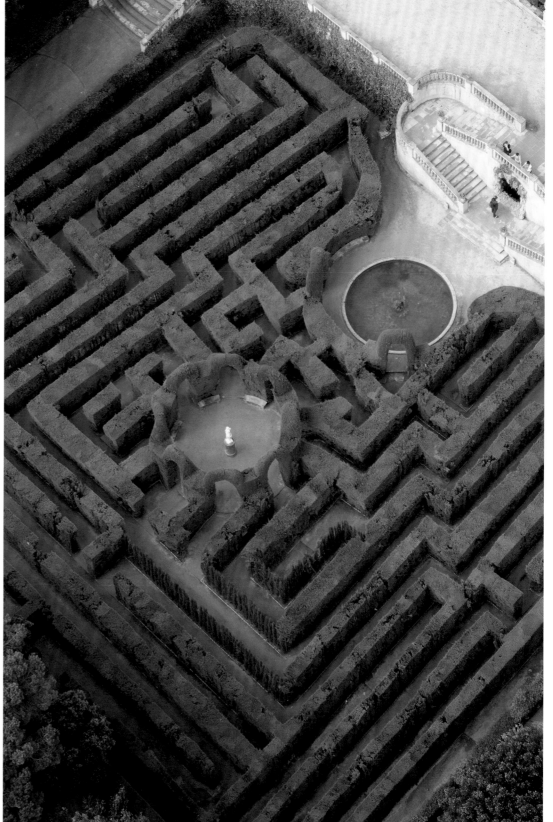

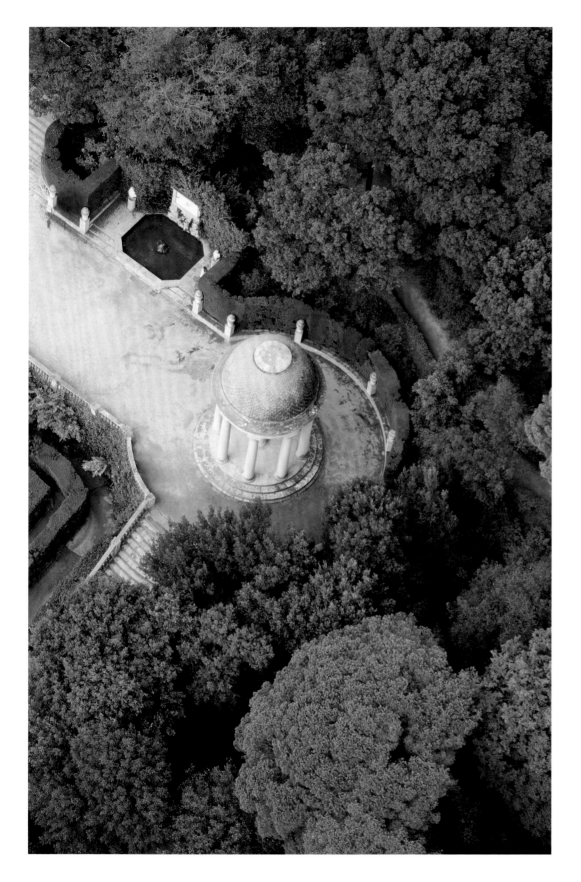

This spread
PARC DEL LABERINT TRIPTYCH, *Barcelona*

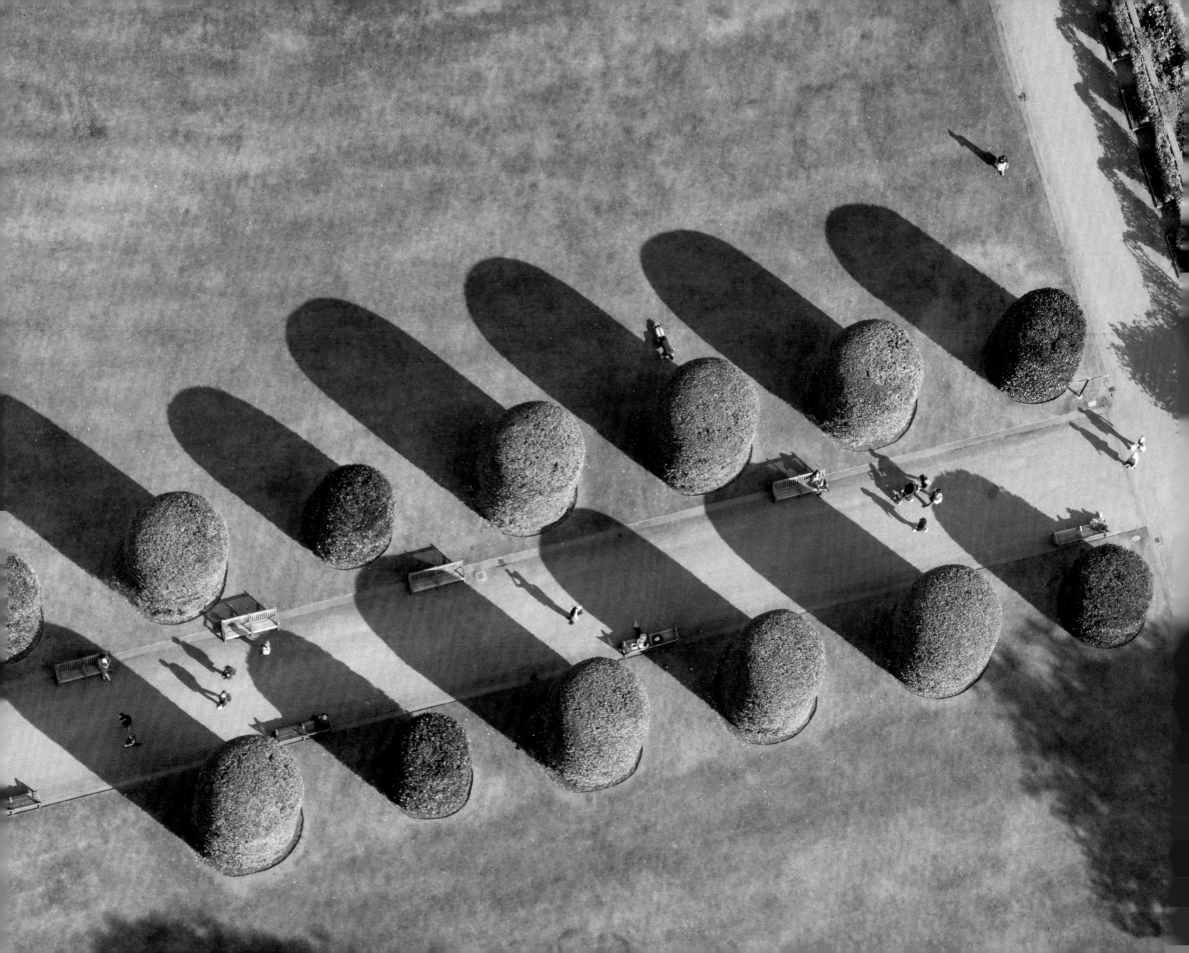

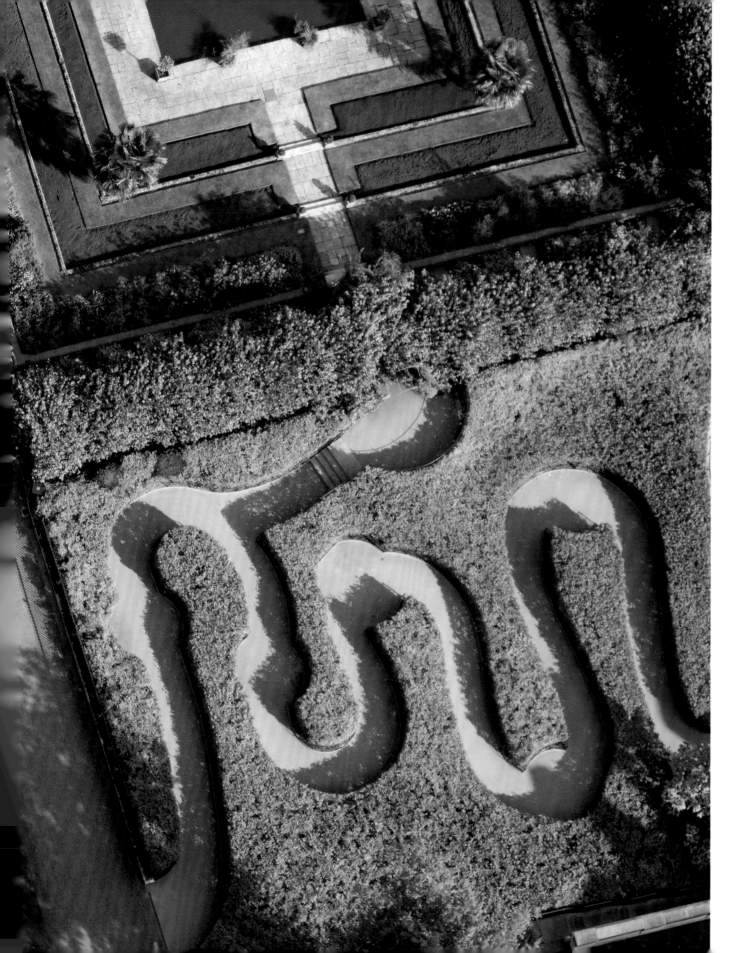

This spread
KENSINGTON PALACE GARDENS,
London

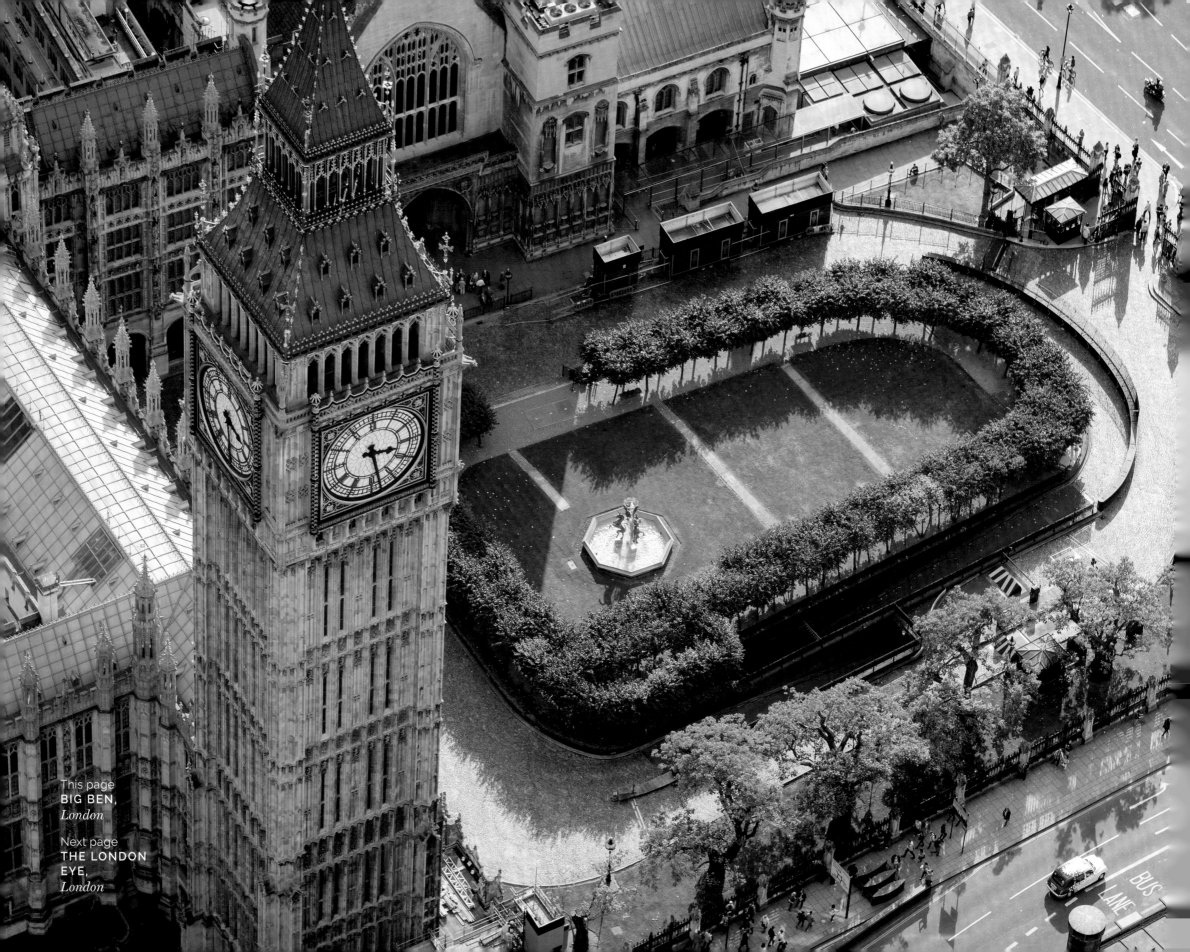

This page
BIG BEN,
London

Next page
THE LONDON EYE,
London

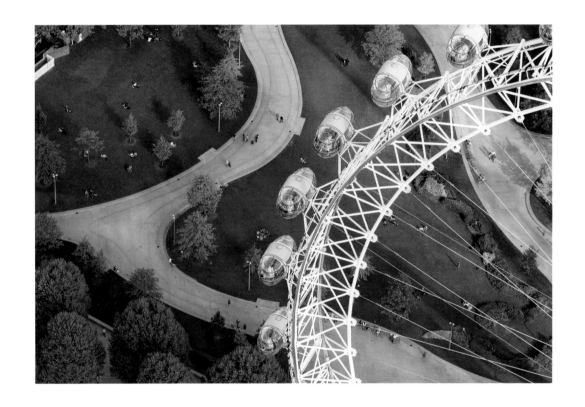

As I was flying above Hyde Park
I noticed a specific grassy corner with
a multitude of green-and-white-striped
sun loungers. Intrigued by this oasis
amid the roaring city, I decided to take
in the views of the park from the chairs.
I love that this city offers this shared
escape, whether just for a lunch break
or an entire afternoon.

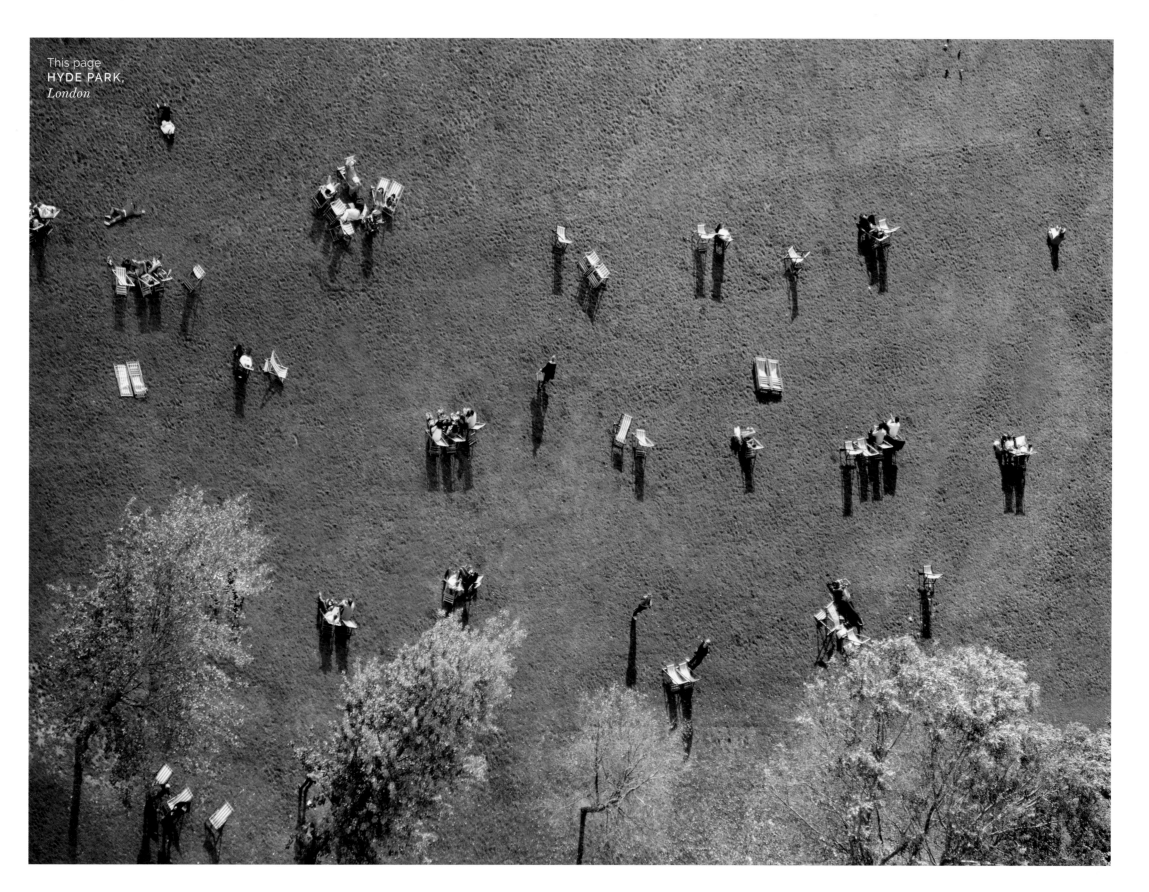

This page
HYDE PARK,
London

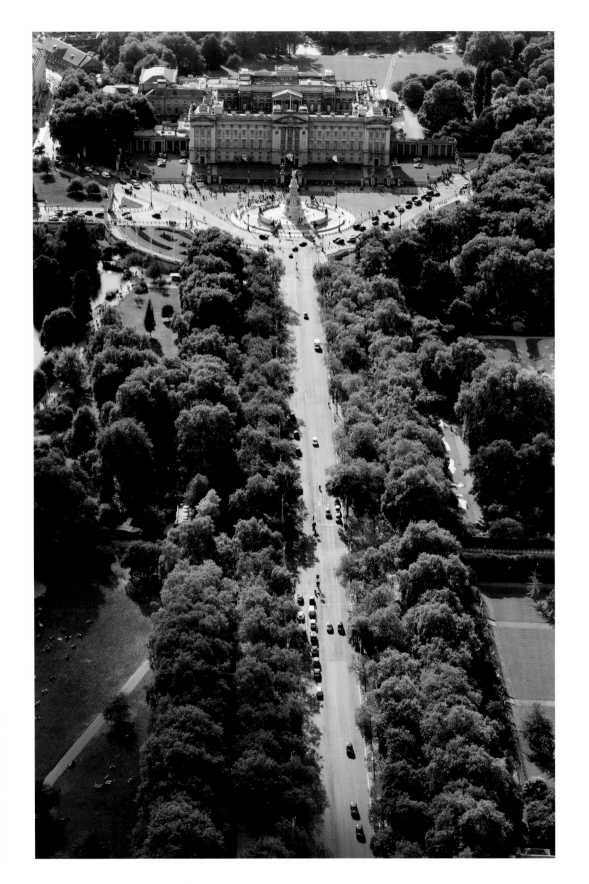

This page
**THE MALL
BUCKINGHAM
PALACE,**
London

Next page
**BUCKINGHAM
PALACE,**
London

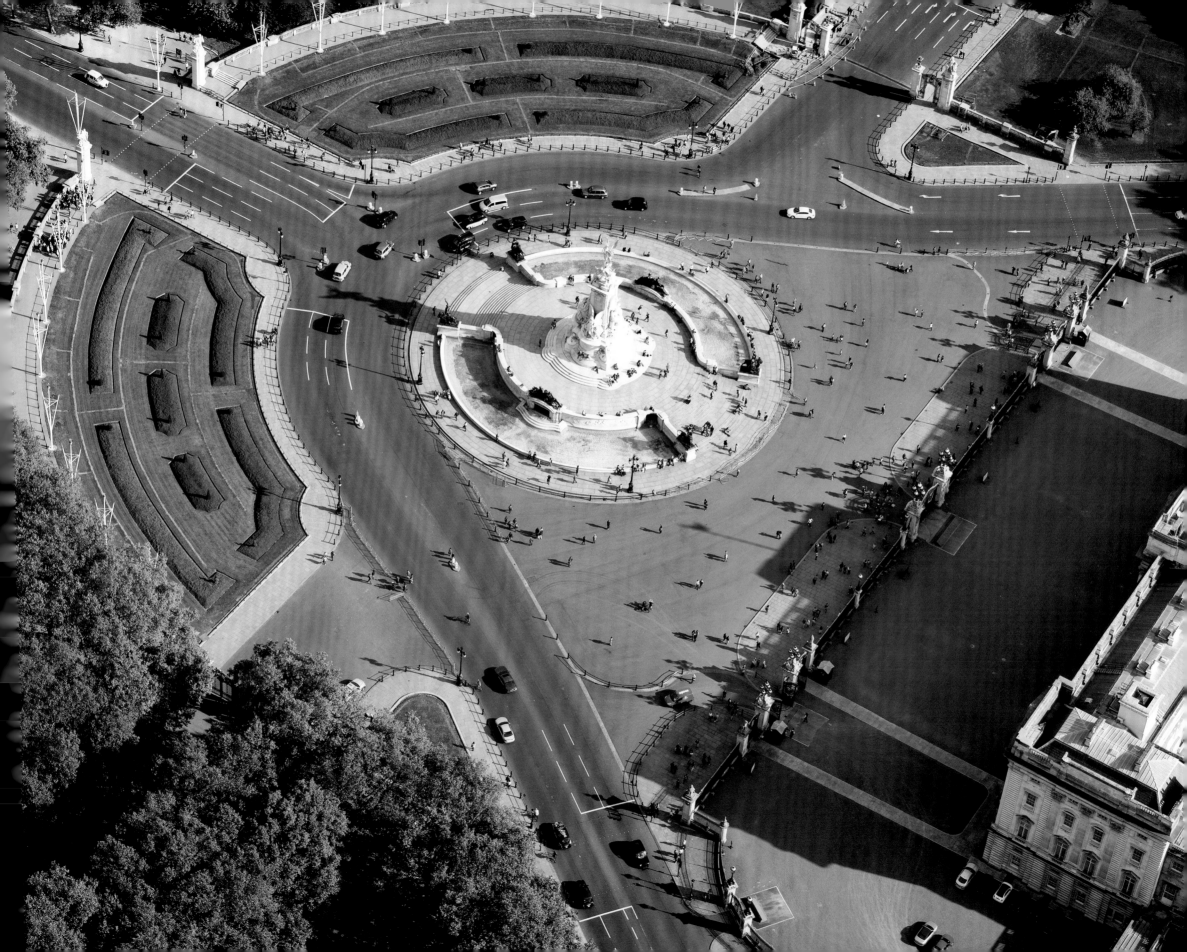

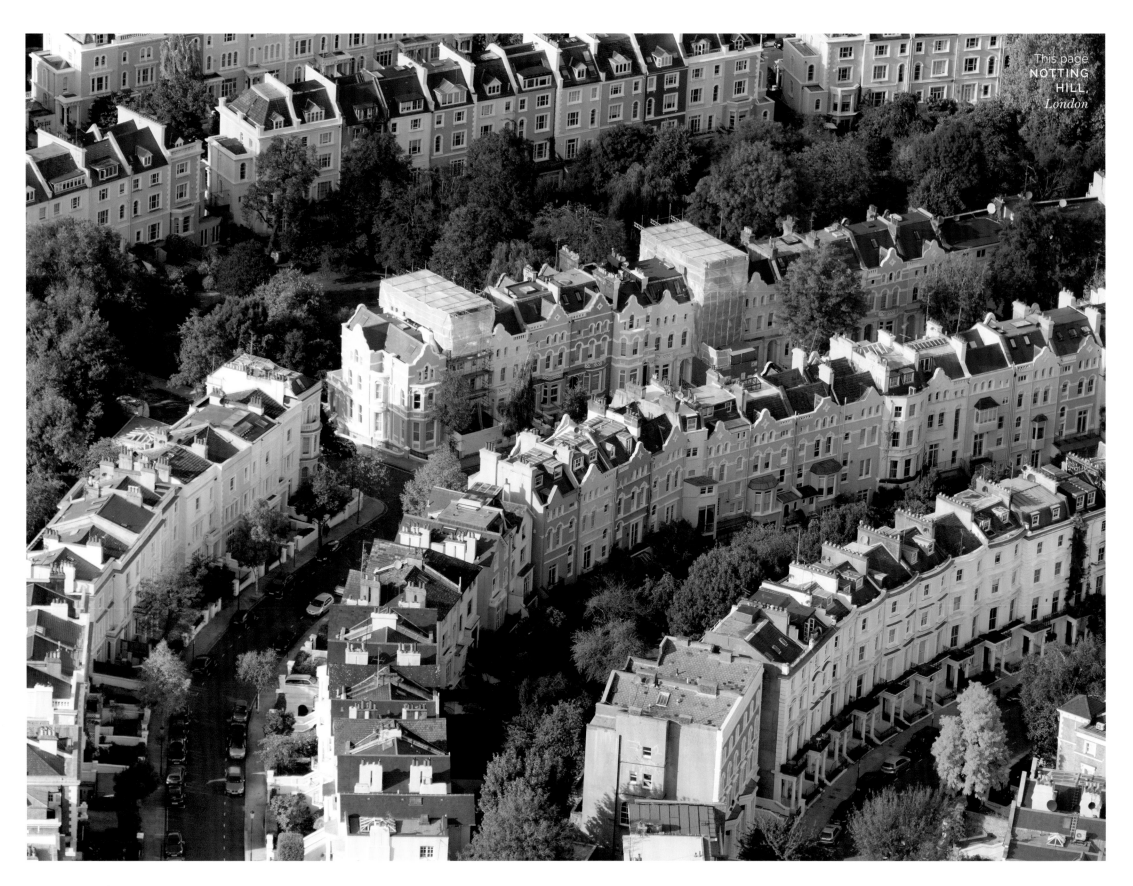

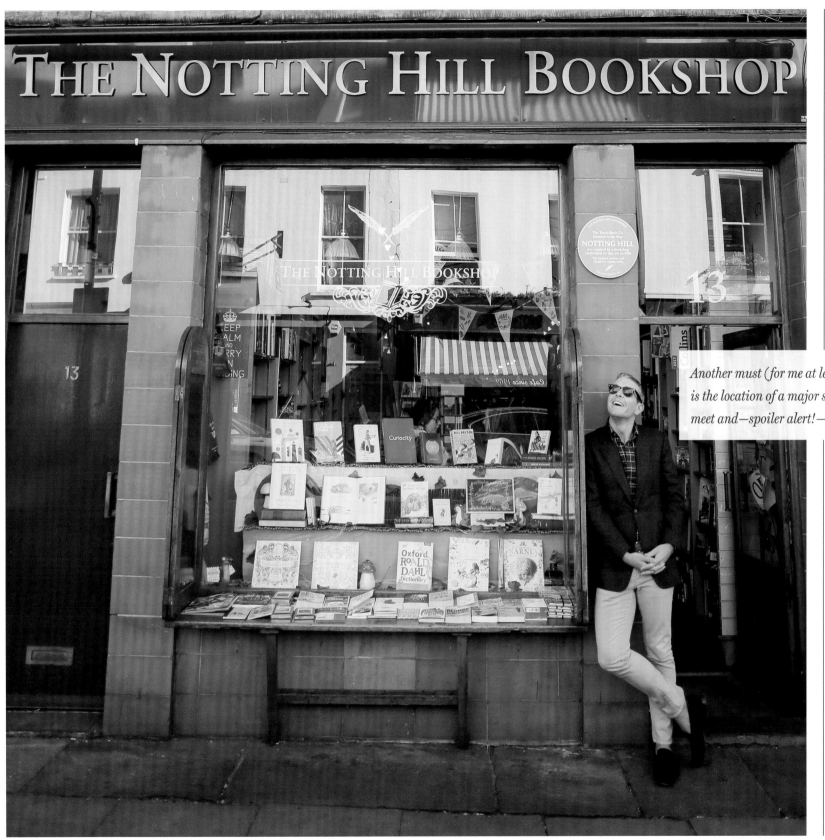

London

London has much to offer any tourist, but for me personally, I have always wanted to escape to the famed neighborhood of Notting Hill. After photographing this spectacular location from above, I knew I had to make it there on my next trip.

Attempting to live vicariously through one of my favorite rom-com movies, *Notting Hill*, I set out on my own adventure to find locations from this beloved film.

Starting at Portobello Road Market, famed for its antiques, fashion, and food vendors, one finds a photograph waiting around every corner. I couldn't help but fall in love with the rainbow-painted townhomes surrounding the area as well.

Another must (for me at least) is a visit to The Notting Hill Bookshop, which is the location of a major scene in the movie where the two main characters meet and—spoiler alert!—eventually fall in love.

After visiting a few more locations from the movie, I finished off the day at one of the local pubs in the neighborhood, taking in the scenery of this truly romantic district. In London, people are allowed to stand just outside the pub with their drinks, which clearly doesn't happen very often in the States. I suggest anyone visiting from "across the pond" should take advantage of this British tradition.

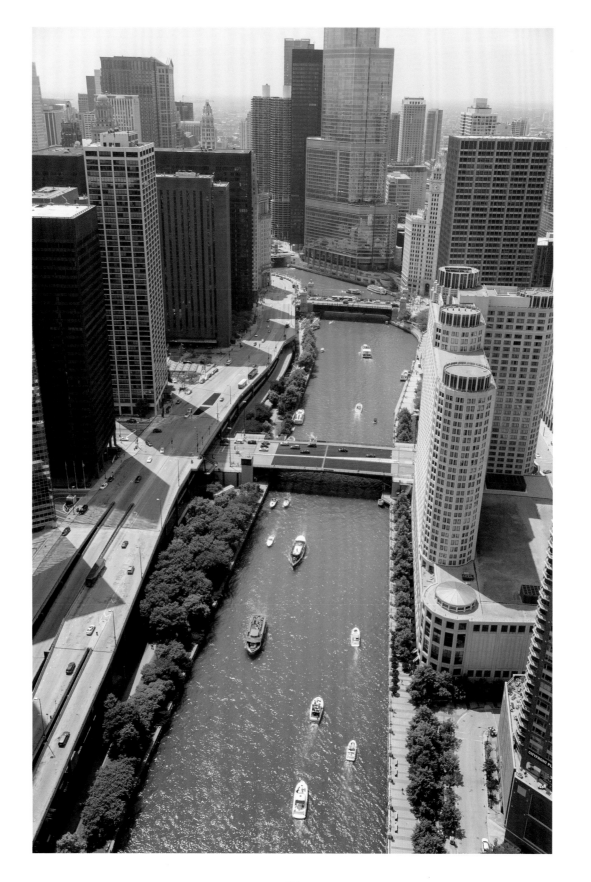

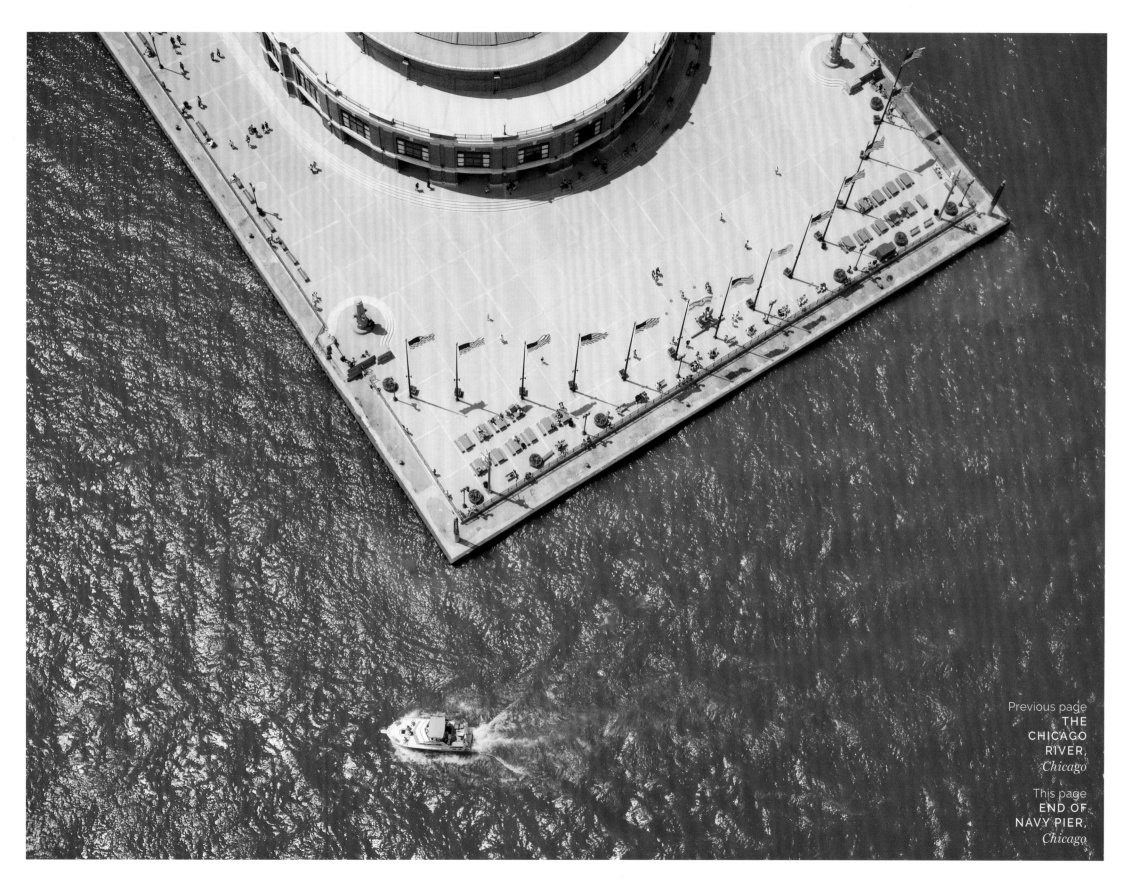

Previous page
THE CHICAGO RIVER,
Chicago

This page
END OF NAVY PIER,
Chicago

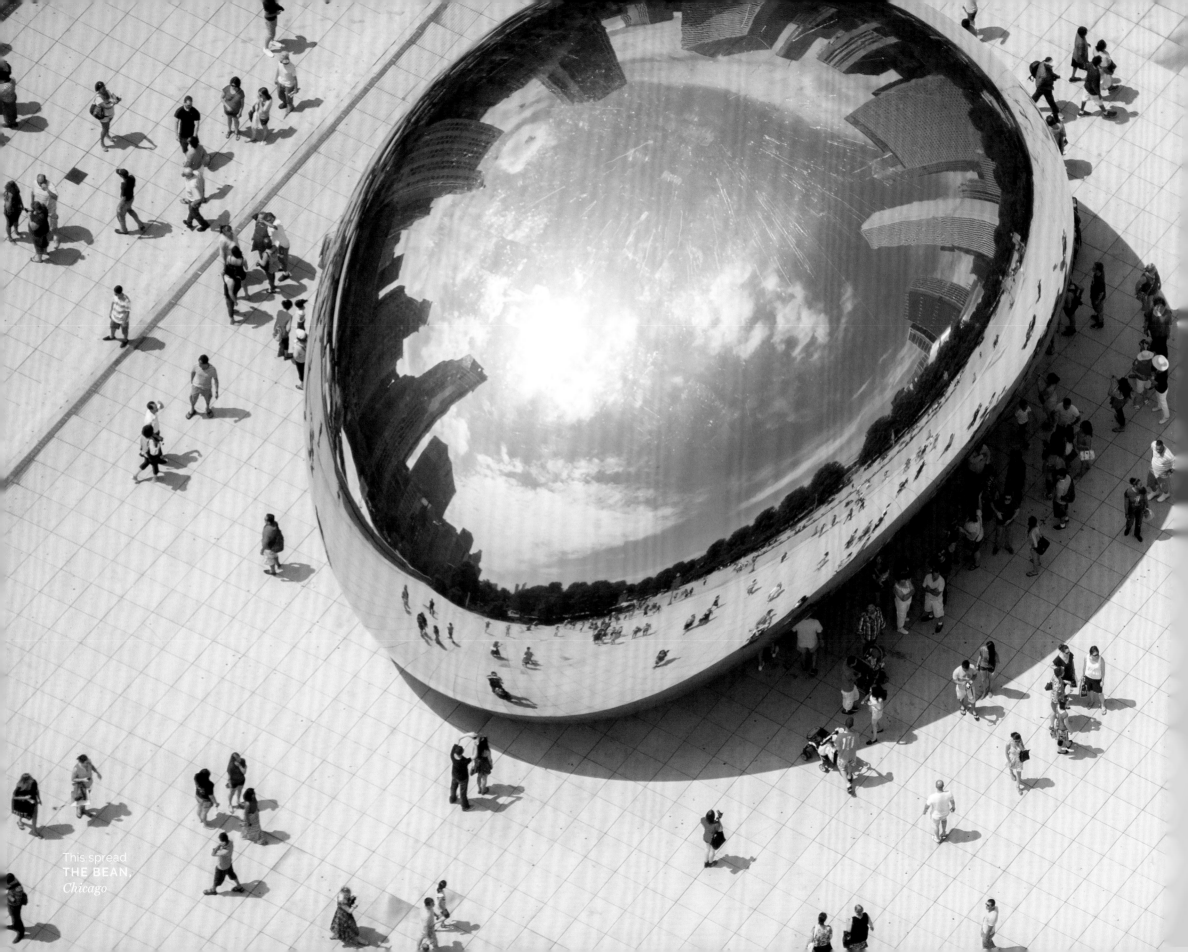

This spread
THE BEAN,
Chicago

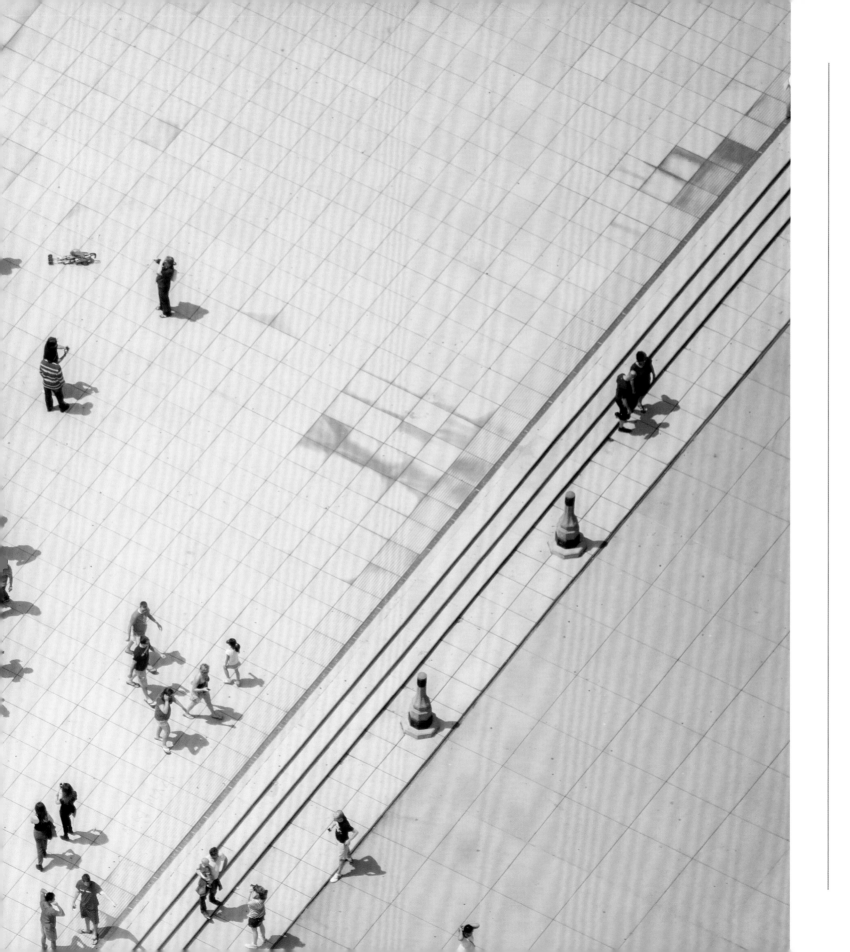

Chicago is such a classic American city, and it's one I grew up visiting with my family, as my maternal grandparents owned a summerhouse along the shores of Lake Michigan. Whenever I'm in town, one of my favorite spots to visit in Chicago is the 24-acre park featuring sculptor Anish Kapoor's Cloud Gate. *Nicknamed "The Bean," this sculpture is a magnet for tourists and locals alike, reflecting beautiful views of the Chicago skyline. Millennium Park is a lovely place to walk around and enjoy the gardens and sculptures. If you're in the city during the spring or summer months, don't miss out on its free concerts, either.*

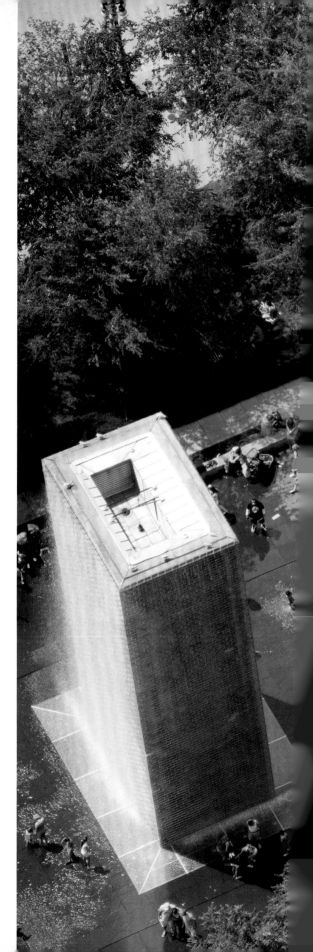

This spread
**MILLENNIUM
PARK CROWN
FOUNTAIN,**
Chicago

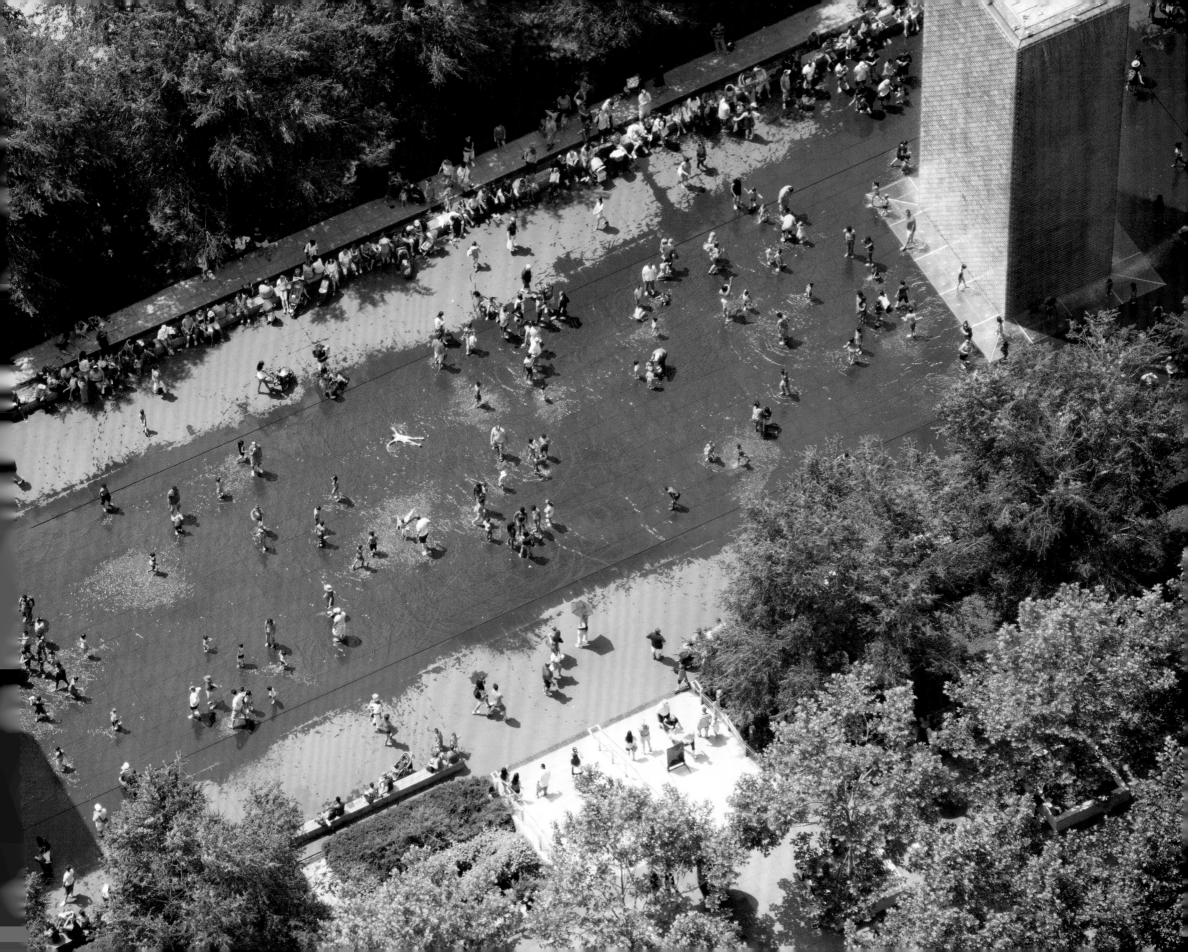

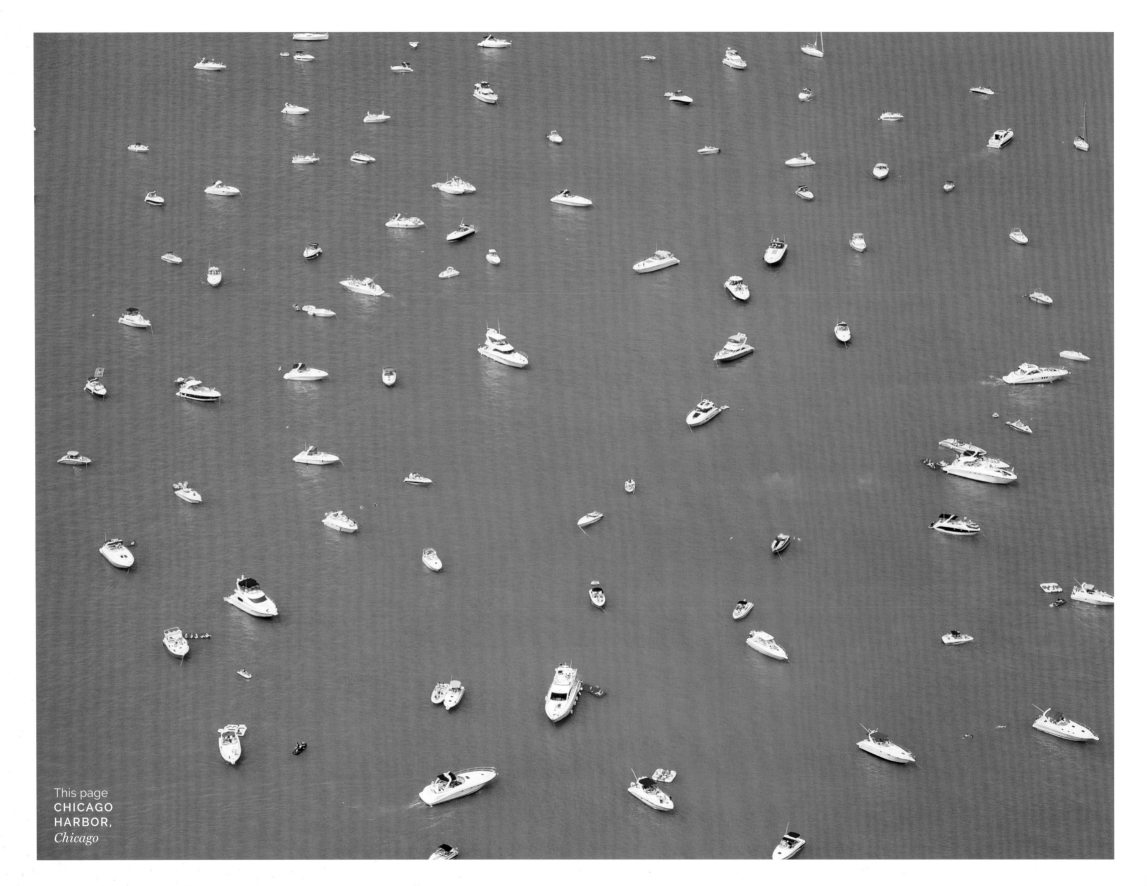

This page
CHICAGO
HARBOR,
Chicago

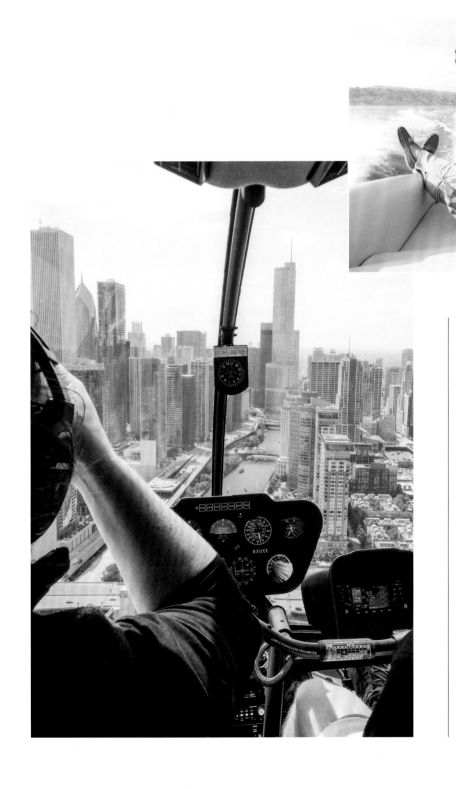

Although I love strolling through Chicago's parks, the two best ways to truly take in this city are by cruising along the shoreline of Lake Michigan or from high above the building skylines. If you don't have a helicopter handy, my go-to spot is the Terrace Rooftop Bar, which has great cocktails and spectacular views of the city.

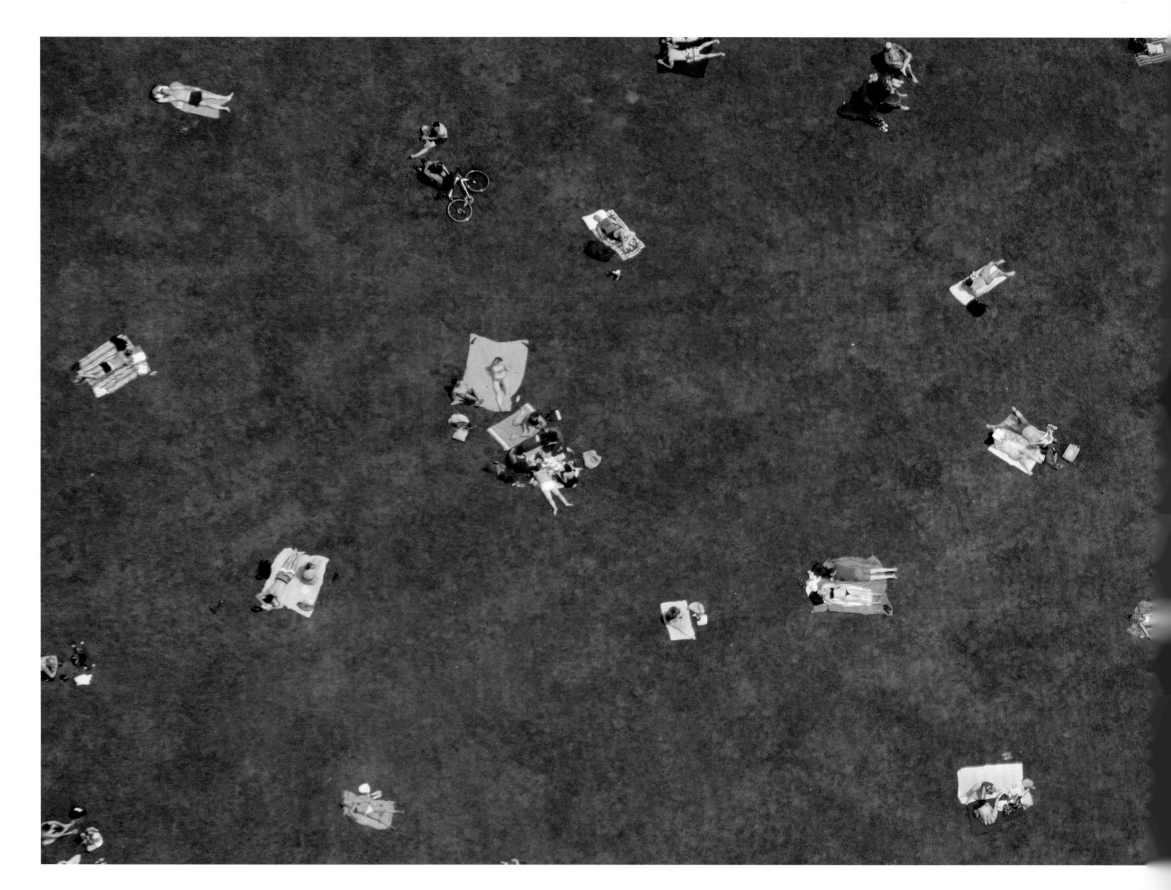

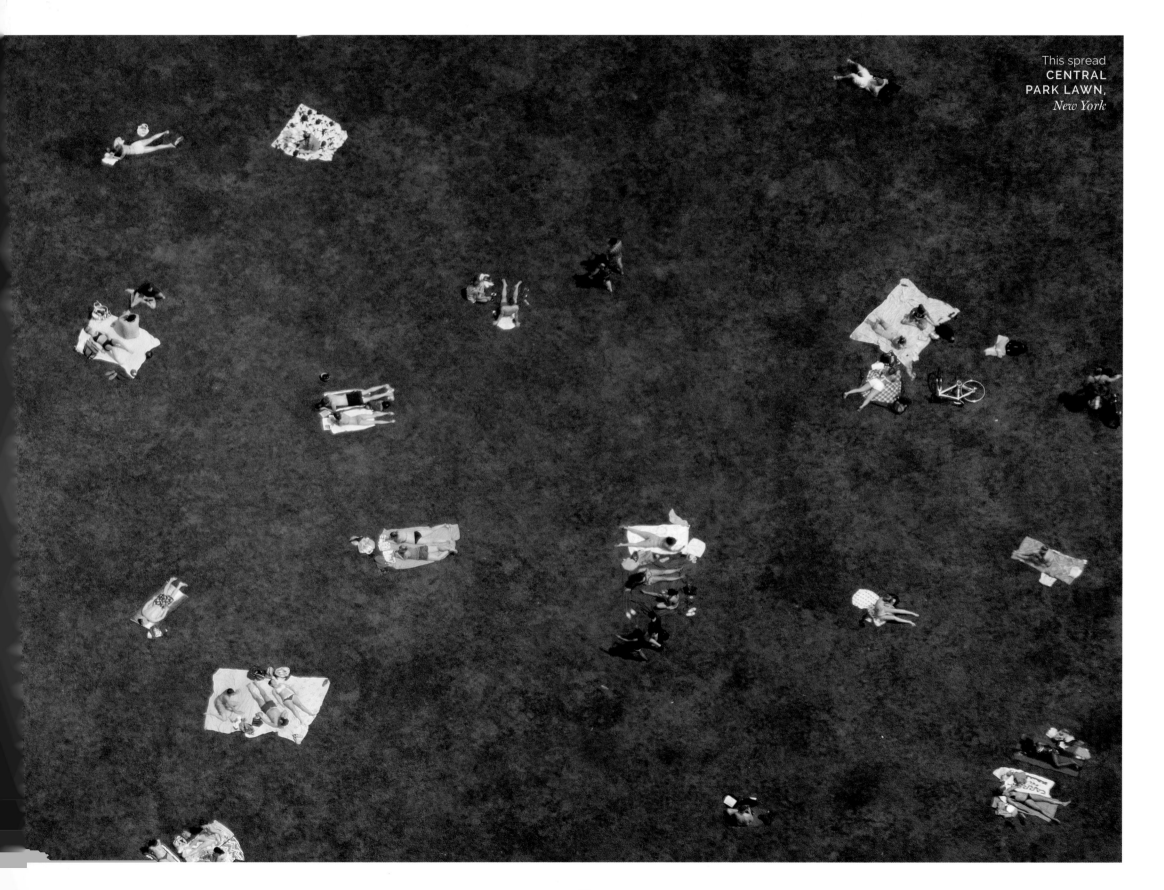

This spread
CENTRAL PARK LAWN,
New York

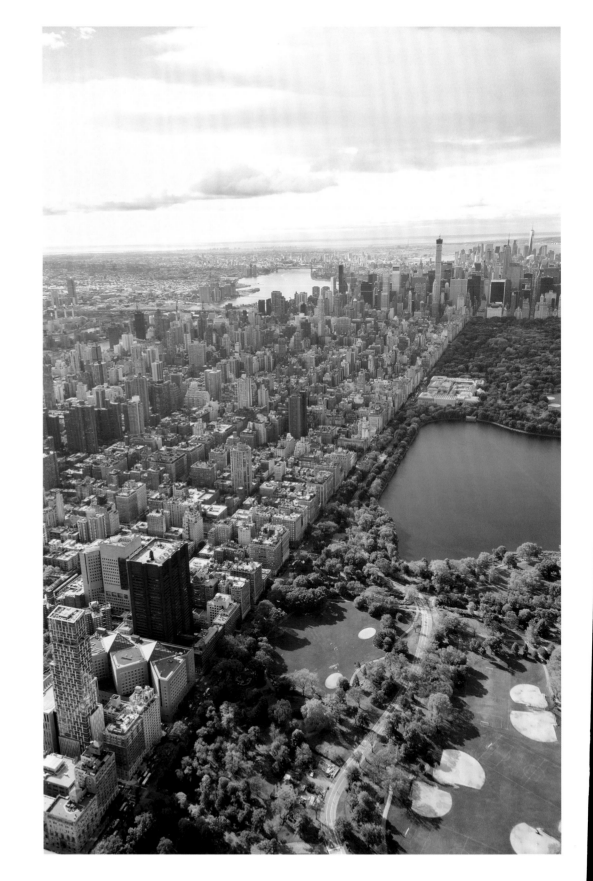

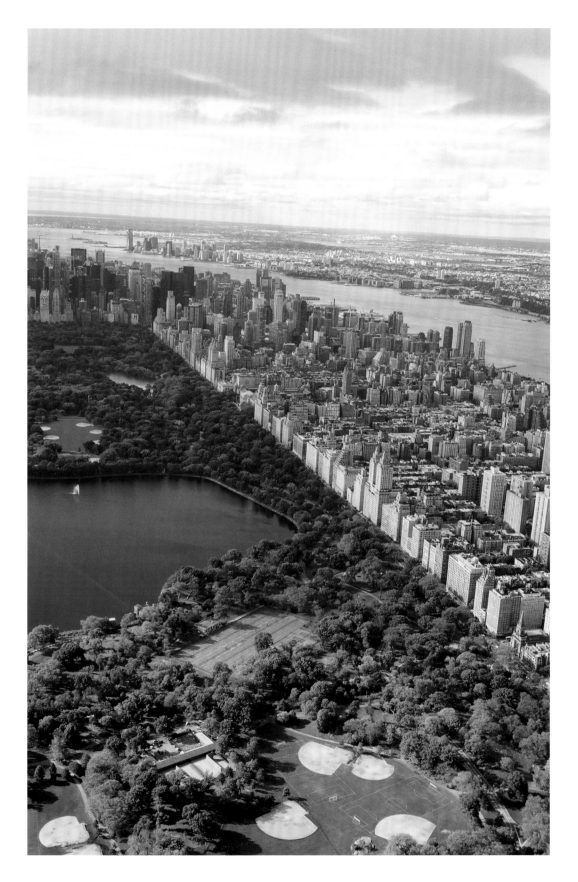

This spread
**CENTRAL PARK
DIPTYCH,**
New York

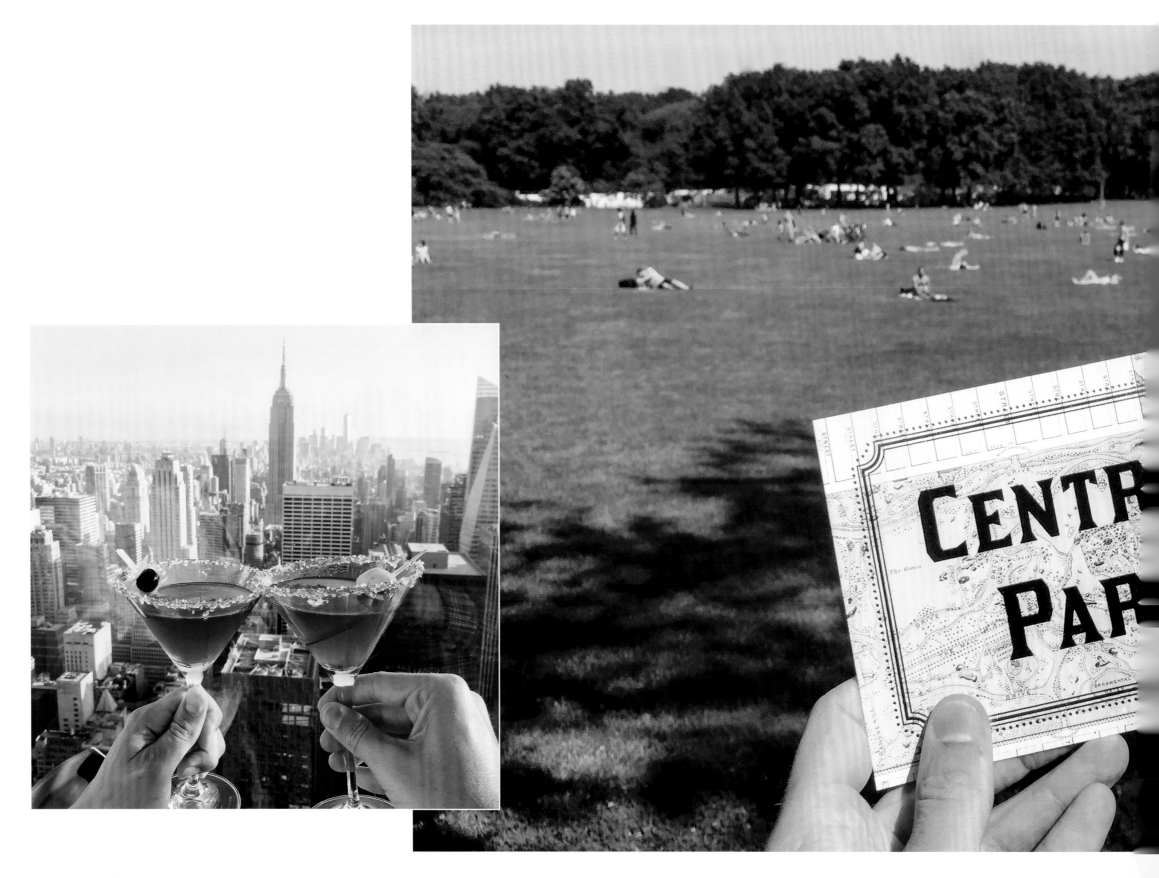

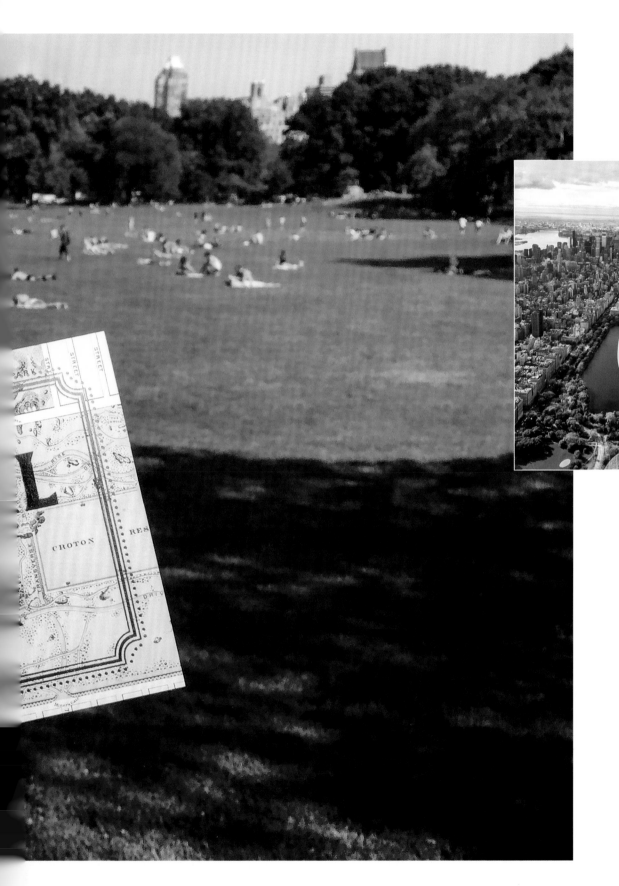

It was so much fun seeing the New York City skyline in an amazing new way. Manhattan is one of the most stunning cities from above. The day I shot "Central Park," "Brooklyn Bridge," and "Manhattan" was an extra-special flight as I had news correspondent Jenna Bush Hager in the helicopter filming a feature story about me and my work for the Today Show. Seeing the story on national television a few weeks later was totally surreal and certainly a moment I will never forget.

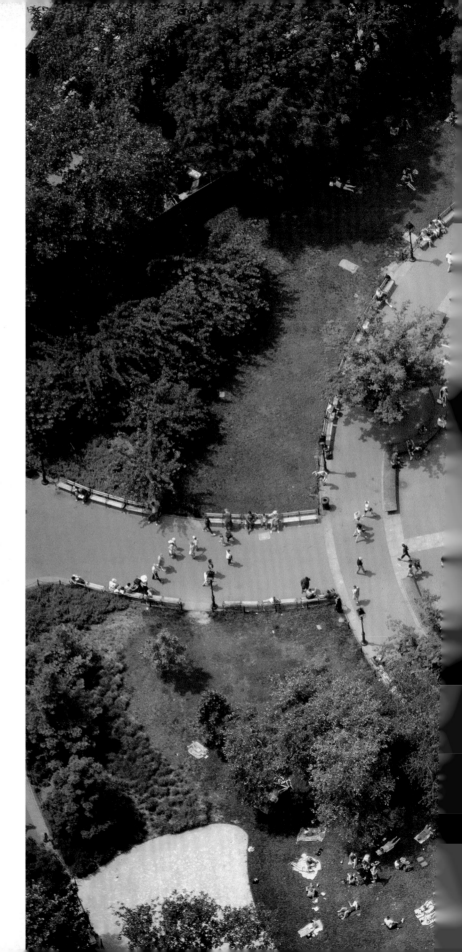

This spread
WASHINGTON
SQUARE PARK,
New York

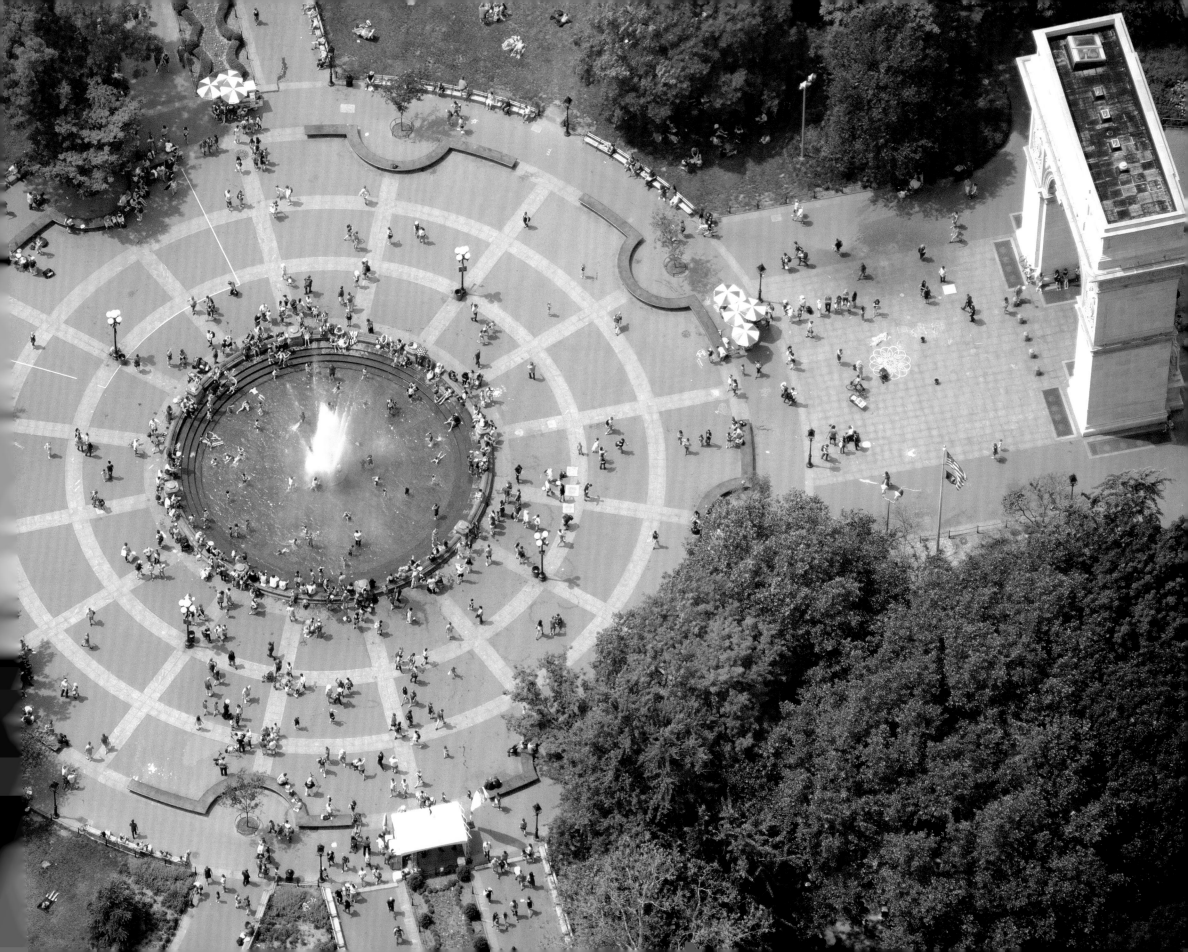

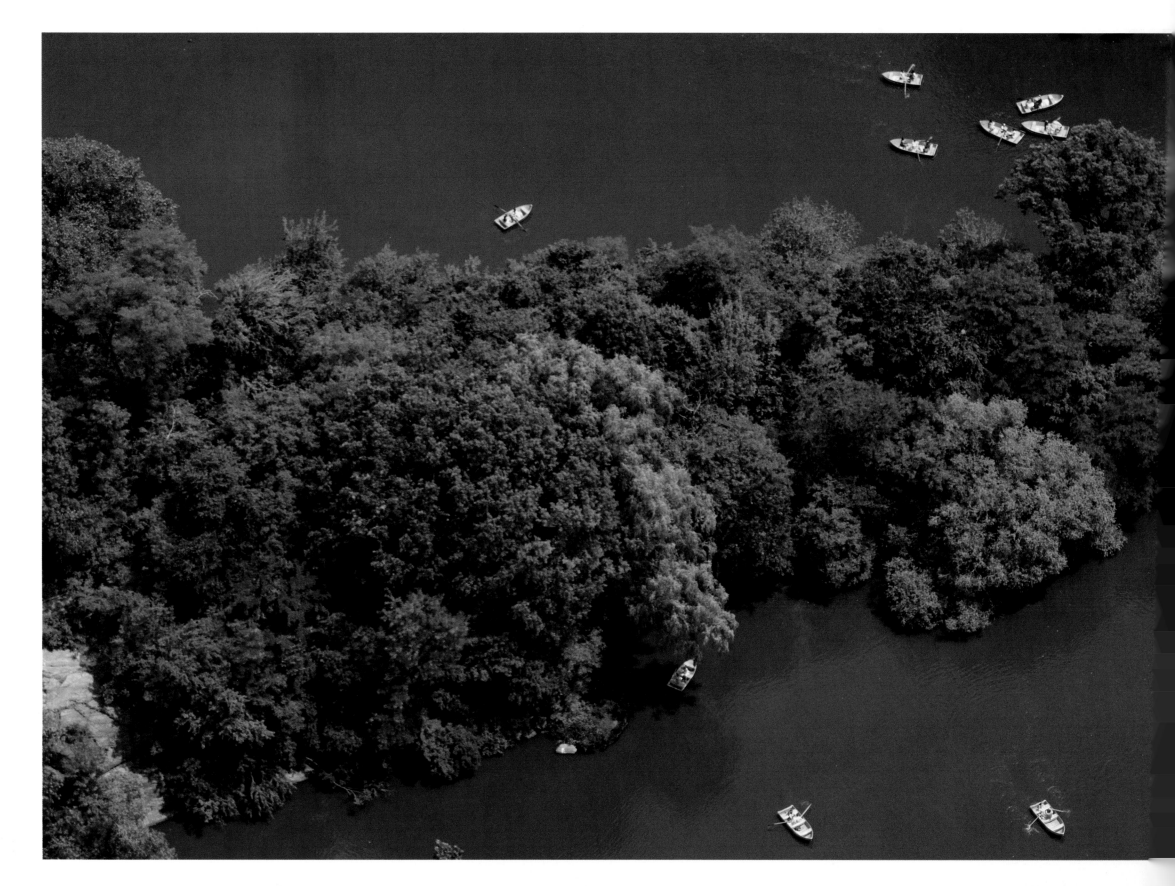

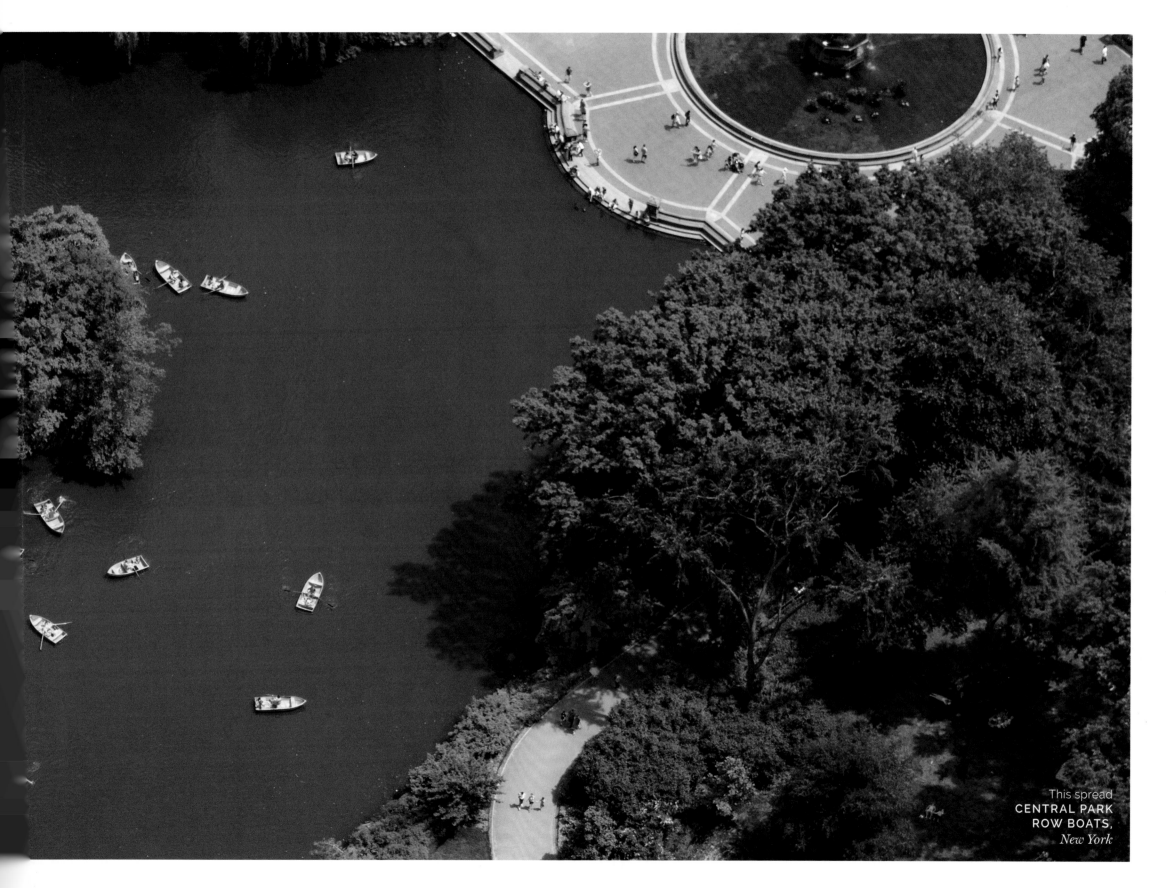

This spread
**CENTRAL PARK
ROW BOATS,**
New York

THANK YOU

To **everyone who has supported my journey**,
I thank you deeply from the bottom of my heart.

To **my incredible staff**, I treasure the time we spend
together and thank each of you endlessly for your devotion
to making every day a joyful getaway.

To **Isabella, Paige, Brad, Nicholas, Michelle, and Rebecca,**
thank you for helping me breathe life and love into
each and every page of this book.

To **my dearest friends,** thank you for the compassion
you have shown me over the years—and for always staying
close, even when I am far away.

To **my parents, my sister, and my extended family,**
I love you endlessly.

Lastly, **to my husband Jeff,** for whom this book
is dedicated, thank you for your incredible strength that
gives me the courage to take flight each and every day.

Credits

CONTRIBUTING EDITOR
Isabella Lyle-Durham

COPY EDITOR
Paige Yingst

PHOTO EDITORS
Brad Stire
Nicholas Scarpinato

BOOK DESIGNER
Michelle Kim

GRAY MALIN TEAM
Isabella Lyle-Durham
Paige Yingst
David Howard
Kristen Gray
Nicholas Scarpinato
Kate Leiva
Christine Chen
Brad Stire
Jeff Richardson
Linsay Long
Isabelle Blye

LEGAL/PR
Danielle Frisa
Bollare Team

ABRAMS
Senior Editor:
Rebecca Kaplan

Creative Director:
John Gall

Design Manager:
Danny Maloney